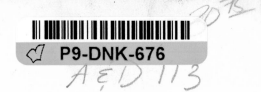
The Art
of Drawing

Reproduced on the cover:

Lucas Cranach the Younger (1515–1586; German).
Portrait of Princess Elizabeth of Saxony. c. 1564.
Wash on rose-colored paper, 15½ × 11¼″ (39 × 29 cm).
Kupferstichkabinett, Staatliche Museen, Berlin.

The Art of Drawing

Third Edition

Bernard Chaet
Yale University

Holt, Rinehart and Winston
New York Chicago San Francisco Philadelphia
Montreal Toronto London Sydney
Tokyo Mexico City Rio de Janeiro Madrid

Publisher Robert Rainier
Editor Karen Dubno
Picture Editor Joan Scafarello
Picture Research Assistants Barbara Curialle, Leslie Yudell
Special Projects Editor Pamela Forcey
Copy Editor H. L. Kirk
Production Manager Nancy Myers
Art Director Louis Scardino
Design and Layout Caliber Design Planning

Composition and camera work York Graphic Services
Color separations The Lehigh Press, Inc.
Printing and binding Capital City Press

Library of Congress Cataloging in Publication Data

Chaet, Bernard.
 The art of drawing.

 Includes index.
 1. Drawing—Technique. I. Title.
NC730.C45 1983 741.2 82–15404

ISBN 0-03-062028-7

Address correspondence to:
383 Madison Avenue
New York, NY 10017

3 4 5 046 4 3 2

CBS COLLEGE PUBLISHING
Holt, Rinehart and Winston
The Dryden Press
Saunders College Publishing

To my students
whose talent and enthusiasm
motivated the experiences
described on the following pages

Preface

This third edition of *The Art of Drawing* focuses on the latest developments in my drawing classes, which began at the Yale School of Art in 1951. The student examples herein cover three decades and the beginning of a fourth. Their work, seen in constant dialogue in time, has been my inspiration for this volume.

In the first three chapters the many languages of drawing are introduced, together with important formal considerations which are seen here to be expressive in themselves when matched to chosen thematic material. Right from the beginning, I will argue, it is important to think about choosing an attitude rather than imitating a style. The unstated goal here is to make students believe, from the outset, that drawing is an art rather than an acquired skill or technique.

The fourth chapter, Media and Materials, is a book within a book. Blended and integrated into the existing material is a technical guide to media that covers all dry and wet media (plus a better formula for fixing charcoal and pastel than one can buy in existing commercial spray cans). Monotype is seen here, as I have found it in class, as a drawing process closely related to wash drawings; at the same time it bridges drawing and painting, as well as drawing and printmaking. Knowledge of the technical aspect of materials is a necessary partner to the draftsman's form-making function, for the artist imagines his or her future work in terms of a chosen medium.

In Chapters 5 through 10 most readers will find the heart of the book. Landscape, Forms from Nature, Interiors and Objects, Skulls, Animals, and the Figure are seen from two equally important views. First there is analysis of individual forms, that is, forms seen volumetrically in space. After each form is analyzed it is seen as part of an ensemble. Structure and composition are the twin goals.

The test of knowledge of the skeleton's structure is expanded in this edition with many new student examples. Charts and diagrams cannot teach the student the structure of the skeleton (the skeleton being the stand-in for the figure).

Conceptual thinking is the issue: one can only draw what one knows. Looking at a head or a figure without memorizing the inner structure produces a drawing without a visual culture: the masters, old and new, teach us that they have committed the figure to memory.

The final test for independent thinking is Chapter 11 on Individual Projects. Here we can witness the process of developing themes. Only when a student selects a theme can he or she learn what is necessary to fulfill the concept. This is where self-education must deliver the ultimate goal of this book: to commit to memory the forms of human beings and their environment as a basis for future interpretation.

The final two chapters are concerned with learning how orchestrated marks become expressive—and how each one of us has his or her own natural handwriting in drawing. The study of master works is as rewarding as the study of forms from nature. We can learn to discover how each master reinvents a personal world.

This book is intended for students, artists, and connoisseurs. I do not suggest that instructors and students who use it follow the order. The order here, however, is the one I use in my teaching; the chapters are designed to go from simple to complex forms and ideas.

The students whose works are reproduced are majors in painting, printmaking, graphic design, sculpture, and architecture. I have been blessed with talented and responsive students.

• • •

I am grateful to the following, who read the manuscript and made constructive suggestions: Katherine Allen, The Maryland Institute, College of Art, Baltimore; Ronald Binks, University of Texas, San Antonio; Frank Dippolito, Tacoma Community College, Washington; Robert Dodge, Bucks County Community College, Pennsylvania; Harold Linton, Lawrence Institute of Technology, Michigan; Norman Nilsen, Pratt Institute, Brooklyn, and State University of New York at Purchase; Richard Raiselis, City University of New York and York College; John Schrader, East Tennessee State University.

The editors of the first two editions—Dan Wheeler and Rita Gilbert, as well as Joan Curtis, picture editor—must be thanked for their previous indispensable help. Karen Dubno, the editor for this edition, asked good questions. Special thanks go to Joseph Szaszfai for the photography of student work and to Janet Husmer for the typing of the manuscript.

B.C.

New Haven, Connecticut
October, 1982

Contents

CHAPTER 1

Directions

Since the Renaissance the art of drawing has come increasingly to be considered a unique graphic experience rather than simply the making of preliminary sketches to be translated into other media. The working drawings of the Old Masters give us an intimate glimpse of the artist's search and experimentation with ideas and forms, for they often suggest the initial impulse that subsequently gave birth to a fully developed artistic concept. Today we admire not only the immediacy of these studies but also the individual handwriting the drawing itself reveals, which may later be hidden or lost in the transposition to another medium.

Each generation invents new functions for drawing and resurrects old ones. For example, some modern artists use drawing to create an expressive division of space or to build spatial relationships; for others it serves as a compositional search for the unknown. Many artists still regard drawing as a rehearsal for more formal works while others consider it as simply form-making in black and white. In fact, drawing can be all these things and more, individually or in combination. Each artist's vision determines the function drawing will serve and the direction it will take; five works by a single master in a variety of media within a thirty-six-year span will illustrate this point.

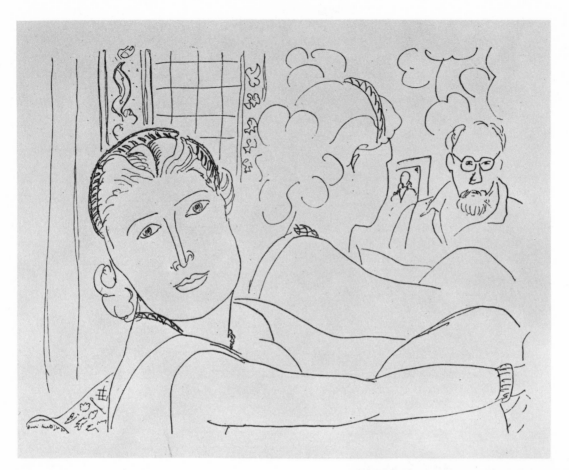

above: **1** Henri Matisse (1869–1954; French). *Le Peintre et Son Modèle*. 1936. India ink.

right: **2** Henri Matisse (1869–1954; French). *Young Girl with Long Hair*. 1919. Graphite pencil on paper, 21 × 14½″ (53 × 37 cm). National Gallery of Art, Washington, D.C. (Rosenwald Collection).

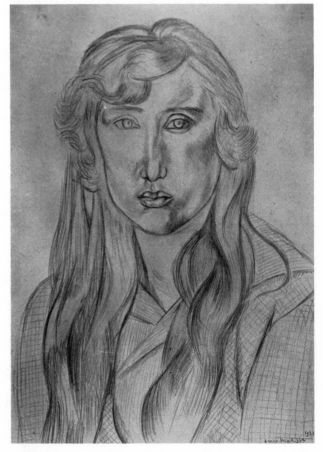

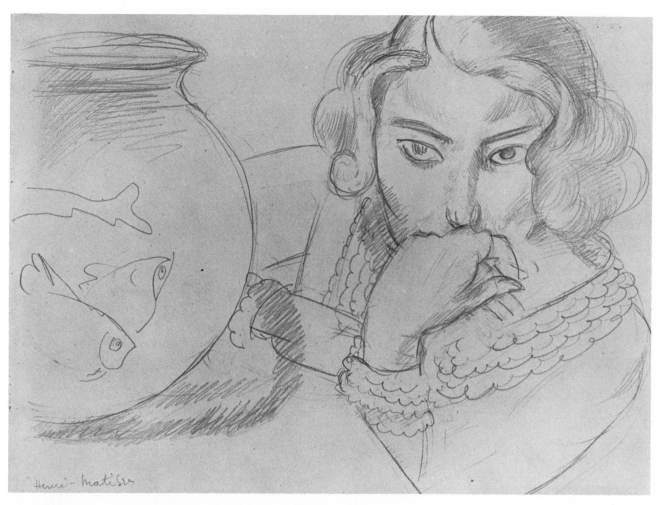

3 Henri Matisse (1869–1954; French). *Young Girl by Aquarium*. Graphite pencil, 9⁹⁄₁₆ × 12⅝″ (24 × 32 cm). Baltimore Museum of Art (Cone Collection, formed by Dr. Claribel Cone & Miss Etta Cone of Baltimore, Maryland).

The genius of Henri Matisse makes the line drawing in Figure 1 seem, at first glance, very easy to do. But careful study reveals that line has been manipulated skillfully to perform three functions: It projects the forms into space, and it both controls and energizes the entire composition. Obviously, this is a masterful use of line, and it is the result of long experience. The beginning artist cannot expect to acquire such ability instantly.

In a much earlier drawing by Matisse, *Young Girl with Long Hair* [2], we can examine a part of the process by which a draftsman develops an individual style. One "invents" oneself as an artist by trying out many attitudes toward form. In this pencil drawing the incised features (eyes, nose, and mouth) testify to the study of works of such masters as Hans Holbein, who created simplified, individual, and seemingly rounded forms in drawing. Matisse combines this sculptural quality with a personal preference for arabesque rhythm, as in the flowing, continuous contours of the face, hair, and clothing. The modeled structure is interwoven into these linear movements. Matisse often played such apparently contradictory styles against one another. This drawing in which each stroke reacts to its neighbor in a classical tautness is an example of drawing as a unique work of art rather than merely a study. By contrast, in Figure 3 we see a study in the same medium, pencil. Here the line is more fluid, the pace more rapid, the effect more casual.

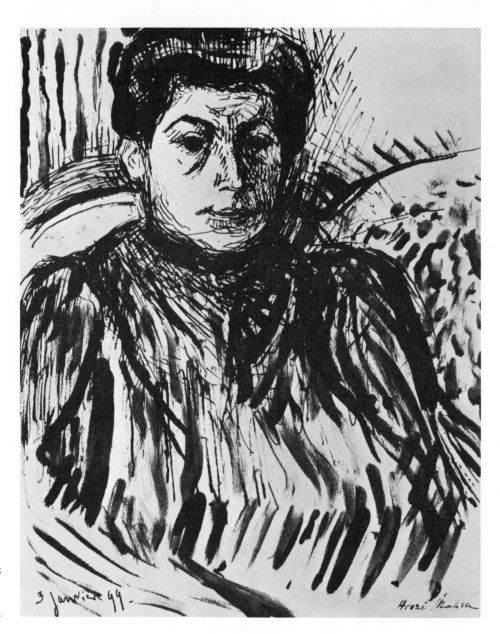

4 Henri Matisse (1869–1954; French). *Portrait of Madame Matisse.* 1899. Pen and ink wash. Collection Jean Matisse.

Another drawing thirty-two years earlier shows how Matisse's turn-of-the-century Fauvist attitudes determined his graphic means. In the portrait of Madame Matisse [4], pen and brush strokes produce a variety of textures that together make an image of great intensity. This energetic grouping of contrasting strokes demonstrates the artist's interest in violent color interactions. A different graphic language, a pencil drawing of 1915, presents angular linear thrusts and overlapping planes, reflecting the fact that Matisse is here contending with a cubist influence [5].

From this brief Matisse series, which reveals a master changing techniques and drawing tools throughout his career, we discover a fact that will be often re-emphasized: Drawing is not a single technique; it is the personal choice of an appropriate graphic language to fit the demands of a particular concept.

Pier and Ocean [6] by Piet Mondrian is a visual dance. The dancers, horizontal and vertical strokes (or shapes), interact in concert with the white space between them. This work shows that art deals with abstract ideas as well as with unique perceptions of the natural world. Mondrian evolved these motifs from his experi-

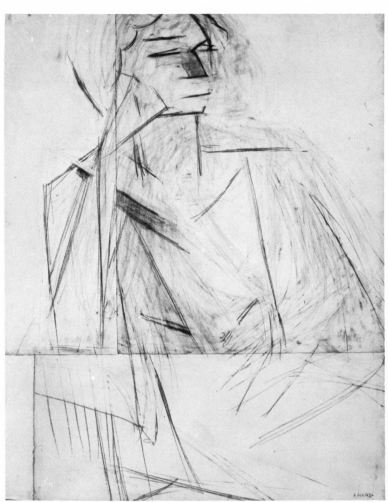

right: **5** Henri Matisse (1869–1954; French).
Portrait of Eva Mudocci. 1915. Graphite pencil,
36½ × 28″ (93 × 71 cm). Private collection.

below: **6** Piet Mondrian (1872–1944; Dutch).
Pier and Ocean. 1914. Charcoal,
20 × 24¾″ (51 × 63 cm). Collection Haags
Gemeentemuseum, The Hague.

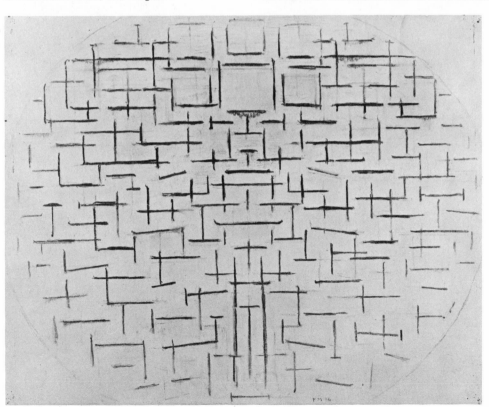

ence in drawing natural forms, as in *Trees at the Edge of a River* [7]. Here the play of the shapes of the spaces between the trees and branches and their reflection in the water has been implanted in the artist's memory as a visual motif. His predilection for a certain kind of structure is apparent, for one sees what one wants to see in nature—or, better, finds what one needs.

Jean Arp's *Automatic Drawing* [8] reflects in visual terms an interest in an immediate, unrehearsed "stream-of-consciousness" performance. Yet this "automatism" is under the control of the artist's innate feeling for order and his previously selected form-shapes. The large black organic shapes (upper right) group and act together because of their proximity and similarity, while the diagonal line (upper left) anchors the whole composition and serves as a magnet to attract all the gently moving and changing shapes. This cohesion is possible because Arp directs it, whether consciously or subconsciously.

In Willem de Kooning's *Figure and Landscape* [9] an effect of immediacy is produced by whiplash strokes speeding through the compositional space. The individual shapes of woman and landscape mirror each other within these pyrotechnics. Unlike Arp's *Automatic Drawing*, this work has no anchor to slow down its constant and all-over motion. Important here also is an opportunity to

7 Piet Mondrian (1872–1944; Dutch). *Trees at the Edge of a River*. Charcoal and estompe on buff laid paper, 28⁵⁄₁₆ × 33½" (72 × 85 cm). Baltimore Museum of Art (Nelson and Juanita Greif Gutman Fund).

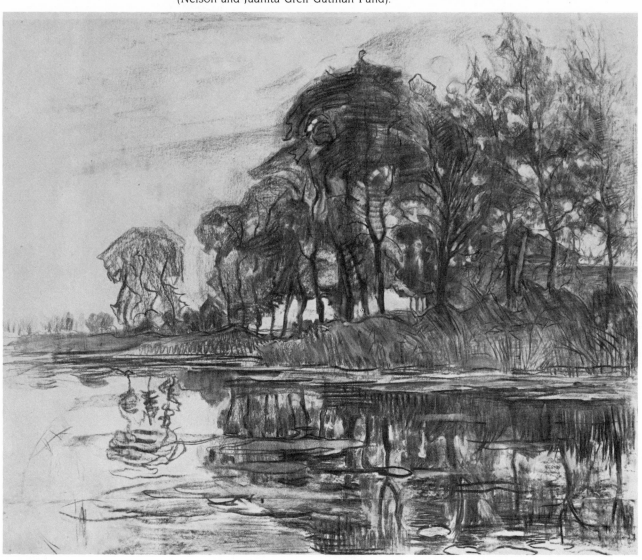

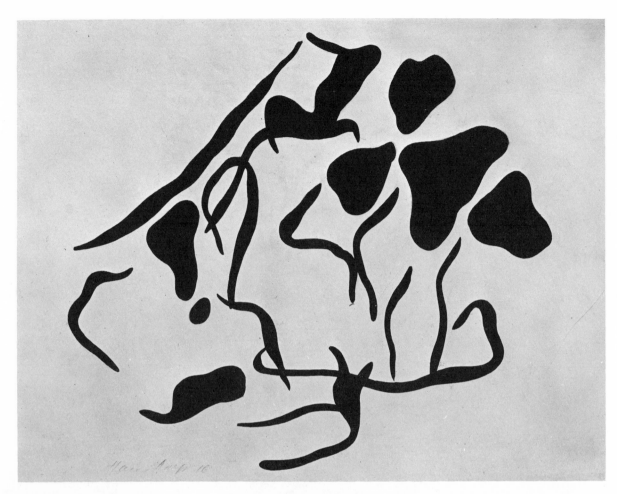

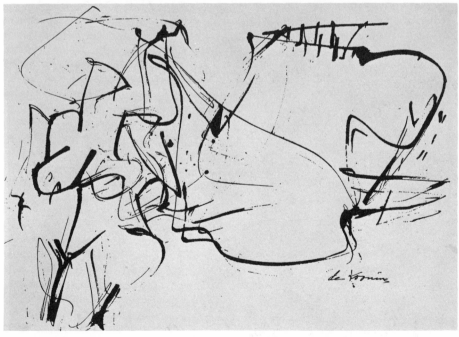

above: **8** Jean (Hans) Arp (1887–1966; French). *Automatic Drawing.* 1916. Brush and ink on gray paper, 16¾ × 21¼″ (43 × 54 cm). Museum of Modern Art, New York (given anonymously).

left: **9** Willem de Kooning (b. 1904; Dutch-American). *Figure and Landscape.* 1954. Pen and ink, 16 × 20″ (41 × 50 cm). Private collection.

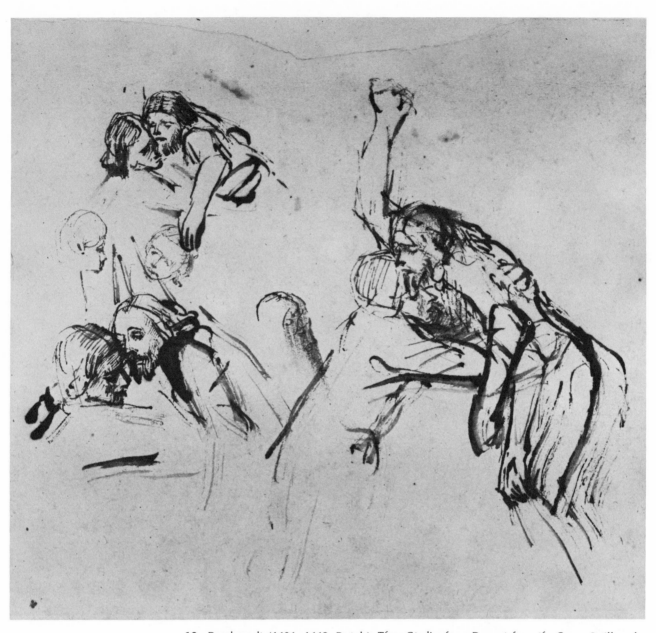

10 Rembrandt (1606–1669; Dutch). *Three Studies for a Descent from the Cross*. Quill and reed pen and brown ink, 7½ × 8⅟₁₆″ (19 × 20 cm). Collection of Mr. and Mrs. Eugene Victor Thaw (promised gift to the Pierpont Morgan Library).

observe an influence from de Kooning's countryman Rembrandt, whose drawing "handwriting" is one of the most masterful and personal in the history of art [10].

Pierre Bonnard is essentially a colorist, and in *Canaries* [11] he alludes to this interest through his choice of materials. Using partly dried ink and a comparatively rough brush Bonnard produces a texture that suggests an atmospheric haze, an almost colorist effect.

In *Juggler with Dog* [12], the weight and fluidity of the line is derived from Calder's circus series of linear sculptures produced from wire alone. Here the vast space containing a circular stage surrounded by benches that echo its shape is extended to large windowlike shapes that end the space. Inside this linear arena, animal, table, juggler, and ball are made transparent by the magical line.

The drawings individual readers will find most appealing are the ones that come closest to their own sense of what is aesthetically satisfying. To those who

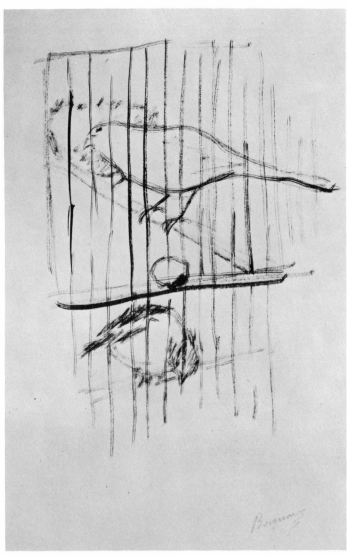

right: **11** Pierre Bonnard (1876–1947; French). *Canaries*. 1904. Brush, 12 × 7½″ (30 × 19 cm). Phillips Collection, Washington, D.C.

below: **12** Alexander Calder (1898–1976; American). *Juggler with Dog*. 1931. Ink on paper, 23¾ × 30¾″ (58 × 78 cm). Whitney Museum of American Art, New York (gift of Howard and Jean Lipman).

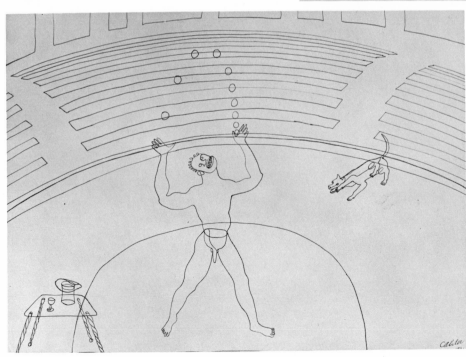

strive for the perfect adjustment of elements functioning simultaneously, Mondrian's work will be of particular interest. To the colorist, Bonnard's suggestion of atmosphere will invite study. The artist who believes in the automatic release of subconscious impulses will be attracted to Arp, while Calder will find his audience among students who see economy and witty spatial ambiguity as goals. Those who prefer speed and spontaneity will be moved by de Kooning's style.

Each of these illustrations exhibits the natural flow of a personally developed attitude. It is our hope initially to encourage the young artist first to become aware of personal preferences and then to keep them always in mind. At the same time, the student must realize that the art of drawing does not possess one set of principles that need only be learned to result in mastery. But an understanding of the expressive means of drawing (form, line, texture, composition, and so forth) as well as the mechanical tools artists use is essential to the development of a personal vision, which in turn gives birth to an individual style.

The specific knowledge required for drawing depends upon the attitudes of the individual draftsman and the goals set forth as a personal commitment. The creative artist learns what is needed to fulfill that vision and discards the rest. In short, one absorbs only what is personally meaningful. In learning to draw, one must address problems that can challenge one's image-making capacity.

At the same time, it is true that much basic education in the visual arts consists of game-problems that produce results without the conscious involvement of the participants. To speak about texture or line, for example, divorced from all other considerations within a work of art, can be misleading, for texture, line, value, and the rest are tools in the service of vision and not an end in themselves. And to discuss these qualities without reference to a particular drawing leads to the inevitable pseudoscientific diagram that delivers generalities which may or may not be pertinent. Thus, in this preliminary consideration of means, composition, and materials in drawing we will isolate and examine certain qualities in the drawings illustrated, but this will serve only to highlight for purposes of study elements that belong to a total artistic statement and have meaning only within the context of a specific work of art.

CHAPTER 2

The Expressive Means of Drawing

Line, value, texture, form, and color are the plastic means by which the artist can express graphic ideas. Although the term *plastic* denotes something formed or molded, as in the three dimensions of sculpture, the draftsman can, by a skillful *choice* of line, value, and texture, create a very real sense of plasticity within the two dimensions of a flat surface. The "flat" arts of drawing and printmaking are generally considered the *graphic* arts, rather than the plastic one of sculpture. Color also is, in the pure sense, often alien to these graphic arts, and while real color certainly is used by some artists in their drawing, some effects of color can be realized by exploiting in monochrome the variations that are possible in line, value, and texture.

Support, *ground*, *page*, and *sheet* are all terms draftsmen use in identifying the surface, or field, on which they place their marks.

At the outset, then, we can say that drawing is a graphic linear production in black and white on a paper support, but—as we have seen and shall observe in the course of this volume—the art of drawing is almost infinite in its expressive range and in the means that make this variety possible.

Line

By traditional definition, a *line* is the product of a dot moving across the surface of a support, such as paper. Once put down, the line can establish boundaries and separate areas. It can, by its direction and weight on the page, generate a sense of movement. By applying lines in patterns of parallel and cross-hatched marks, the draftsman can simulate texture on a perfectly smooth paper surface with line

alone. Indeed, using line—that simplest and most subtle of graphic means— exclusively, the artist can realize any visual effect desired.

A frequent association with the verb *to draw* is the verb *to sketch*, and within this definition the most common tool is the graphite pencil, familiar to everyone by the inaccurate term "lead" pencil. Pencils are available in various degrees of hardness and softness, and they can be made to produce both the instantly recorded and casually modeled grays in Jean-Auguste-Dominique Ingres' *Nude Study* [13] and the long, clean, unbroken lines and the tonal shading seen in his study for *Stratonice* [14]. In Figure 14 the line has great tensile strength, contouring the nude form with almost seismographic accuracy, but the line also becomes a subtle gray modeling of the form's volumes. Ingres has thus achieved a perfect marriage of two kinds of action: One is not conscious of where the line ends and where the forming tone begins.

A similar contrast is evident in two drawings by Amedeo Modigliani. In *Mario the Musician* [15] Modigliani's pencil expresses a quick, direct gesture, yet within

13 Jean-Auguste-Dominique Ingres (1780–1867; French). *Nude Study.* c. 1839. Graphite pencil. British Museum, London (reproduced by courtesy of the Trustees).

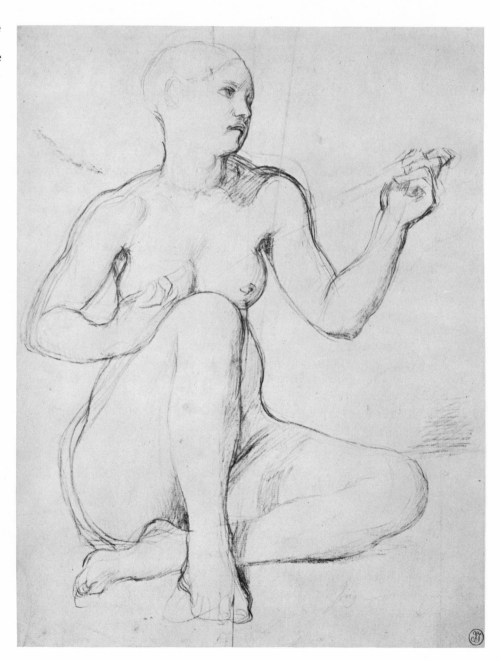

The Expressive Means of Drawing

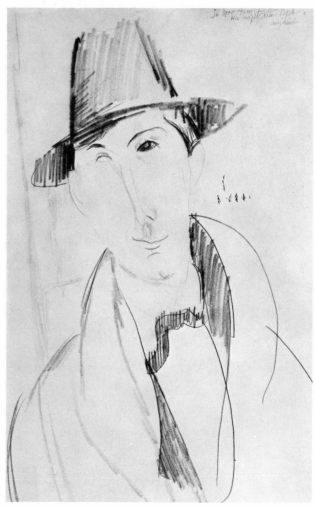

below: **15** Amedeo Modigliani (1884–1920; Italian). *Mario the Musician*. 1920. Graphite pencil, 19¼ × 12″ (49 × 28 cm). Museum of Modern Art, New York (gift of Abby Aldrich Rockefeller).

above: **14** Jean-Auguste-Dominique Ingres (1780–1867; French). Study for *Stratonice*. 1834–1840. Pencil, 15½ × 8⅝″ (39 × 22 cm). Museum Boymans-van Beuningen, Rotterdam.

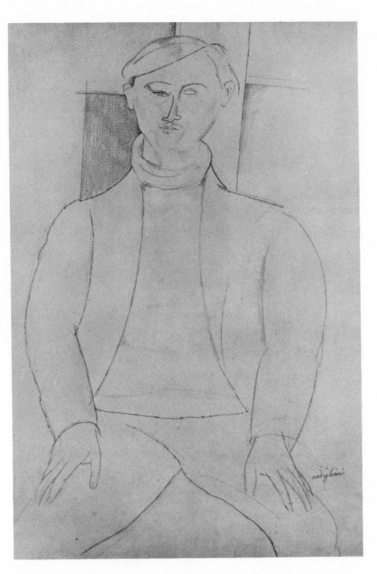

16 Amedeo Modigliani (1884–1920; Italian). *Portrait of Jacques Lipchitz.* 1916. Graphite pencil, 12¾ × 9″ (32 × 23 cm). Collection Lolya R. Lipchitz.

this sketchiness the artist molds the planes of the hat around the head and those of the coat around the neck. The same instrument defines the contours of the forms in a more severe, self-conscious line in *Portrait of Jacques Lipchitz* [16].

The drawings illustrated here were executed primarily in line and with the most ordinary but most elastic of tools—the graphite pencil—and in each example the means mirror the artist's intention. Technique or style is simply a natural by-product.

Value

The academies of the past taught that each drawing should possess a full range of values, from very light to very dark. In reality, it is the artist's vision that dictates the choice of a particular range of light, not a set of rules. For example, the original of Figure 17 reveals a very pale pink-toned paper and pale flesh tones executed in watercolor on the head and hair; the very paleness of the drawing creates a unique mood—a particular light.

Lucas Cranach's *Portrait of Princess Elizabeth of Saxony* [18; see also the cover] is a wash drawing on rose-colored paper; here, too, there is an absence of a full range of values. The features are spotlighted: The darkest forms, the eyes, pene-

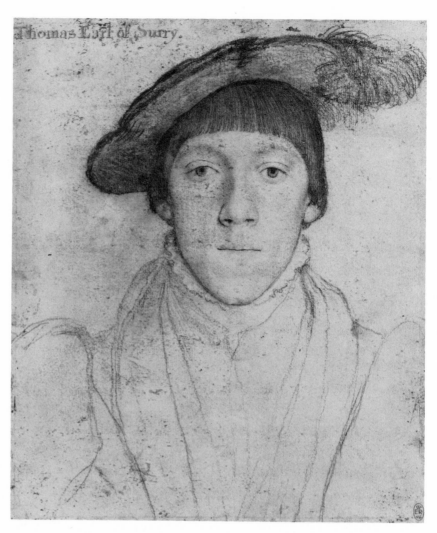

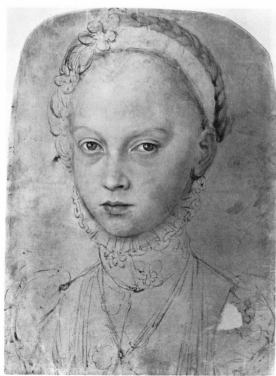

above: **17** Hans Holbein the Younger (1497/8–1543; German). *Henry Howard, Earl of Surrey.* (The inscription at upper left has been proved incorrect by recent scholarship.) Black and colored chalks on pale pink priming, with India ink and brown watercolor wash, 10 × 8¼″ (25 × 21 cm). Royal Library, Windsor Castle, England (reproduced by gracious permission of Her Majesty Queen Elizabeth II).

left: **18** Lucas Cranach the Younger (1515–1586; German). *Portrait of Princess Elizabeth of Saxony.* c. 1564. Wash on rose-colored paper, 15½ × 11¼″ (39 × 29 cm). Kupferstichkabinett, Staatliche Museen, Berlin.

19 Jean-Auguste-Dominique Ingres (1780–1867; French). *Portrait of Madame Hayard*. c. 1812. Graphite pencil on white wove paper, 9 × 7″ (23 × 18 cm). Fogg Art Museum, Harvard University, Cambridge, Mass. (bequest: Meta and Paul J. Sachs).

trate the soft pallor of the page, and the mouth, the next-darkest form, is seen after the eyes in a succession of focuses. This direction of focus makes the work unique.

In the pencil drawing *Portrait of Madame Hayard* [19] the lines below the head are simply outlines. They do not bend or grasp the surface depicted. The head, however, is molded softly, the mouth gently stretched. Had Ingres used the same modeling in the dress and hands, the effect would have been overdone, and the viewer would have been prevented from participating in the particular experience directed by the artist.

The Expressive Means of Drawing

Texture

The term *texture* quite properly suggests the characteristics of rough or smooth. It is the tactile quality, the sense of touch, that we perceive in art. A textural effect can, as we have seen, be fabricated from the artist's use of lines and tonal values; or it can be the real physical nature of the surface the artist works on or of the drawing medium, such as grainy chalk.

Texture, like value, is more than just an added attraction in a work of art. Texture is automatically created when we draw a dark line across a page. The violent opposition of black and white creates a vibration similar to that caused by complementary colors. Texture, like any natural by-product of a process, must be absorbed into a larger context so that it enhances an idea.

For example, in Vincent van Gogh's *La Crau as Seen from Montmajour* [20] the vibrations of different kinds of lines and dots are harmoniously orchestrated to sweep us through a panoramic space.

In another Van Gogh drawing, *The Zouave* [21], we see an interaction of different kinds of marks (or groups of textures) that create different wavelengths. Each group of distinct marks acts upon its neighbors in an aggressive confrontation. The face composed of tiny dots plays against the cross-hatching of the hat, and both interact with the vertical strokes of the background. These separate textures are, in a sense, stand-ins for the color relationships in the painting to which this

20 Vincent van Gogh (1853–1890; Dutch). *La Crau as Seen from Montmajour.* 1888. Black chalk, pen, reed pen, and brown and black ink, 19¼ × 24″ (49 × 61 cm). National Museum Vincent van Gogh, Amsterdam.

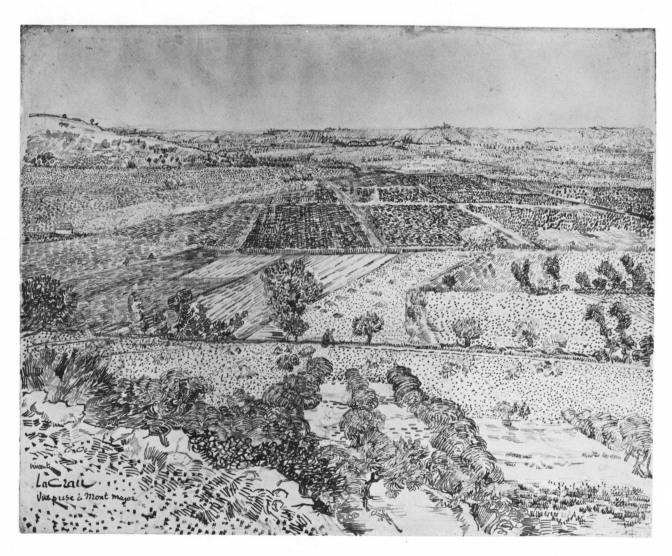

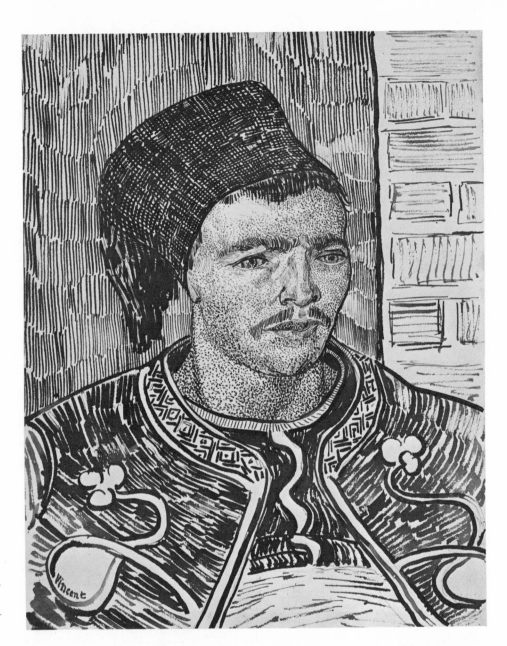

21 Vincent van Gogh (1853–1890; Dutch). *The Zouave.* 1888. Reed pen and ink, 12⅝ × 9½″ (32 × 24 cm). Solomon R. Guggenheim Museum, New York (Justin K. Thannhauser Collection).

study was ultimately applied. But the drawing exists as a work of art in its own right. The interaction of textures serves as a light-giving exercise, an ensemble of opposing marks that creates a unified vibration.

Similarly, in Rembrandt's *Christ Carrying the Cross* [22] different kinds of marks create different textures. Here, however, two distinct instruments have been used: pen and brush. The dry brush, which has been dragged across the rough paper, attaches itself to the fluid wash figure on the left to create an L-shaped frontal plane. The plane thus formed frames the center of interest, the head of Christ. (The value of the pen strokes in the head keeps it in place behind the frontal plane even though it is the center of interest.) Finally, the rest of the drawing is accomplished with lightly sketched lines, with but one spot of wet wash to counter the dark figure pulling to the left. Texture, then, not only creates a special light with the play of different kinds of surface marks—wet, dry, sketchy, and loose strokes—but it also indicates planes in space.

A sensitive visual dialogue of textural energies emerges from a range of very light to very dark pen strokes combined with a light, delicate wash in Claude Lorrain's *Saint John in the Wilderness* [23].

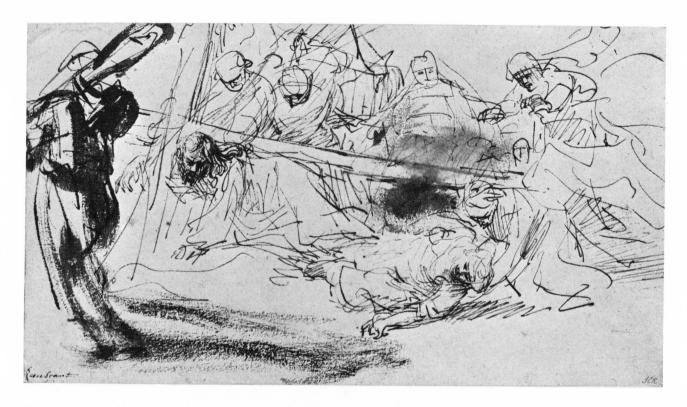

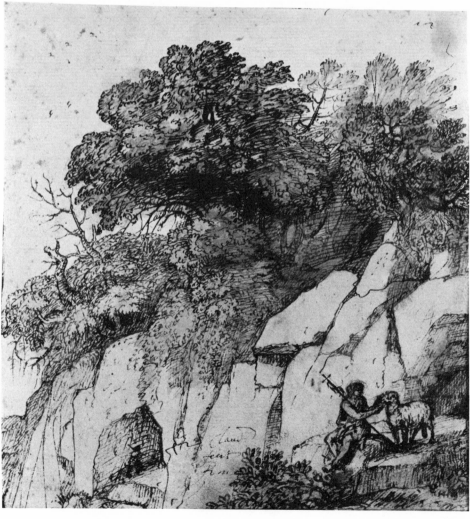

above: **22** Rembrandt
(1606–1669; Dutch). *Christ
Carrying the Cross*. c. 1635.
Pen and ink with wash,
5⅝ × 10⅛″ (14 × 26 cm).
Kupferstichkabinett, Staatliche
Museen, Berlin.

left: **23** Claude Lorrain
(1600–1682; French). *Saint
John in the Wilderness*. Pen and
brown wash, 8¾ × 8″
(22 × 20 cm). Private
collection.

Form

Form is the shape of the images defined in an artist's work, whether "real" or abstract or two- or three-dimensional. The term can thus apply not only to the shape of recognizable things but also to the form of particular areas or of the whole, the sense of volume created—even the shape of the surface on which the draftsman works. In addition, we often speak of the "formal" qualities in art, and this usually encompasses the full range of visual elements—line, tone, texture, color, and so forth—that may characterize an artist's overall style or performance in a given work. Through this comprehensive range of meanings "form" denotes the visual substance of a work of art.

Space

Space is an even more complex factor in the graphic, two-dimensional arts than is form. There is the space on the surface of the draftman's paper, which, in visual terms, is often referred to as the *picture plane*. There is also the deep space, or environmental space, that the artist knows to exist in the natural world, a space that contains forms and permits them to move about in it.

Through an experience of space and of the placement of forms in it, an artist works the surface of a drawing so as to give graphic expression to a personal vision of forms organized in spatial relationships. Forms are thus arranged in

24 Jacques Villon (1875–1963; French). *Self-Portrait*. 1934. Graphite pencil with pen and ink, 9¹¹⁄₁₆ × 8⅞" (25 × 23 cm). Courtesy Galerie Louis Carré, Paris.

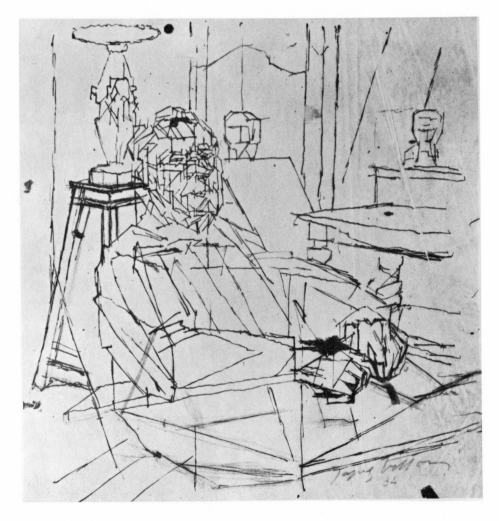

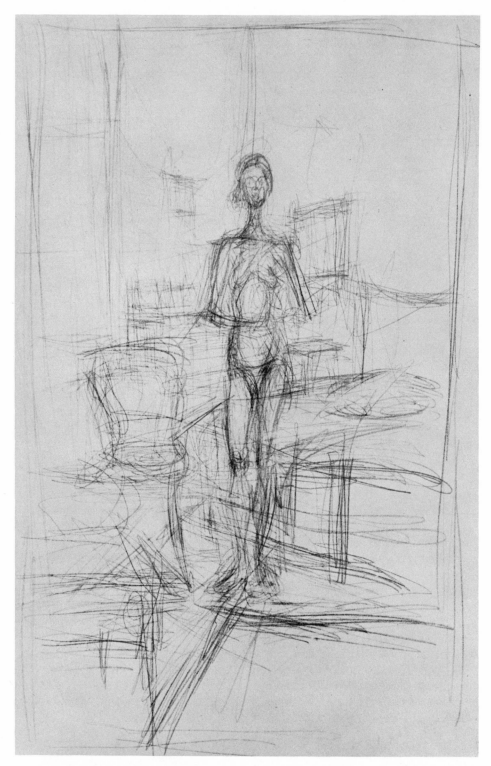

25 Alberto Giacometti
(1901–1966; Swiss). *Nude in a
Room*. 1951. Graphite pencil,
19¾ × 12⅝" (50 × 32 cm).
Private collection, Paris.

relation to each other, to the space "in front"; that is, between the forms and the viewer. Of particular importance is the way in which forms are constructed in relation to the drawing itself, the scale and shape of which define a powerful spatial field. Study, for example, the difference between the way Villon [24] blocks out the weights of parts of the figure and furniture as each section recedes into the picture space and the way Giacometti seems to rush his pencil through the space in his search to locate the figure in his invented space [25].

The relationship between form and space, the essence of composition, will be dealt with in greater detail in Chapter 3 as well as throughout the book.

CHAPTER 3

Composition

Drawing shares with painting an interest in common visual phenomena that we normally encounter in design courses. Perhaps the Italian word *disegno*, which refers to both design and drawing, comes closer to our meaning. The two acts—''to draw'' and ''to design''—are indeed interrelated. We may call composition the act of giving a unique sense of order, a life, to the forms we choose to work with. This act of composing—or locating forms in concert on a two-dimensional plane—does not mean merely enriching the chosen forms by enveloping them in a nicely designed arrangement. It is rather the transformation of a theme into a spatial structure that finally merges with the content. A good example of a compositional search is Van Dyck's pen-and-wash study for *Diana and Endymion* [26], in which the artist sets up a flow of events in a special sequence on the page.

Artists should explore the perceptual phenomena that are the engineering devices of the visual arts as carefully as they do the various instruments and materials of their art. Both types of experimentation give the young artist tools in developing a personal form vocabulary.

Figure-Ground

In Albrecht Dürer's *Adam and Eve* [27] the white figures clearly exist in front of the dark background, which acts simply as a curtain. The relationship of figure to ground is clear. However, in a series of compositions by Ralph Coburn [28, page 24] the distinction between what is figure (foreground) and what is ground (background) changes continually. In *Variable* I(*a*) the black triangles at the top read as black shapes in front of a white ground; but if we scan the whole composition we notice that the white triangles along the bottom begin to appear as frontal shapes

22

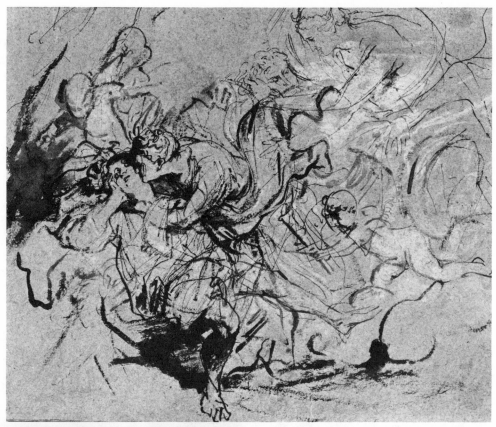

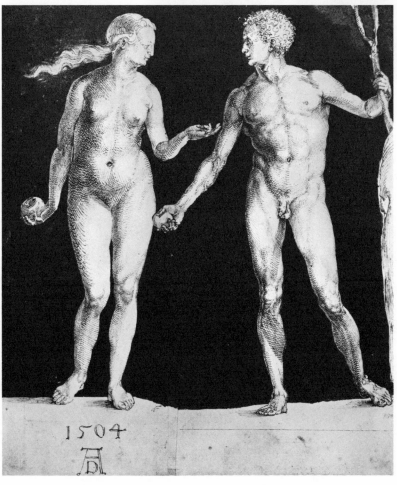

above: **26** Anthony van Dyck (1599–1641; Flemish). *Diana and Endymion.* Pen and point of brush, with brown ink and brown wash heightened with white tempera on gray-blue paper. 7½ × 9″ (19 × 23 cm). Pierpont Morgan Library, New York.

left: **27** Albrecht Dürer (1471–1528; German). *Adam and Eve.* 1504. Pen and ink with wash on white paper, 9⅝ × 7¹⁵⁄₁₆″ (24 × 20 cm). Pierpont Morgan Library, New York.

Figure-Ground 23

against a dark ground. Sections in between can be read either way, depending on how we focus. In *Variable* I(*b*) the play between what is figure and what is ground is more ambiguous. Both examples have a relatively simple order, *Variable* I(*a*) reading as distinct horizontal rows of triangles and *Variable* I(*b*) reading as diagonal stripes. The shift between figure and ground becomes more intense in *Variables* I(*c*) and I(*d*) because the simple rhythmic order is destroyed. In the latter two examples the eye moves more rapidly from top to bottom over the broken pattern.

28 Ralph Coburn (b. 1923; American). *Variable* I (four versions). 1968. Plexiglas, each 16″ (41 cm) square. Courtesy Alpha Gallery, Boston.

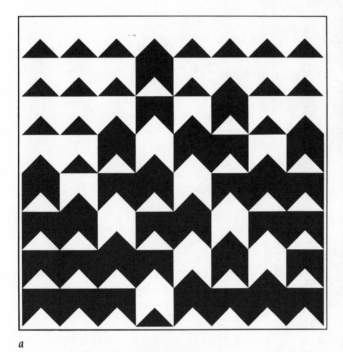

a

b

c

d

These four "variables" were not created with drawing materials, but they fit the concept of drawing as form-making in black and white. Each work is composed of sixty-four 2-inch squares of magnetized laminated plastic. The four compositions illustrated here were all made from one design, which can produce more than a million variations. What is important is the visual speed and action of the figure-ground relationships—the possibility of more than one reading from a single composition.

In Josef Albers' pen-and-ink *Structural Constellation* [29] the distinction between figure and ground, or foreground and background, fluctuates constantly. Ruled, hard-edge lines make the alternate "readings" possible as the direction of

29 Josef Albers (1888–1976; German). *Structural Constellation*. 1954. Pen and ink, 14½ × 11″ (37 × 28 cm). Courtesy the artist.

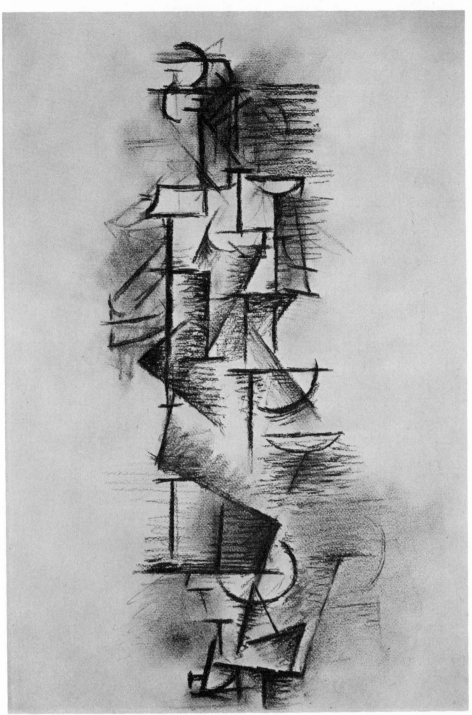

30 Pablo Picasso (1881–1973; Spanish). *Female Nude*. 1910. Charcoal, 19¹/₁₆ × 12⁵/₁₆″ (48 × 31 cm). Metropolitan Museum of Art, New York (Alfred Stieglitz Collection, 1949).

the planes, and thus our point of view, shifts back and forth. Pablo Picasso's *Female Nude* [30] also produces different readings, but not in purely graphic terms. The nude is buried in the overall structure of the composition and we search, focusing and refocusing, to define the contours of the figure.

The idea of dual reading can be traced back easily to medieval illuminated manuscripts, border designs from earlier cultures, and some Renaissance compositions. It is clear that finding two or more visual solutions to one structure is an integral part of our way of perceiving pictorial space.

Interspace

The empty spaces between distinct forms are often referred to as negative space, or interspace, as opposed to the positive form-shape. Cézanne, in his graphite pencil drawing *Tree and House* [31], tries to shape and define the empty air space between the trees. He considers this interspace full and volumetric. The shapes of these spaces around the forms are enclosed and released alternately by the sharp and soft edges of the trees, so that space becomes an invisible but seemingly flowing mass.

Van Gogh wrote in his letters about the resemblance between the movement of a field of grass and that of the ocean. In his *Landscape: The Harvest* [32] the pen strokes change direction constantly—contracting and moving apart—as one follows them up the page. They become, in effect, a kind of visual inhaling and exhaling. It is clear that in this landscape the white ground (interspace) between strokes is an active participant in the vibration.

31 Paul Cézanne (1839–1906; French). *Tree and House*. c. 1890. Graphite pencil, 18⅜ × 12″ (47 × 30 cm). Whereabouts unknown.

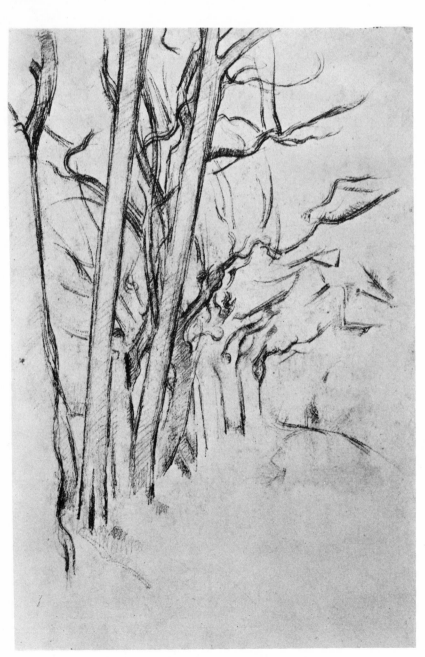

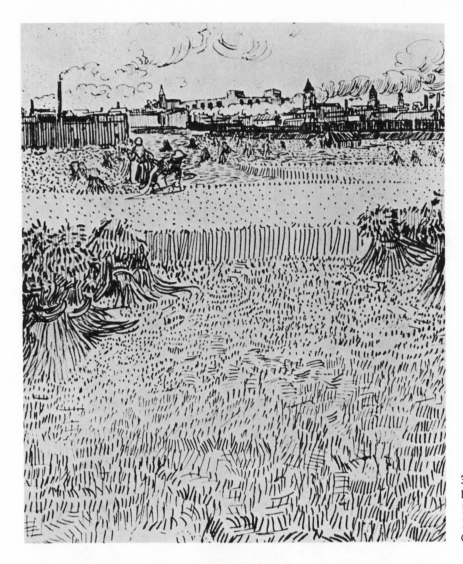

32 Vincent Van Gogh (1853–1890; Dutch). *Landscape: The Harvest.* 1888. Reed pen and ink, 12¼ × 9½" (31 × 24 cm). Collection J. Hessel, Paris.

Rhythm

A sense of measured movement through time is a basic part of composition, especially in larger works. In a magnificently staged study for a *Crucifixion* [33], Nicolas Poussin produces a steady, even beat across the picture space. Each section and each actor within the larger movement is suspended, moving slowly at a regular pace through the whole space in perfect balance harmony—the mechanism of a miraculous work.

Placement

We all seem to learn of the compositional tradition that warns against placing the main event in the center. But notice how Rembrandt moves us into the center of his invented space in Figure 34. He places us immediately behind the main figure with only a corner of a table, with its massive leg, to keep us at our distance. This table restrains the viewer; at the same time it connects the figure to the imagined floor plane by repeating the diagonal of the figure. These weights are balanced with a few quick, weightless lines to describe a head on the left and an interior room divider on the right. Notice, too, the implied connection between the two heads, which seem to be communicating.

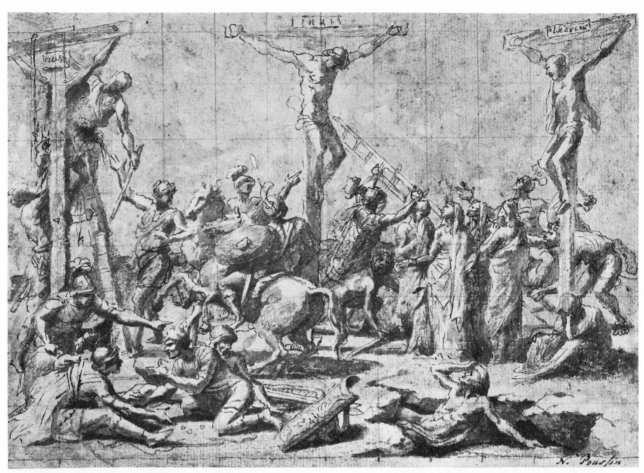

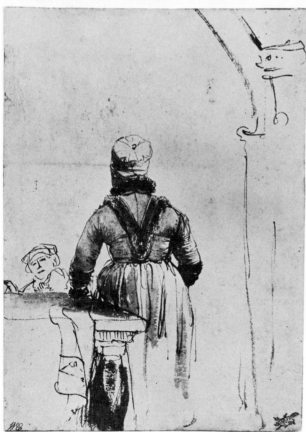

above: **33:** Nicolas Poussin (1594–1665; French). *Crucifixion.* Pen and ink over chalk, 7 × 9⅘″ (18 × 25 cm). Museum der bildenden Künste, Leipzig.

left: **34** Rembrandt (1606–1669; Dutch). A *Woman in North Holland Dress.* c. 1642. Pen and brown wash, 8¾ × 6″ (22 × 15 cm). Teylers Museum, Haarlem.

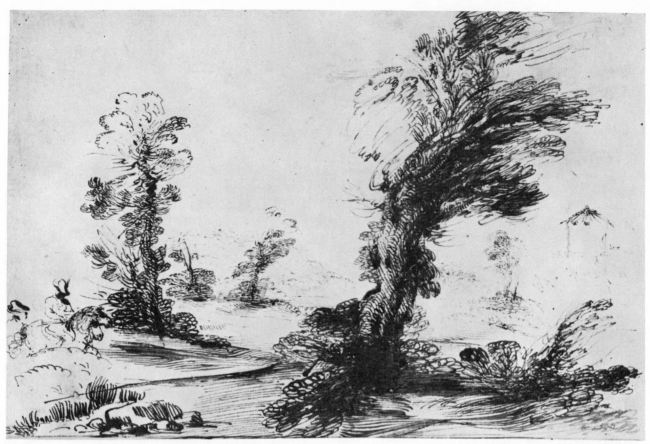

above: **35** Guercino (1591–1666; Italian). *Landscape*. Pen and ink, 7 × 10¼″ (18 × 26 cm). Teylers Museum, Haarlem.

right: **36** Wassily Kandinsky (1866–1944; Russian). *Untitled Drawing*. 1932. Pen and ink, 13¾ × 9″ (35 × 23 cm). Collection Mrs. Josef Albers, New Haven, Conn.

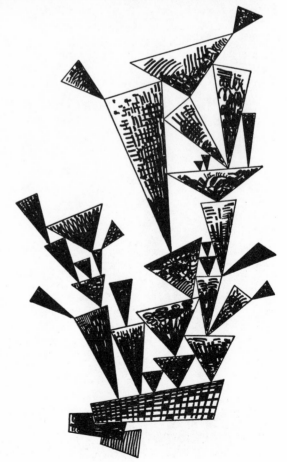

Speed

In Figure 35, Guercino's rapid, circular strokes produce tree forms that seem to spin wildly in space. At the same time, the trees are placed like props equidistant from each other—a balancing action that almost cancels the intensely dynamic effect of the strokes.

Pressure

The force or lack of force that one form exerts on another depends on the pressure at their meeting point and the angle of their meeting. In Wassily Kandinsky's *Untitled Drawing* [36] the three bottom forms overlap one another to create a trio of pressure points at their intersection. These pressure points act in unison to form weights that seem to hold up the "tree" of triangles. Because the triangles barely touch each other edge to edge, they form an almost weightless void compared to the weight at the base. Both kinds of pressure join in the total effect.

Two examples of another artist's work also demonstrates degrees of pressure. In Giovanni Battista Piranesi's *Prison Interior* [37] we sense the architectural

37 Giovanni Battista Piranesi (1720–1778; Italian). *Prison Interior*. Pen and brown ink with India ink wash over black chalk, 7³⁄₁₆ × 9¹¹⁄₁₆″ (18 × 24 cm). Pierpont Morgan Library, New York.

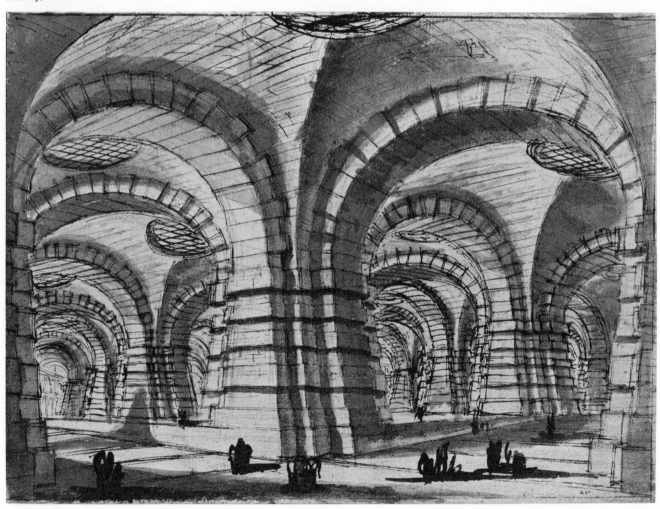

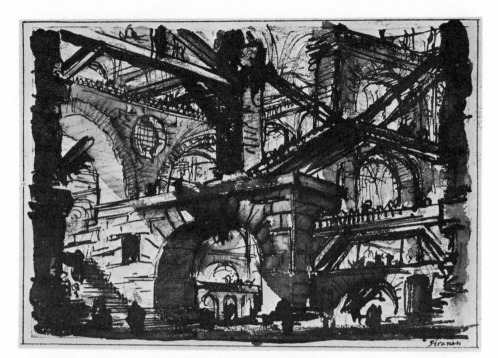

right: **38** Giovanni Battista Piranesi (1720–1778; Italian). *Sketch of a Construction.* Pen and wash over chalk. Kunsthalle, Hamburg.

bottom: **39** John Marin (1870–1953; American). *Lower Manhattan.* 1920. Watercolor, 21⅞ × 26¾″ (56 × 68 cm). Museum of Modern Art, New York (Philip L. Goodwin Collection).

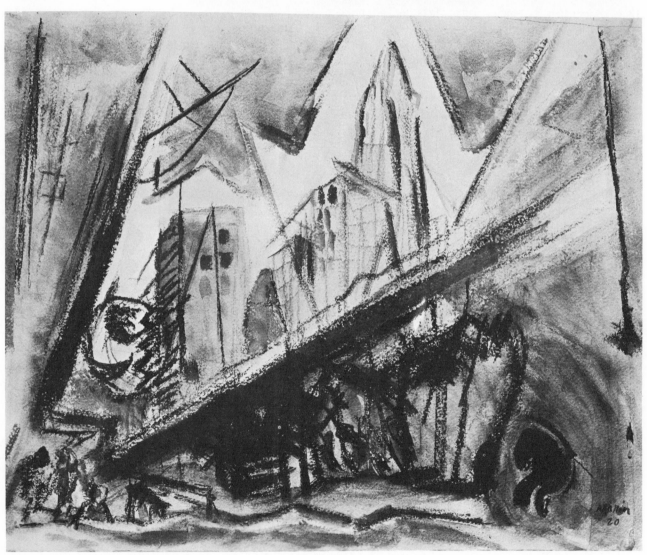

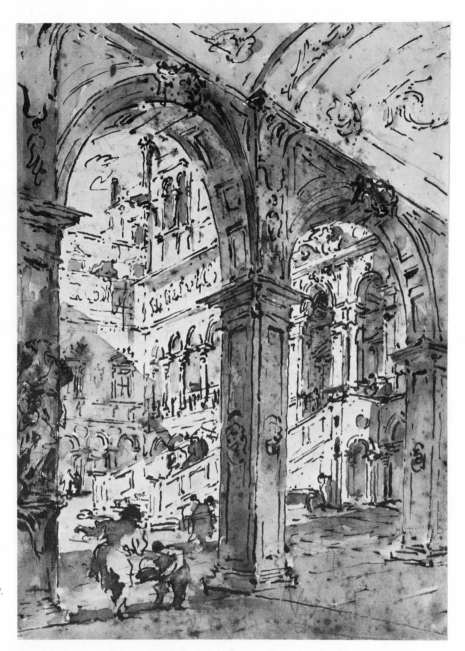

40 Francesco Guardi (1712–1793; Italian). *Courtyard of the Ducal Palace.* 11¾ × 7⅜″ (30 × 19 cm). Metropolitan Museum of Art, New York (Rogers Fund. 1937).

members overlapping but not exerting much pressure on each other. However, in the sketch of a construction in Figure 38 we can feel the weight of the masses of these bisecting angles.

Bisecting forms appear also in John Marin's watercolor *Lower Manhattan* [39], but they do not meet within the compositional space. The point of their forceful impact, which we follow by extension, is a loud visual shock off the left corner of the page. This suggested crash, interrupted as it is, is completed by the viewer, but at the artist's direction. Marin experimented with such pressure-filled experiences many times in his career.

Perspective

Instead of keeping us at a safe distance and guiding us gently to the background, Francesco Guardi plunges us into the midst of his architectural invention, *Courtyard of the Ducal Palace* [40]. He lets us look up through the arches and beyond. Yet

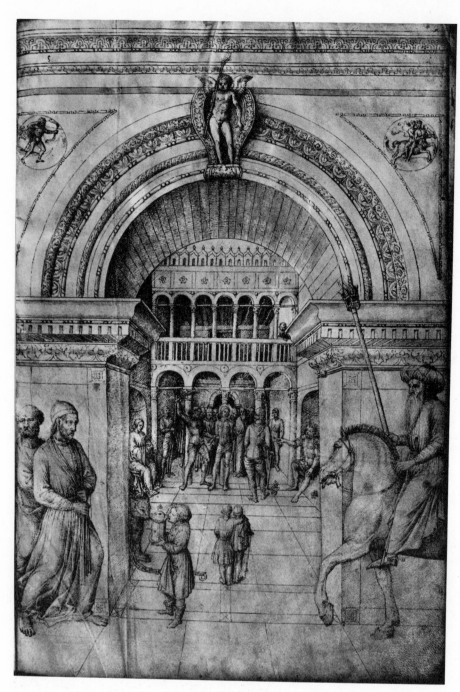

41 Giovanni Bellini (c. 1430–1516; Italian). *The Flagellation*. Pen and ink. Louvre, Paris.

we seem to be moving through a space that is compressed because of the agitated handwriting. This physical sensation has been engineered by Guardi's personal use of perspective.

By contrast, in Giovanni Bellini's *The Flagellation* [41] the system seems to overwhelm the drama of the subject. A stiff, self-consciously constructed perspective creates a firmly measured architectonic space into which variously scaled figures and a prancing horse have been inserted. The occasional inconsistencies in Bellini's scaling of the figures can be compared to the perspectival distortion and spatial displacement intentionally and very knowingly employed to create a psychological mood in Giorgio de Chirico's *The Prodigal Son*. [42].

Overlapping planes recede to a shallow background in Andrea Mantegna's *Battle of the Sea Gods* [43]. The cramped space is equivalent to a sculptured relief, and the violent action of the figures and horses makes them seem to erupt from

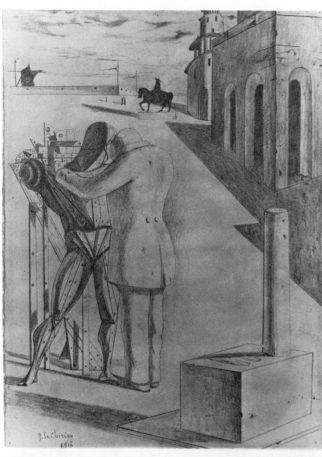

left: **42** Giorgio de Chirico (1888–1978; Italian). *The Prodigal Son.* 1917. Graphite Pencil, 12⅜ × 8⅞" (32 × 23 cm). Collection Judith Rothschild.

bottom: **43** Andrea Mantegna (1431–1506; Italian). *Battle of the Sea Gods.* c. 1490. Engraving, 11⅝ × 17¹⁄₁₆" (30 × 43 cm). Museum of Fine Arts, Boston (gift of Francis Bullard in memory of Stephen Bullard).

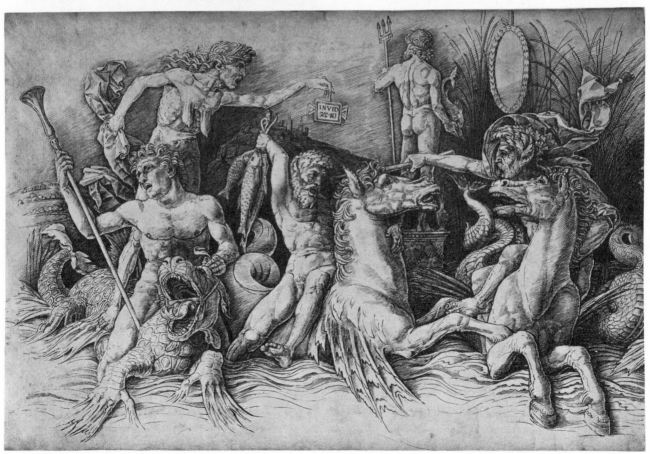

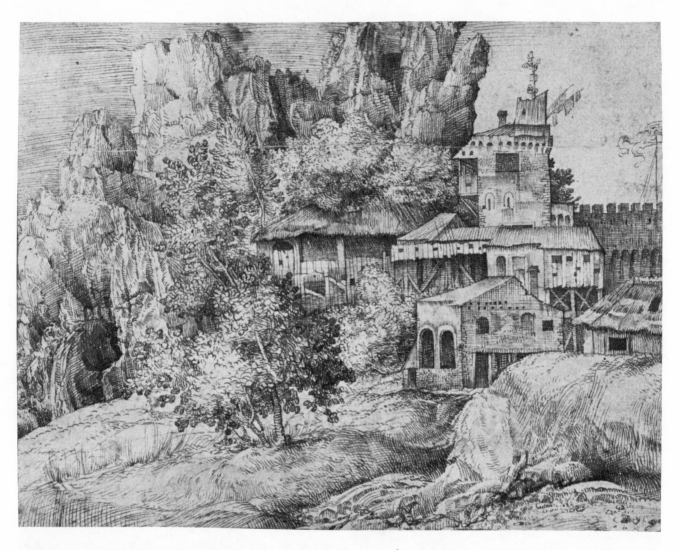

44 Domenico Campagnola
(1484–1550/80; Italian).
Buildings in a Rocky Landscape.
Pen and brown ink, 6 × 7¹¹⁄₁₆″
(15 × 20 cm). Pierpont
Morgan Library, New York.

their crowded stage. Even more shallow is the space in *Buildings in a Rocky Land-scape* [44], where all the forms are so flattened that the buildings seem to be growing out of the mountains.

The placement of figures in an architectural environment necessarily affects their volume as they relate to the setting. A moment's study of Jan van Eyck's *Maelbeke Madonna* [45] reveals that the sense of volume in the figures comes almost entirely from the detailed spatial rendering of the architecture. Taken by themselves, the figures seem flat and two-dimensional, rather like paper cutouts set in front of a deep space.

Two twentieth-century drawings will demonstrate that pictorial space always remains subject to individual invention, for the way in which space is organized is itself expressive. Jacques Villon in his *Self-Portrait* [24, page 20] diagrams and dissects the whole space of the drawing. Lines that establish planes locate the figure and relate it to its surroundings. A strong oblique line just below the hands sets up a system of planes that tilt back into space, while the furniture behind the head counters this movement.

Like Mantegna, Fernand Léger in a study for *The Smoker* [46] establishes a narrow spatial field. There is very little space from the circles that represent smoke to the head behind the circles, to the strong vertical stripe behind the shoulder to our left, to the horizontal stripes, to the final white wall plane. In this structure, with its tension between circles, horizontals, and verticals, space moves back in planes parallel to the picture plane. We can compare this to the oblique cutting into space in Villon's drawing.

36 *Composition*

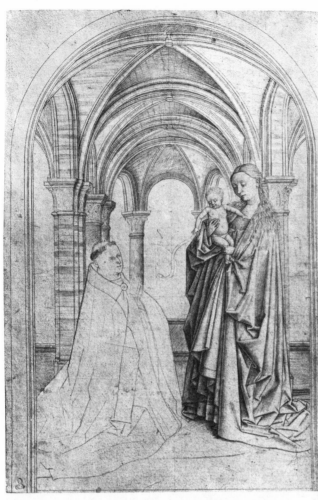

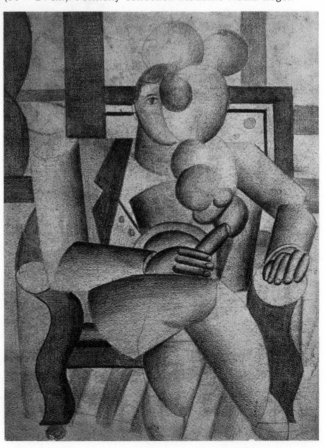

below: **46** Fernand Léger (1881–1955; French). Study for *The Smoker*. 1921. Graphite pencil, 12⅛ × 9⅜″ (31 × 24 cm). Formerly collection Madame Nadia Léger.

above: **45** Jan van Eyck (1390–1441; Flemish). *Maelbeke Madonna*. Silverpoint, 11½ × 7″ (30 × 18 cm). Albertina, Vienna.

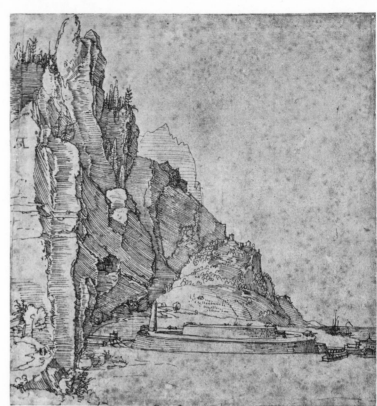

right: **47** Albrecht Dürer (1471–1528; German). *Landscape with a Fort Near the Sea.* 1526. Pen and ink. Biblioteca Ambrosiana, Milan.

bottom: **48** Vincent van Gogh (1853–1890; Dutch). *Cypresses.* 1889. Bamboo, reed, and steel pens over pencil: 18½ × 24⅖″ (47 × 62 cm). Kunsthalle, Bremen.

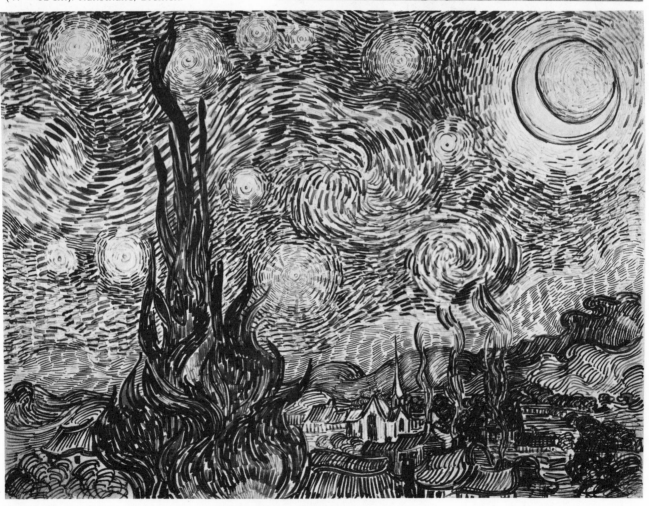

Scale

The scale of any object or structure is usually defined in terms of some other object or structure. In *Landscape with a Fort Near the Sea* [47] Dürer gives the rock formations the scale of a mountain by juxtaposing them against smaller forms representing boats, houses, and trees. However, even without these details, the mass of rock dominates the page and thereby assumes scale. We will explore this problem of scale in Chapter 6, when we attempt through drawing to transform rocks into mountains.

"Real" Space and Picture Space

The space at the bottom of Van Gogh's *Cypresses* [48] is clear and logical: Trees overlap the view of the town, buildings exist in normal relationships to one another, and mountains recede into the distance. But as we look upward to his principal forms, the stars, the enormous scale of these celestial giants overpowers the scene below. The negation of "real" space is a by-product of Van Gogh's dramatic psychological vision.

In Poussin's pen-and-wash *The Death of Meleager* [49] vibrations of light move through the tree forms and penetrate the clouds to form continuous vertical movement. This pattern, which produces a true visual drama, nevertheless de-

49 Nicolas Poussin (1594–1665; French). *The Death of Meleager*. Pen and ink with wash, 9⅞ × 7¼" (31 × 24 cm). Louvre, Paris.

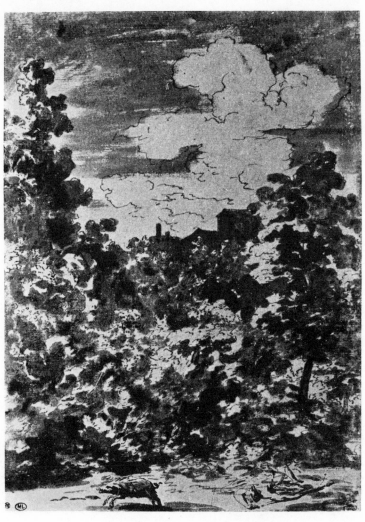

creases the "normal" planar relationships of foreground, middle ground, and background. The visual reality in this drawing is a two-dimensional wall of light. Needless to say, our implication here is that faithful imitation of nature, however much it may require genuine skill, is not a criterion for measuring artistic ability.

Distortions

When one views El Greco's mural-size painting *The Burial of Count Orgaz* [50] installed in the place for which it was designed, the effect is quite different from seeing it in reproductions. The painting was conceived to be observed from a particular viewing height, with the viewer's eye level well down in the bottom third of the picture. As one looks up into the arched top section of the painting, the Christ figure, the angels, and the flowing drapery all form a vivid spatial thrust. But in a reproduction these forms seem distorted and awkward in relation to the rest of the painting.

The same can be said of El Greco's *The Holy Family* [51]. Standing directly in front of the painting, one is forced to use peripheral vision to contain the forms that bulge and stretch out at either side. The viewer thus becomes physically involved with the painting. Again, the reproduction—with its distorted cheeks and heads, its pulling arms and draperies—can only hint at the intended effect.

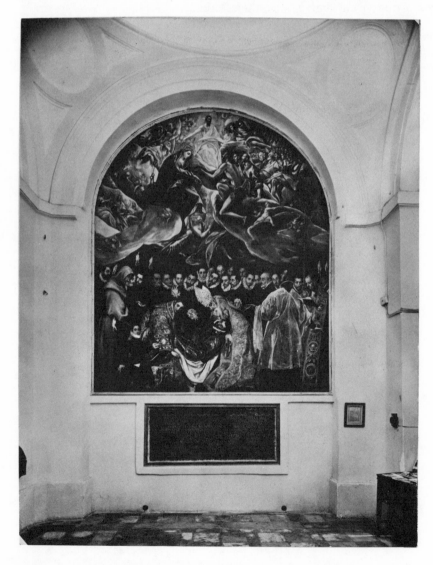

50 El Greco (1541–1614; Spanish [Cretan born]). *The Burial of Count Orgaz.* 1586. Oil on canvas, 16′ × 11′10″ (4.9 × 3.6 m). San Tomé, Toledo.

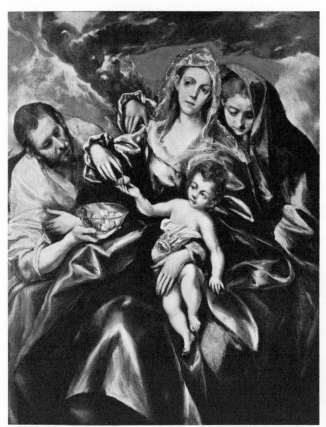

above: **51** El Greco (1541–1614; Spanish [Cretan born]). *The Holy Family*. 1592. Oil on canvas, 4'3⅞" × 3'3½" (1.5 × 1 m). Cleveland Museum of Art (gift of the Friends of the Cleveland Museum of Art in memory of J. H. Wade).

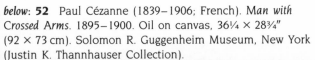

below: **52** Paul Cézanne (1839–1906; French). *Man with Crossed Arms*. 1895–1900. Oil on canvas, 36¼ × 28¾" (92 × 73 cm). Solomon R. Guggenheim Museum, New York (Justin K. Thannhauser Collection).

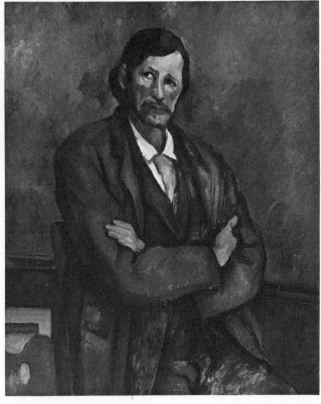

The distortions in Cézanne's *Man with Crossed Arms* [52] are oddly similar to El Greco's, and in some ways they serve the same purpose. As in the two El Greco paintings, the proportions of the figure change depending on the viewer's position in relation to the canvas. However, in addition to this, Cézanne's work gives the effect of many different viewpoints from the *same* eye level. The pulling out of the clockmaker's right shoulder, the sloping away of the far side of the figure, and the stretching, contradictory planes of the head all combine to create the impression that the figure is seen from several angles simultaneously, even when the viewer is standing directly in front of the painting.

Throughout this discussion we have extracted and analyzed specific qualities in the drawings and paintings that are illustrated in order to understand better the form-life that makes each a work of art. In the following chapter we will see how familiarity with the various tools and media of drawing aids visual thinking.

CHAPTER 4

Media and Materials

Drawing is a unique art that employs special tools and materials. The artist imagines future work in terms of these familiar materials, but interest in them is not carried to the point of preoccupation with "technique" as an end, separated from subject matter. If a tool or a type of paper excites the artist, it is absorbed into the whole concept of the drawing.

In our examination of line in Chapter 2 we saw the relevance of the medium one chooses to this expressive purpose. A feeling for media, an awareness of their physical, sensuous qualities and their expressive potential, is native to most artists, who savor the silver gray of pencil, the velvety blackness of charcoal, the intensity and brilliance of pastels, and the transparent fluidity of ink wash. In this chapter our primary concern will be for the marking instruments—the media—of drawing, but we will also discuss the grounds and surfaces the artist may choose to work upon.

53 Pablo Picasso (1881–1973; Spanish). *Ambroise Vollard*. 1915. Graphite pencil, 18⅜ × 12⁹⁄₁₆″ (47 × 32 cm). Metropolitan Museum of Art, New York (Elisha Whittelsey Collection, 1947).

Dry Media

Graphite pencil

In Chapter 2 we mentioned graphite pencil, the most common of drawing tools, to illustrate variety of line; we saw how Ingres and Modigliani used the harder, lighter range of graphite and extended the range by subtly blending the light line into darker tones. We also noted that each used a softer, darker variety for faster, more immediate, performances. To reinforce these examples we present two drawings by Picasso. In Figure 53 we see Picasso challenging Ingres in his own domain, appropriating his linear, clear yet soft gradations in graphite pencil: a supreme tribute that narrows the hundred years between. Please note again: using the whole range of light to dark does not make a drawing more successful;

54 Pablo Picasso (1881–1973; Spanish). *Portrait of Renoir* (after a photograph). 1919. Graphite pencil and charcoal, 24 × 19⅛″ (61 × 49 cm). Musée Picasso, Paris.

one uses only the range one needs for the particular message. For example, in another mood four years later Picasso uses only one grade of soft dark graphite pencil to transcribe his portrait of Renoir [54].

Colored pencil
Here the tonal range from very light to very dark is restricted to about half because colored pencils do not get as dark as other pencils, but this does not concern those who admire its special light. One must be careful, however, to test the light-fastness of colored pencils to prevent use of colors that fade quickly in ordinary light conditions. To test-mark a sheet with all the colors, cut in half and place one half in a book, the other half on an inside windowsill. In two weeks the halves should prove identical. Our tests show that shades of pink or violet are the most likely to fade.

Silverpoint
In Hendrick Goltzius' portrait of a boy [55] the medium is an undefined metal point: Although copper or gold have been used, silver remains the metal most often employed. It is one of the oldest of the drawing media, surviving from antiquity. It

is closely related to hard pencil and pen and ink in both its directness and its grouping of lines to produce tones. Silverpoint cannot be used on ordinary paper, but only on a surface that has been specially prepared to "hold" the silver left by the draftsman's marking action. The ground for silverpoint drawing used to be prepared by coating the surface with casein white or a thin size of glue, mixed with a fine abrasive material such as bone dust. Today the most usual ground is water-color (Chinese) white.

To work with silverpoint, place a long silver wire in a modern mechanical pencil and shape it to a fine point. You will be handling what appears to be an ordinary tool. Moreover, you do not need any special skill to prepare the ground. Take a sheet of rag paper (not too rough), tape it to a board with tan paper tape, and coat it smoothly, using a large watercolor brush and Chinese white water-color diluted with just enough water to keep it fluid. Two or three smooth coats will do. (There exist older formulas—for example, rabbitskin glue and bone dust or another abrasive material—but Chinese white works just as well.) You may want to mix the white ground with some neutral watercolor paint. In doing so, keep the ground light, because silverpoint produces gray tones.

You can practice the silverpoint technique on some inexpensive clay-coated paper called "cameo." Although this takes the silverpoint well, it does not "skate" on the surface, nor are the lines as clear as on the Chinese (zinc) white. You can also coat cardboard or paper with acrylic gesso and "draw" with aluminum nails. In general, do not try to gouge the surface to make darks since the drawing will oxidize, producing darks when it gradually turns. To make corrections you can erase lightly and recoat here and there with the white ground, but silverpoint is essentially a one-chance performance.

55 Hendrick Goltzius (1558–1616; Dutch). *Portrait of Jacob Matham as a Boy of Thirteen.* Metal point on prepared yellow colored paper, 3½ × 2⅓" (9 × 6 cm). Teylers Museum, Haarlem.

56 Sarah Haviland. *Self-Portrait*. 1978. Silverpoint. Collection Yale University School of Art.

In Goltzius' example the forms seem fairly rigid; however, in a student reaction to a demonstration on silverpoint [56] the cross-hatched forming usually associated with etching or pen attains a special gray light like no other medium. See figure 204 for another student example of silverpoint.

Chalk

The term *chalk* as it is used today usually refers to conté crayon, which comes in many shades, from red to brown to black. Conté crayon can be sharpened with a sandpaper stick or left fairly blunt. (Chalk may also refer to pastel, a much softer medium. Because of its coloristic effects, pastel will be discussed separately.) The seven examples here will show the wide effect possible with this versatile tool.

In John Constable's *Salisbury Cathedral from Old Sarum* [57] the paper is gray; clearly seen strokes, both sharp and soft-edged, are applied in different lengths and pressures. On the right sharply drawn swiftly moving strokes feature a lone tree supported by a light ground made of softly applied markings. As the space moves from middle distance to far the strokes dissolve in the paper. The play of the neutral ground and the various densities of stroke and pressure in both black and white make for a visual richness. Yet the drawing seems to be a swiftly transcribed sketch. In short, the artistry is hidden. In *Young Woman with Her Back Turned* [58] Paolo Veronese uses chalk to perform an immediate transcription of body gesture. The figure is modeled by a fast-moving line that keeps the contours fluid. This fluidity keeps us moving throughout the page.

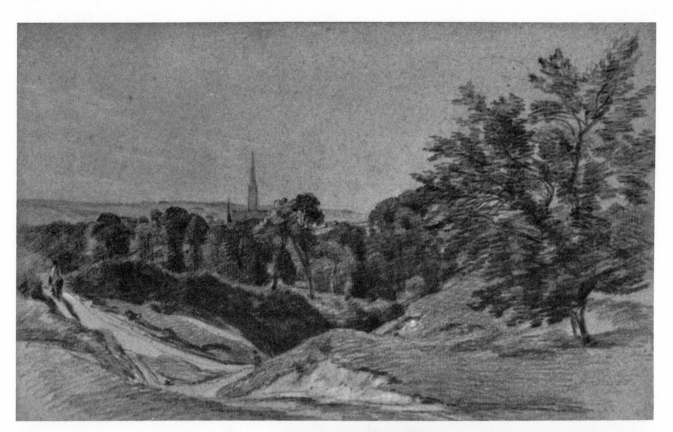

above: **57** John Constable (1776–1837; English). *Salisbury Cathedral from Old Sarum.* Black and white chalk on gray paper, 7½ × 11¾″ (19 × 30 cm). Oldham Art Gallery and Museum, Oldham, Lancashire, England.

right: **58** Paolo Veronese (1528–1588; Italian). *Young Woman with Her Back Turned.* Black chalk on gray-white paper, 16 × 12¾″ (41 × 32 cm). Fogg Art Museum, Harvard University (gift of Carl H. Pforzheimer).

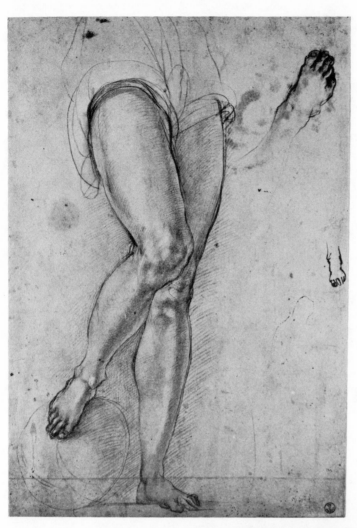

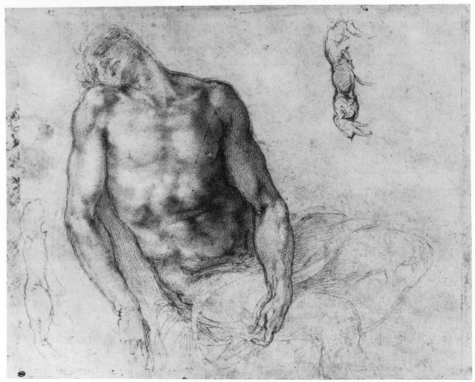

left: **59** Jacopo Pontormo (1494–1556; Italian). *Study of Legs*. Chalk. Uffizi, Florence.

below: **60** Michelangelo (1475–1564; Italian). *Study for a Pietà*. Chalk, 10 × 12⁹⁄₁₆" (25 × 32 cm). Louvre, Paris.

Jacopo Pontormo's *Study of Legs* [59] was drawn with sharpened chalk, but the touch is much softer, to the point of becoming a visual whisper. We can sense the artist delicately rubbing these fine tones (perhaps with his finger) into the fabric of the paper. Line blends into tone to bring out, in this case, a hint of the planar mass.

Michelangelo used chalk in two manners. In Figure 60 comparatively dry, tiny strokes fuse at a distance to create a delicate, shimmering type of modeling that is almost impossible to reproduce. In Figure 61 he adopts a more fluid, painterly use of chalk that we would normally associate with Titian and other Venetian draftsmen. Velvety rich darks at the center of interest gradually give way to planes produced by groupings of parallel lines, which in turn yield to pure line at the upper corners. The light areas of the chest and legs of the Christ figure and the back of the figure below are compressed and weighty; it hardly seems possible that they are formed simply by the white of the page.

61 Michelangelo (1475–1564; Italian). *The Descent from the Cross.* c. 1555. Red chalk on discolored pale buff paper, 15 × 11″ (38 × 28 cm). Ashmolean Museum, Oxford.

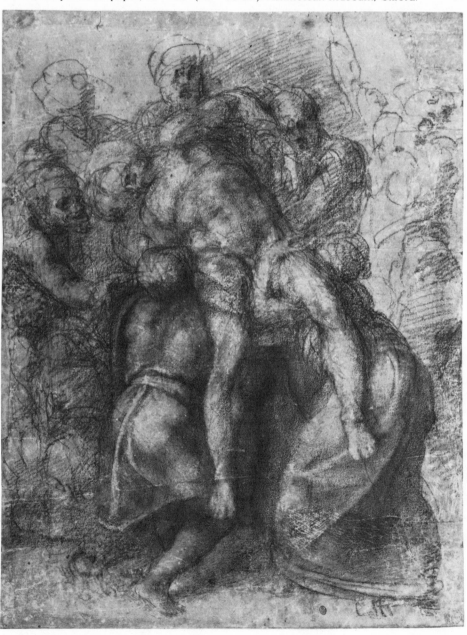

above: **62** Matheus Bloem (active 1640–1664; Dutch). *Group of Trees.* 1659. Chalk on brown paper, 11¼ × 19⅓″ (29 × 49 cm). Herzog Anton Ulrich-Museum, Braunschweig.

below: **63** Francisco Goya (1746–1828; Spanish). *Bullfight (Two Groups of Picadors Rolled Subsequently by a Single Bull, No. 32 in the Tauromaquia series).* 1812–1815. Red chalk. Prado, Madrid.

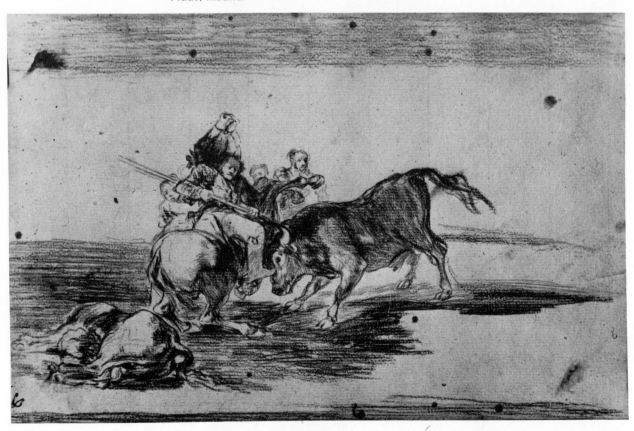

A straightforward use of the conté crayon is seen in *Group of Trees* by Matheus Bloem [62]. There is no rubbed-in softness, as in the Pontormo. Rather, the tooth of the rough drawing paper picks up particles of chalk, which is applied in light, swift, free-moving strokes.

Francisco Goya's penchant for dark, dramatic, pressure-filled scenes receives a strong, full treatment in *Bullfight* [63], a drawing in which the artist has used white paper to represent not only air but planes as well. For example, the seemingly empty white space directly behind the figures functions as a plane, perhaps the wall of the arena. Its boundaries are established by the lightly sketched mass at the top. In this reproduction, which reveals the texture of the paper, we can see the play of darks alternately filling in the grain of the paper and remaining on the surface.

Crayon

Crayon includes the ordinary *wax crayon* and the greasy stick or pencil known as the *lithographic crayon*, so called because it works well in the water-and-grease technique of making prints by the process of lithography.

John Flannagan employs the blunt edge of a lithographic crayon in *Dog Curled Up* [64]. The artist, a sculptor, captures the dog's posture in one direct gesture. Although the planes are defined only in terms of contour, we do not feel cheated. The concept, again, dictates the use of the tool. It should be noted that lithograph crayon comes in pencils in a variety of hard and soft—and in stick form. Our guess is that this drawing was accomplished with blunt-edged stick.

Warning: The so-called wax crayons sold for children's use are not wax but paraffin. Most, if not all, of the colors are dyes, which may fade. The test for fading is the same as for colored pencils (page 44).

64 John Flannagan (1895–1942; American). *Dog Curled Up*. Lithographic crayon, 11¹³⁄₁₆ × 17¹⁵⁄₁₆″ (30 × 45 cm). Addison Gallery of American Art, Phillips Academy, Andover, Mass.

Charcoal

Charcoal comes in hard and soft varieties, the softer producing the darker line. Compressed charcoal, which is much more dense and black than the traditional kind, can be used to create darks as rich as those in *Head of John the Baptist in a Saucer* by Odilon Redon [65]. Redon called his velvet-textured, highly personal drawings "my blacks."

An anonymous student at the turn of the century produced the charcoal drawing in Figure 66 from a cast of a Greek sculpture. In it the student rubbed charcoal into the paper to hide the individual strokes. The suppression of any personal handwriting was a major goal in traditional academic training.

By contrast Matisse, in *Maternité* [67], incorporates into the finished drawing the erasures created by his search for the correct location of forms on the page. The aura provided by these erasures eventually becomes part of the figures and their environment.

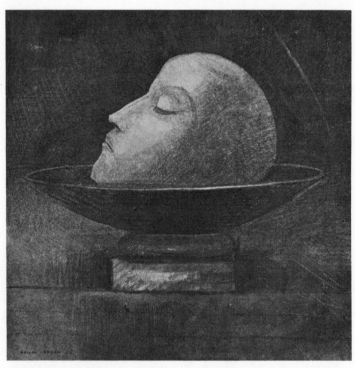

above: **65** Odilon Redon (1840–1916; French). *Head of John the Baptist in a Saucer.* c. 1917. Charcoal, 14½ × 14⅜″ (37 × 36 cm). Rijksmuseum Kröller-Müller, Otterlo, Holland.

right: **66** Anonymous. *Cast of a Greek Sculpture.* Late 19th–early 20th century. Charcoal. Collection the author.

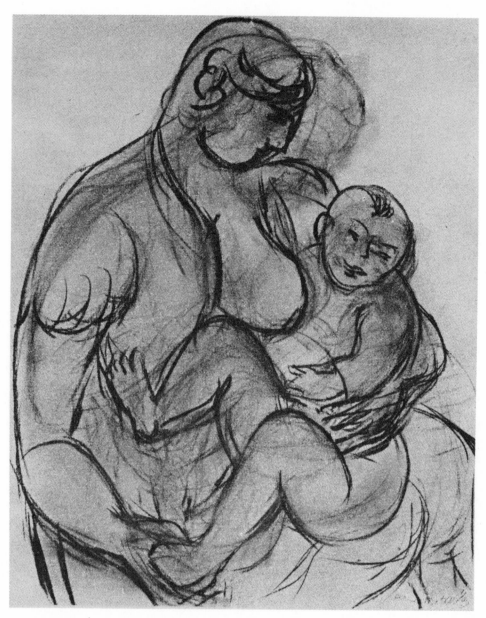

67 Henri Matisse (1869–1954; French). *Maternité*. 1939. Charcoal.

Fixatives

The modern spray-can fixatives for dry media work well if you follow directions. Keep the spray can 12 inches away from the drawing, and do not flood it. Remember that these fixatives are dangerous. The solvents are deadly. There are instances of artists who have contracted blood disease and ultimately died from using spray-can fixatives improperly. The chemicals must be used in well-ventilated rooms—better still, out-of-doors. Besides the spray-can fixatives a highly recommended fixative is Magna varnish, thinned with four parts denatured alcohol. This formula works well for conté and charcoal and particularly for pastel. Spray on the fixatives with an atomizer. The recommended method is with a spray can powered by a replaceable cylinder of nontoxic, nonflammable gas that produces a fine mist. Another possibility is acrylic mat medium used with such a sprayer or any equivalent equipment. Fixatives do, of course, change the color and must be used sparingly. You can frame a pastel without fixing it by placing narrow strips of wood between the glass and the painting.

Liquid Media

Pen and ink

Among the most flexible of drawing media is pen and ink. A wide variety of effects can be obtained, depending upon the type of pen point, the amount and kind of ink, and the pressure exerted. (Wash is ink diluted with water.) Of course wet and dry can be mixed. Remember that the Van Gogh pen drawings have pencil underneath.

Modern drawing inks are made from dyestuff (usually particles of a carbon pigment), shellac, and water. If you are curious enough about the quality of other types to try to make your own carbon ink, use this recipe:

1. Take 8 ounces of water, and heat it almost to the boiling point.
2. Remove the water from hotplate, and add 1 ounce of rabbitskin glue, stirring until the glue is completely dissolved.
3. Into a mortar place 1 level tablespoon of lampblack dry color of good quality.
4. Add 2 teaspoons of the hot glue size, and work the lampblack into the glue with a pestle. Although the two ingredients do not seem miscible at

68 Various types of pen points and their drawing characteristics.

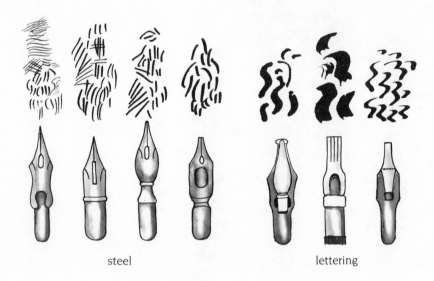

steel lettering

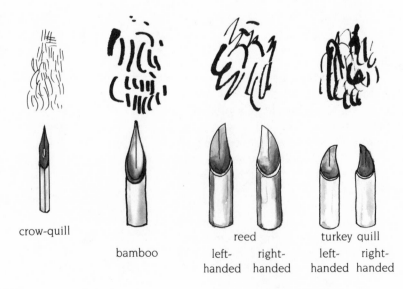

crow-quill

bamboo

reed
left- right-
handed handed

turkey quill
left- right-
handed handed

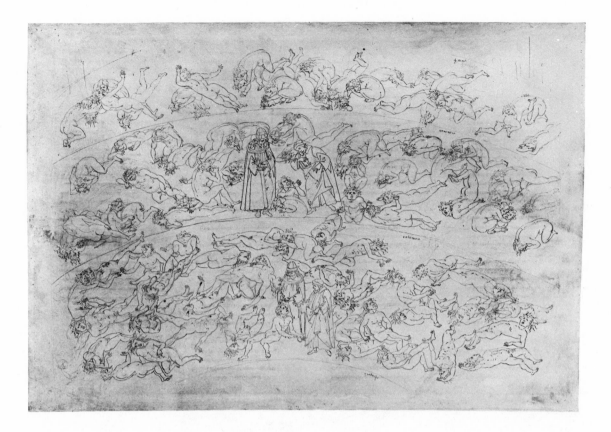

first, vigorous circular grinding will produce a smooth paste within one or two minutes.

5. Continue the grinding until the mixture is well worked, then add 1 teaspoon of the hot glue size, and work it well into the paste.
6. You can then follow one of two procedures in forming the stick or cake of ink:
 a. Pour the mixture into a shallow porcelain or glass receptacle to dry. Although it will not affect the quality of the ink, the stick or cake will crack or warp during the drying process.
 b. Pour the cream-thick ink into a receptacle, stirring and working it as the moisture evaporates until it can be pressed into a semisolid stick form. Then cover or wrap the stick in wax paper, and allow it to dry slowly.
7. As in the case of Chinese ink sticks, the liquid can be brought to the proper consistency and intensity by rubbing the sticks with a proper amount of water, in a porcelain dish or a slate ink-saucer.*

69 Sandro Botticelli (1444?–1510; Italian). *Inferno* XXXIII, illustration for Dante's *Divine Comedy*. c. 1482–1492. Pen and ink, 12¾ × 18″ (32 × 46 cm). Kupferstichkabinett, Staatliche Museen, Berlin.

Having bought or made your ink, it is time to experiment with different pens. Figure 68 illustrates the marks produced from four different steel pen points; three lettering pens; the smaller crow-quill steel point; and pens made from bamboo, reed, and turkey.

In Figure 69, Sandro Botticelli's *Inferno* XXXIII (illustrating a scene from Dante's *Divine Comedy*), an ordinary medium-weight steel pen point may have been used to achieve this fairly uniform, continuous line. The lines clearly define the shape and posture of each figure, and they also compress the whole space of the composition into a unified field. Forms do not project from, or drop behind, this uniform frontal plane.

* James Watrous, *The Craft of Old-Master Drawings* (Madison: University of Wisconsin Press, © 1957 by Board of Regents of University of Wisconsin System), p. 86. This book also contains information about making crayons and chalks from raw ingredients.

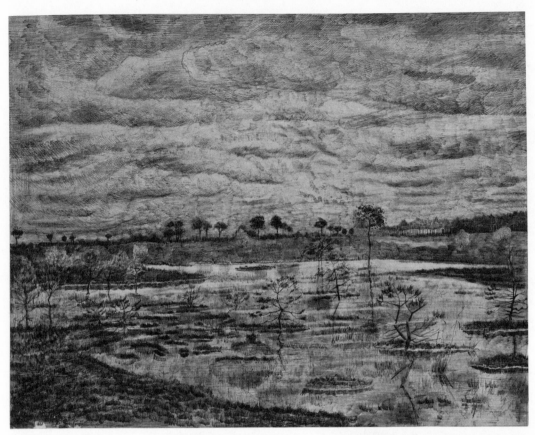

above: **70** Vincent van Gogh (1853–1890; Dutch). *The Swamp*. 1881. Pen and ink over graphite on paper, 18⅜ × 23⁵⁄₁₆″ (47 × 59 cm). National Gallery of Canada, Ottawa.

right: **71** Sebastiano Ricci (1659–1734; Italian). *The Education of the Virgin*. Pen and brown ink over black chalk, 9³⁄₁₆ × 6³⁄₁₆″ (23 × 16 cm). Metropolitan Museum of Art, New York (gift of The Florence and Carl Selden Foundation, Inc., 1967).

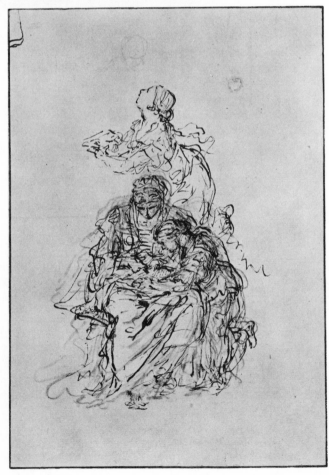

In *The Swamp* [70] Van Gogh employed a crow-quill pen to produce tightly packed groups of hatchings. The dense packing of the strokes, so atypical of the artist, shows us that a tool's special qualities can be extracted by an artist sensitive to its qualities. A lesser artist might have forced the tool into a preconceived stylization.

In Sebastiano Ricci's *The Education of the Virgin* [71] steel point has been used. Modern pen points come in many sizes and shapes, and the artist should experiment with several different kinds to find those that feel the most natural. In Ricci's drawing a staccato rhythm creates an appropriate aura. (Notice the underdrawing in black chalk).

The length of a stroke of the steel pen point is limited by the amount of ink it can hold in one dip. Not so with a new instrument, the ball-point pen. The continuous, free-flowing line in Alberto Giacometti's *Portrait of Herbert Lust in His Father's Topcoat* [72] carves out the geometric core of the head and its location in

72 Alberto Giacometti (1901–1966; Swiss). *Portrait of Herbert Lust in His Father's Topcoat*. 1961. Ball-point pen on paper, 19¾ × 12¾" (50 × 32 cm). Collection Herbert and Virgina Lust.

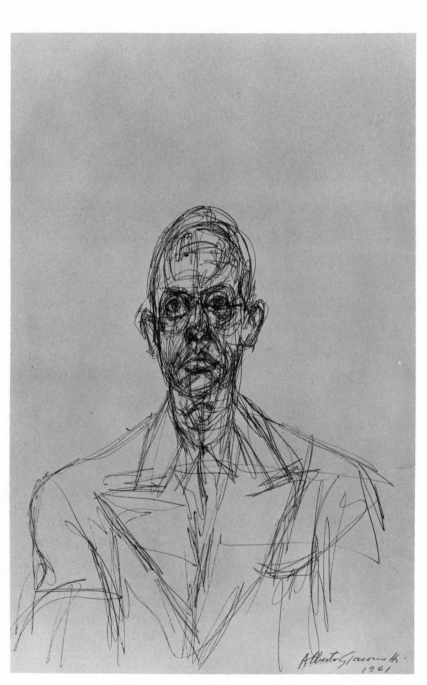

above: **73** Vincent van Gogh (1853–1890; Dutch). *View of Arles.* 1888. Pen and ink, 17 × 21½″ (43 × 55 cm). Museum of Art, Rhode Island School of Design, Providence (gift of Mrs. Murray S. Danforth).

below: **74** Gillis Neyts (1623–1687; Flemish). *Landscape with Castle.* Pen and bistre ink, 7¾ × 12″ (20 × 30 cm). Stedelijk Prentenkabinet, Museum Plantin-Moretus, Antwerp.

the compositional space. This potential for unbroken line is the great advantage of ball-point. However, the ink dyes used in ball-point pens may fade when exposed to constant light. (Test for light-fastness in the same way as for colored pencils; page 44.)

Each tool has its own kind of mark which becomes transformed in every stroke by the individual's personal sense of touch.

In Figure 73 we see Van Gogh, this time using a typical instrument (either quill, reed, or bamboo), perform a brilliant orchestration of light effects—as if the lights are going off and on. He considered this kind of black-and-white vibration an equal to the clash of complementary colors.

In Gillis Neyts' *Landscape with Castle* [74] tiny pen strokes group together to create planes in both the architecture and the foliage. Each mark that builds the plane is visible. A crow-quill pen, the tiniest available, could have been used here also to produce this effect.

Although we normally think of drawing in terms of dark marks on white paper, Hyman Bloom's white-ink drawing *Fish Skeletons* [75] reverses this principle. The white forms set against a dark maroon background have a tendency to move out toward the viewer. Some of the large lines have actually been made with a brush. The thin whitish film in the central portion of the drawing is an especially interesting by-product of the white-ink technique. Artists sometimes prepare an "ink" with white tempera paint and water, which makes it easy to blot out the pen strokes for correction. The residue of this blotting process produces ghostly white washes, which add to the mysterious quality of the work.

The examples of pen-and-ink techniques in this section by no means exhaust the possibilities in this medium. Rather, they are intended to show the potential variety of tools at the artist's disposal and the different effects that can be produced with these materials. There are no rules about what instrument is to be used, and there is no "best" instrument. As with line—or any other component of drawing—the artist's aim determines the means.

75 Hyman Bloom (b. 1913; American). *Fish Skeletons.* 1956. White ink on maroon paper, 17 × 23″ (43 × 58 cm). Collection Mr. and Mrs. Ralph Werman.

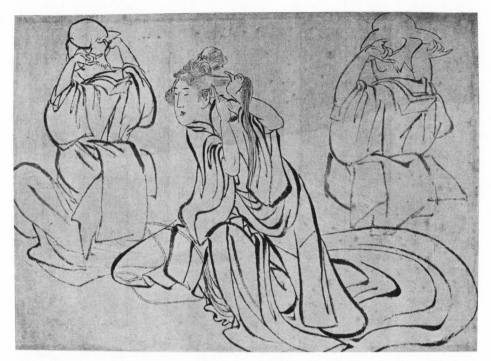

above: **76** Katsushika Hokusai (1760–1849; Japanese). *Three Studies of a Young Woman Dressing Her Hair.* Ink and brush on paper, 10⅝ × 15″ (27 × 39 cm). Musée Guimet, Paris.

below: **77** Paul Klee (1879–1940; Swiss). *Young Man at Rest (Self-Portrait).* 1911. Wash, 5½ × 7¾″ (14 × 20 cm). Private collection, Switzerland.

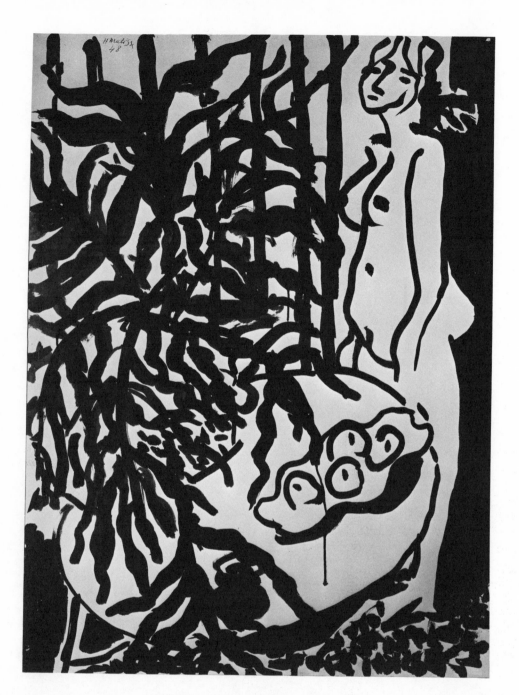

78 Henri Matisse
(1869–1954; French).
Nude with Black Ferns. 1948.
Brush and ink, 41¼ × 29½"
(105 × 75 cm). Musée
National d'Art Moderne,
Paris.

Brush and wash

Oriental artists write as well as draw with a brush, and this tool is as familiar to them as the pencil is to people in the West. The exquisite calligraphy that delights Western eyes is, for the Oriental, simply a natural use of the instrument. Even within this context, however, there is mastery in a drawing by Hokusai called *Three Studies of a Young Woman Dressing Her Hair* [76]. Here bold brush stokes of varying textures describe the folding drapery and activate a spatial sweep around it.

Paul Klee might have used a Japanese brush or a flexible watercolor brush—either of which will produce a thick-to-thin line—in his *Self-Portrait* [77], which surprises us with the unique tilt of the head into the compressed space of the page. Klee broadens the technique by slightly diluting his ink to give a broad wash effect and by applying some strokes (upper and lower left) with an almost dry brush. Matisse might have used the same kind of instrument in *Nude with Black Ferns* [78], a very large ink drawing, but his ink is unadulterated—not mixed with water.

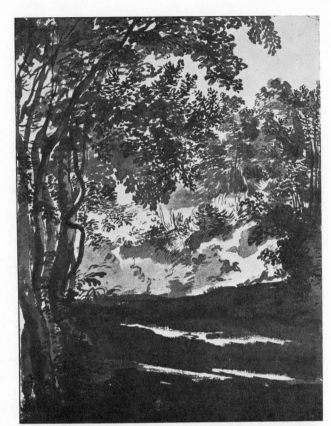

right: **79** Nicolas Poussin (1594–1665; French). *Landscape.*
Wash, 9 × 7½″ (23 × 19 cm). Louvre, Paris.

below: **80** Francisco Goya (1746–1828; Spanish). *Nada, ello
dirá,* preparatory drawing for *The Disasters of War.* Wash.
Prado, Madrid.

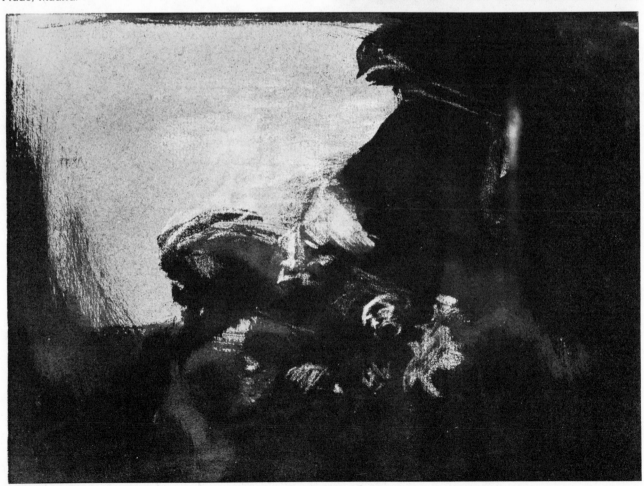

In Nicolas Poussin's brush drawing *Landscape* [79], the watered ink is brushed mostly on the ground plane but the wash, applied in various transparent densities throughout the page, is deftly orchestrated in a playful wet rhythmic spiral.

Goya's preparatory drawing for one of his etchings in the *Disasters of War* series [80] suspends a dramatically poised and frightening wave of darkness that is about to engulf the figure. This virtuoso performance seems to have been accomplished with one fluid stroke of the brush.

It should be evident from these examples that the brush is capable of producing unique and wide-ranging effects, and that the command of its use provides the artist with an extraordinarily expressive tool for the realization of a personal vision.

Monotype

Monotype may be classified by some as a print medium but it is also closely related to brush and wash—and because the printing ink (in place of drawing ink) is thinned with turpentine it obviously also relates to oil painting. In short, in monotype the distinction between media is blurred. You draw on a metal etching plate with printing ink or oil paint. You can thin with turpentine, use a brush to make tones and lines, or, as Degas did [81], cover the whole plate with a thin coat of oily, heavy printing ink and work in reverse, drawing out the lights with a rag. Degas made the white lines by inscribing them on the plate with a blunt, hard point. The monotype image is easily changed. Whole areas or lines can be erased with rag and turpentine. But when the artist is satisfied, the image is printed on an etching press with presoaked dampened paper, the same way one prints an etching except that only one impression can be printed. After the impression is taken,

81 Edgar Degas (1834–1917; French). *Le Bain*. c. 1880–1885. Monotype (first of two impressions), 20¼ × 13⅞″ (51 × 35 cm). Art Institute of Chicago (Clarence Buckingham Collection).

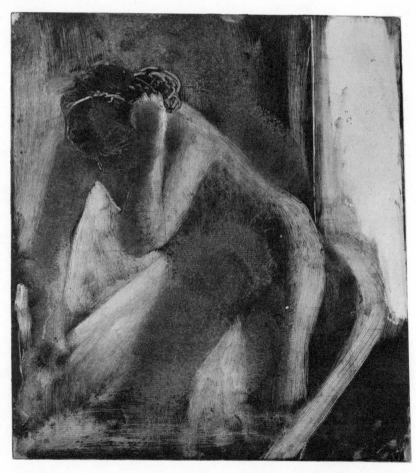

a ghost image sometimes remains on the plate. Degas and monotype artists following him used these leftover images to rework and make variations on the theme. Such a process can lead to countless variations, since each successive impression yields another ghost. Degas even reworked the printed image by adding pastel, watercolor, or oil paints to the finished monotype. If you do not have a printing press you can print by placing the printing paper on the plate (or in this case a heavy glass could be substituted). Rub carefully with a wooden spoon, the way one prints a woodcut.

Student Response

Students who do not naturally respond to a pointed tool, pencil, or chalk—that is, with line and built-up forming tones—sometimes excel in this medium. Our experience has been that the technique of monotype sounds more complicated than is the practice.

In one experiment the studio setup was staged to resemble the Degas monotype. The wide interest in this similarity de-emphasized the interest in the process. One result [82] was a flowing brush-and-ink drawing punctuated with white lines produced by applying the brush handle into the wet ink.

The rough-haired forming strokes of an oil brush are revealed as they construct the back of the model in another response [83]. The relative stiffness of the ink makes this possible.

In Figure 84 the plate was first covered with a coat of printing ink applied with a small roller commonly used for woodblock printing. Firm sharp-edged pieces of cardboard, stiff brushes, and rags are some of the tools used to produce the lights.

The ghost image that remains on the plate inspires one to produce a series of variations. One can test many visual solutions. One can, among other things, add or subtract elements, strengthen and simplify the whole composition, intensify or soften the light. In one student's own words: "I worked with a brush, printing ink,

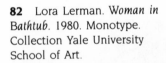
82 Lora Lerman. *Woman in Bathtub*. 1980. Monotype. Collection Yale University School of Art.

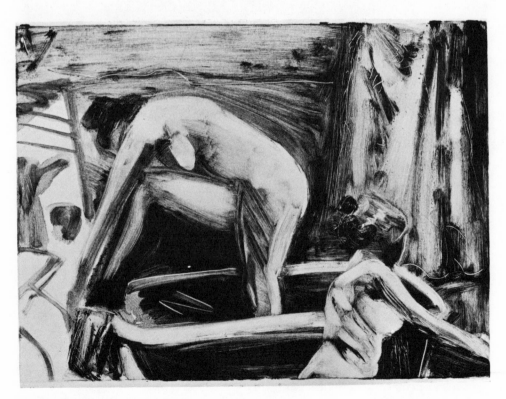

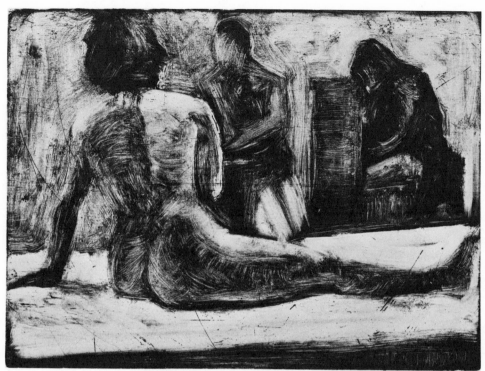

83 John Iorio. *The Model*. 1981. Monotype. Collection Yale University School of Art.

84 Rosanna Warren. *Profile*. 1976. Monotype, 9 × 11¾" (23 × 30 cm). Collection Yale University School of Art.

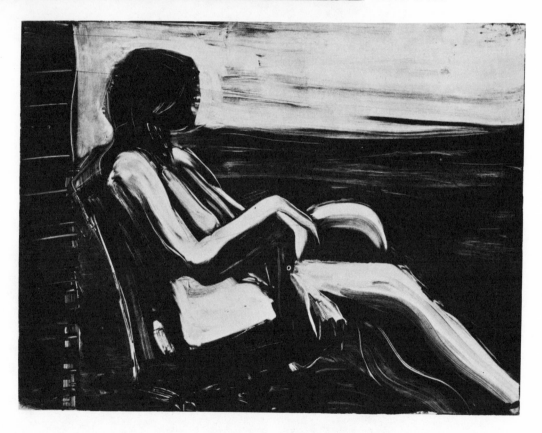

turpentine and rags on a zinc plate. After making my first monotype [85, page 66] I decided that the blacks should be a bit larger [86, page 66]. Instead of wiping the entire plate clean I worked back into the drawing remaining on the plate. I wanted to strengthen the composition and the hierarchy of blacks; I wiped out the man and all of the objects on the table entirely, moved the man back in space and attempted to get a more even floor tone [87, page 67]."

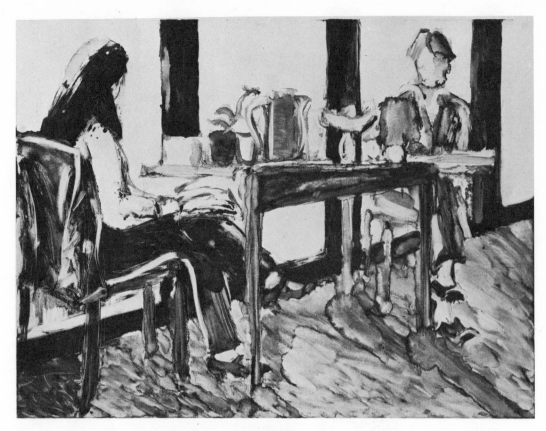

above: **85** Meg Peterson. *Variation on a Theme.* 1981. Monotype. Collection Yale University School of Art.

below: **86** Meg Peterson. *Variation on a Theme.* 1981. Monotype. Collection Yale University School of Art.

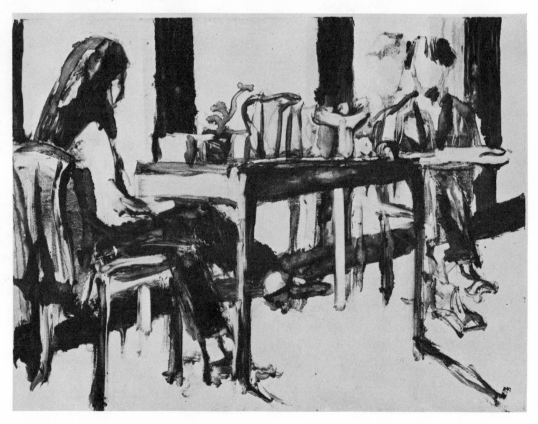

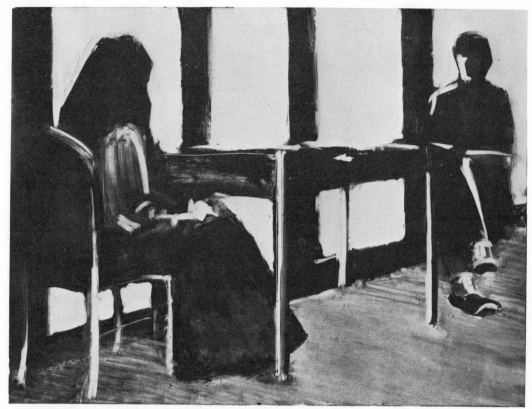

87 Meg Peterson. *Variation on a Theme.* 1981. Monotype. Collection Yale University School of Art.

Color: Wet and Dry

Watercolor

Though it may employ the broadest spectrum of colors, watercolor is linked to drawing in its general use of white as a ground for dark marks. *Tonal* watercolors—those that stay in one color range—seem closer to drawing. But Goya's *Nada, ello dirá* [80, page 62], which we labeled a wash drawing, could just as easily be called a watercolor. In the final analysis, establishing categories is the province of scientists and encyclopedists. Most artists do not concern themselves with this academic problem. We will return to this rich "border" area between drawing and painting in Chapter 12.

Watercolor painting is the application of a thin solution of colored liquid on a light sheet. This medium permits only minor changes. Inspiration, vision, and skill work together to produce an immediacy different from that of any other medium. Unfortunately, the art-education tradition presents watercolor as a medium for beginners, so that what passes for instruction in too many classes is technique alone, without regard for concept. But learning to produce tricky effects or to lay down a flawless wash usually leads to a misplaced emphasis on method and paintings devoid of pictorial invention. Paul Cézanne, whose late works in oil were based on his watercolor experience, would not receive a passing grade if traditional technique were the sole criterion, for his watercolors evolve out of personal perceptions and conceptions. Cézanne's watercolor technique is thus a by-product of his imagination.

mixing pans

watercolor tubes

Japanese

sables

brushes

brown paper tape

metal carrying case

watercolor paper

paper peel-off palette

sponge

88 Supplies for watercolor work include brushes, tubes or cakes of paint, mixing pans or paper palettes, sponge, masonite or plywood support, brown paper tape.

The materials used in watercolor need illustrating [88] and discussion: Pure rag *paper* (page 76) is the best surface for watercolors, because it does not absorb too much of the color but rather keeps it on the surface. Watercolor paper is heavier than ordinary drawing paper and comes in smooth, medium, and rough varieties and in weights that range from thin (number 70) to medium (number 140) and heavy (number 300). The letters CP stand for *cold press* paper, which has a smoother, harder, and slightly less absorbent surface than HP, or hot press. The heaviest papers in the roughest range tend to have a stronger glue size that may initially resist the brush. Some artists therefore prewet sections. Be warned, however, that wrinkles may appear when the paper becomes saturated with water. To prevent wrinkles, you can buy the paper in preglued blocks. Cut the painting out of the block only after it is dry. With single sheets, tape the edges all around to a drawing board or sheet of plywood or masonite; use brown-paper preglued tape that needs wetting. When the watercolor has dried, cut the paper out along the tape. Whatever surface and weight you choose, remember that the intensely white, handmade rag paper is probably the most tactile painting surface available. It stimulates approaching the act of painting by setting the sense of touch in motion. (See page 76 for discussion of papers suitable for all drawing media.)

Pure red sable *brushes* are the best for watercolor because they keep their resiliency, but less expensive white-haired Japanese brushes also work well. Metal or porcelain palettes for mixing are usually part of the container for cake watercolors. In addition, you can buy large porcelain containers made for this purpose.

Throw-away *palettes* are fine because they reflect the same strong white as the paper. However, only the mat-surface variety is useful; the shiny paper palette causes water to bead, making it impossible to mix colors. Yet the shiny variety is useful for depositing paint at the end of a painting session, for the colors stay moist for days.

Besides brushes and palettes, you will need a *sponge* to prewet the paper or to soak up mistakes; tissues are also useful.

Plate 1 Albrecht Dürer (1471–1528; German). *The Crab* (*Eriphia spinifrons. Herbst*). 1782. Watercolor, 10¼ × 14″ (26.3 × 35.5 cm). Museum Boymans-van Beuningen, Rotterdam.

Plate 2 Joseph Mallord William Turner (1775–1851; English). A *Whale Aground*. Watercolor, 9⁵⁄₁₆ × 3³⁄₁₆″ (23.6 × 8.1 cm). British Museum, London.

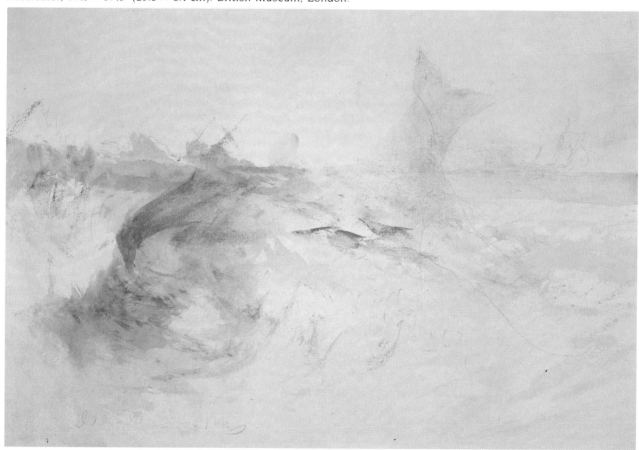

Plate 3 Childe Hassam (1859–1935; American). *The Island Garden*. 1892. Watercolor, 17½ × 14" (44.5 × 35.5 cm). National Museum of American Art (formerly National Collection of Fine Arts), Smithsonian Institution, Washington (gift of John Gellatly).

Plate 4 Paul Cézanne (1839–1906; French). *Foliage*. 1895–1900. Watercolor and pencil, 17⅝ × 22⅜" (44.7 × 56.8 cm). Museum of Modern Art, New York (Lillie P. Bliss Collection).

Plate 5 Emil Nolde (1867–1956; German). *Sea with Mauve Clouds*. Watercolor on Japan paper, 14⅜ × 20″ (36.5 × 50.8 cm). Nolde-Stiftung Seebüll, West Germany.

Plate 6 Jean Baptiste Siméon Chardin (1699–1779; French). *Self-Portrait* (also called *Portrait of Chardin at His Easel*). 1771. Pastel, 16 × 12¾″ (40.5 × 32.5 cm). Louvre, Paris.

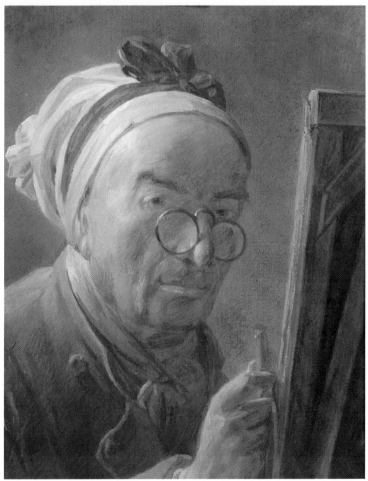

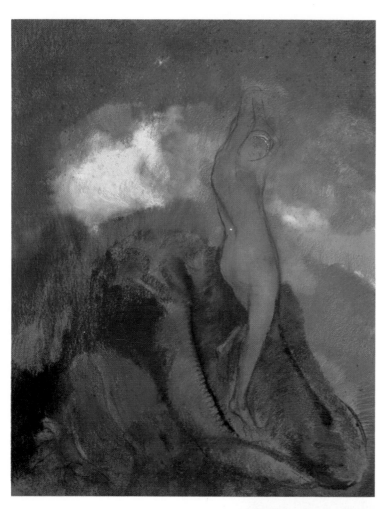

Plate 7 Odilon Redon (1840–1916; French).
The Birth of Venus (La Naissance de Vénus).
c. 1910. Pastel, 32⅜ × 25″ (82.2 × 63.5 cm).
Musée du Petit Palais, Paris.

Plate 8 Edgar Degas (1834–1917; French). *La
Sortie du Bain*. Pastel. Louvre, Paris (gift of
Hélène and Victor Lyon).

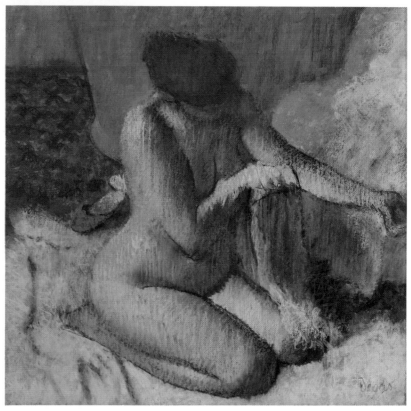

Gouache usually means the addition of white—that is, Chinese (zinc) white watercolor—to the watercolor, either through mixture with the colors or as a separate coating of white on which the transparent color is floated. In technical terms, adding a layer of white to the paper changes the ground from white paper to white watercolor—and the medium from watercolor to gouache. You can, however, simply refer to this as watercolor over white ground. Manufacturers also produce opaque gouache colors in a gum arabic base. These body colors (as opposed to transparent ones) sometimes bear the label *Designers Colors*.

A few examples of the variety of effects possible in watercolor: Dürer's *Crab* [Plate 1, page 69] fills the picture space. The edges are clear, the application smooth. A (hard) cold-press paper would be best to attain this evenness of edge. A softer (hot-press) paper would be best for the opposite effect; in Turner's A *Whale Aground* [Plate 2, page 69], the magically soft trailing-edged forms seem to appear instantly out of the page.

A firm (cold-press) paper would best receive the blizzard of countless direct firm brush strokes in Hassam's *The Island Garden* [Plate 3, page 70]. It is hard to discern the edges of the individual forms in Cézanne's *Foliage* [Plate 4, page 70], for the flow of shapes is conceived in an overall rhythmic pattern of transparent edges. A hard, firm paper in which the thin washes do not disappear would be the correct support for this effect.

Absorbent Japanese paper would be the logical choice for a concept which imagined the multilayering of many iridescent colors in Emil Nolde's *Sea with Mauve Clouds* [Plate 5, page 71].

Pastel

We have defined drawing as a graphic linear medium and referred to it as "form-making in black and white." Painting, as a separate art, is concerned with color or—to stretch the definition—color-drawing. It is difficult to classify pastel within this terminology. As a form of chalk, pastels may be used to create individual strokes that are both graphic and linear. Yet they surely employ color at full intensity, without a wet medium to darken or change the colors. Pastel, then, is unique—one can draw and color simultaneously.

Chardin's touching last self-portrait [Plate 6, page 71] was in pastel. He explored combining a strong forming light with vivid color accents of blue (ribbon) and red (the actual bright pastel stick). There is a smooth layering of tone on tone to model a strong volume surrounded by a dense tonal background. Against this the color notes vibrate. If one can catch some of Chardin's pastels in a strong sidelight through the glass one can actually see the imprint of the layering of the strokes.

Pastel also reflects Redon's concepts. Against a reddish paper he modeled (lightly) a red figure and a simplified shell to hold his *The Birth of Venus* [Plate 7, page 72]. He exploded a brilliant blue violet sky and pink clouds behind the figure and its container. Notice that the red ground can be seen through the blue sky. Pastel is capable of the purest color, for we don't have the liquid medium to tone down the color. A dry color gives off more light; Redon thus employs one of the medium's unique qualities.

Degas worked almost exclusively in pastel the last thirty years of his life. He built layer upon layer of color (in Plate 8 [page 72] pink and orange strokes over Naples yellow and greenish ochres in the body) separated by a fixative whose formula remains a secret. It is said he sprayed hot water on the work in progress and worked into the wetness with brushes. And on occasion he suspended his pastels in steam so they could produce an impasto quality. He also combined pastel with gouache in layers. All this technical information, however, does not explain his genius with the medium.

See page 53 for discussion of fixatives for pastel and other dry media.

Mixed Media

Mixed media is a loose term used to embrace the infinite combinations of materials and techniques that are possible in a work of art. Any of the tools and substances described above—plus others too numerous to list—might be combined to create a "mixed media" drawing. A great number of different media in one work of course do not guarantee success; the challenge is to make the materials work in harmony to make one image.

One simple combination is a dry medium—pastel, conté crayon, or charcoal—and wash (water) which picks up the dry strokes and tones the water and spreads this new tone [89]. In another mixture gouache over black chalk produces a density that resembles the artist's oil paintings [90].

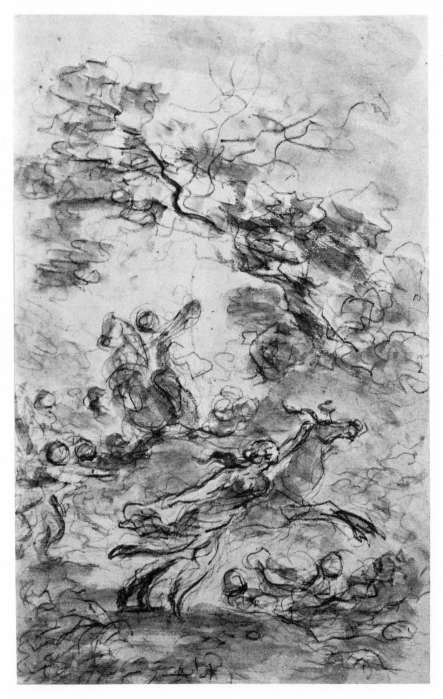

89 Jean Honoré Fragonard (1732–1806; French). *Drawing for Ariosto's Orlando Furioso.* Wash over black chalk. Whereabouts unknown.

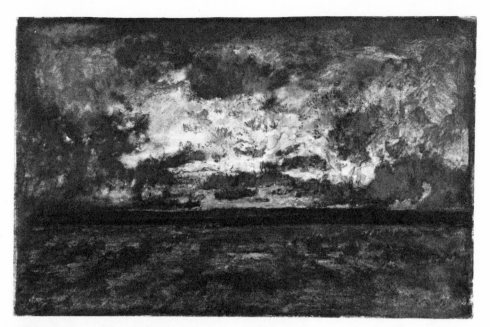

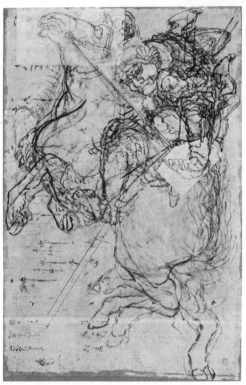

above: **90** Narcisse Diaz de la Peña (1807–1876; French). *Sunset*. Gouache over black chalk on off-white wove paper, 5¾ × 9⅛″ (15 × 23 cm). Baltimore Museum of Art (The Friends of Art Fund).

left: **91** Katsushika Hokusai (1760–1849; Japanese). *Warrior on a Rearing Horse*. Black and red inks on paper. Private collection.

Even masters make changes. In a brilliant Hokusai [91] we witness the master trying out different positions of the horse's legs. In the upper left and middle right, with a surgeon's skill, he glues on corrections. For some artists the process of change we see in this collage technique with its revealing pictorial strategies ranks this drawing higher than a more finished drawing.

In our survey of media we have emphasized that the material, no matter how brilliantly employed, is merely a tool in the service of the artist's vision. If surface handling overpowers a work and "technique" is used for its own sake, the drawing is meaningless. If a particular drawing interests us primarily for this "how" of technique and only secondarily for its subject, it fails as a work of art. The beauty of drawing as an art is that all these qualities exist simultaneously and in balance.

92 Paper samples, with test marks of various media: (1) Classico Fabriano (rough finish); (2) Classico Fabriano (smooth finish); (3) Zaan; (4) Lana; (5) Rives BFK (absorbent surface); (6) Rives BFK (smooth surface); (7) Arches Cover; (8) Toyoshi; (9) Murillo (Fabriano); (10) Strathmore Watercolor; (11) Strathmore Drawing Board (soft surface); (12) Strathmore Drawing Board (smooth surface).

Papers for All Drawing Media

There are as many papers available for drawing as there are tools with which to draw. For this reason we include this information in this section. As always, your own sensibilities and vision must govern your selection. Keep in mind that rag paper is easiest to draw on. The marks stay clearly on the surface without sinking in, and the surface takes erasures without the obvious damage apparent in the cheap wood-pulp papers, such as newsprint. The wood-pulp papers also yellow and get brittle with time, whereas rag papers, if properly stored or displayed, retain their original character.

Every rag paper has a different surface quality, so you should experiment with as many as you can buy.

Do not try large drawings at first. Cutting up each sheet into two or even four parts makes experimentation less costly. In general, the more paper you buy from a company, the cheaper each sheet.

Beyond these basics it is difficult to give exact advice about which paper to choose for a particular project. Most published material on paper deals with the adaptability of various types to printmaking processes. Draftsmen, however, select a paper for its surface, its "feel," and then adapt their vision to these qualities.

Figure 92 illustrates and the following table details a test made with a dozen papers, readily available from the companies listed. Each paper was tested with conté crayon, various pencils, wash, and pen and ink. Charcoal and pastel were omitted because only relative roughness and smoothness were to be considered, and conté reveals this just as well.

Classico Fabriano ITALY

weight: 140 (63.4 kg)
surface: rough
process: hot press
color: ivory
size: 22 × 30 inches (56 × 76 cm)
rag content: 25%
widely available

Takes watercolor and wash well. Too soft for pencil. Conté reveals the very rough surface. Will work with heavy pens—bamboo, reed, and lettering.

Classico Fabriano ITALY

weight: 140 (63.4 kg)
surface: smooth
process: hot press
color: white
size: 22 × 30 inches (56 × 76 cm)
rag content: 25%
widely available

Although sold under the same name as the above, this paper has a different color and surface. It is very smooth and excellent for pen and pencil. A wash stays in place, but does not spread well.

Zaan HOLLAND

weight: approximately 200 (90.6 kg)
surface: rough
process: not indicated
color: natural (tan)
size: $24^3/_8$ × $28^1/_2$ inches (62 × 72 cm)
rag content: 100%
source: Process Materials Corp.

A rough, mechanical surface that takes pastel well. Conté may not cover the surface texture sufficiently. Wash holds, but the wetness dents the paper, although it eventually dries flat. Too soft for pencil; takes ink but blurs slightly.

Lana FRANCE

weight: 140 (63.4 kg)
surface: medium
process: not indicated
color: ivory
size: 22 × 30 inches (56 × 76 cm)
rag content: 100%
source: Process Materials Corp.

Takes all media well and is relatively inexpensive.

Rives BFK FRANCE

weight: 140 (63.4 kg)
surface: medium (absorbent)
process: not indicated
color: white
size: $22^1/_2$ × 30 inches (57 × 76 cm)
rag content: 100%
widely available

Takes wash well, but pen is slightly blurred. Has a granular effect with conté. May be too absorbent for pencil.

Rives BFK FRANCE

weight: 90 (40.8 kg)
surface: medium smooth
process: not indicated
color: ivory
size: 26 × 40 inches (66 × 101.6 cm)
rag content: 100%
widely available

A smoother paper than the above. Takes pen and pencil better. Less absorbent than the above, which keep the wash more on the surface.

Arches Cover FRANCE

weight: 122 (55.3 kg)
surface: medium soft
process: not indicated
color: ivory
size: 22 × 30 inches (56 × 76 cm)
rag content: 100%
widely available

Takes all media well, although pencil effects are soft. Arches Company makes many varieties of paper, including excellent watercolor paper in different degrees of roughness, and smoother and harder drawing paper called Arches Silkscreen.

Toyoshi JAPAN

weight: approximately 120 (54.3 kg)
surface: medium soft
process: not indicated
color: warm white
size: 43 × 75 inches (1.075 × 1.875 m)
rag content: 100%
source: Aiko's Art Materials Import

Excellent for all media except pencil, for which it is too soft. Japanese papers are generally highly absorbent and, therefore, superb for water-thinned techniques. Note the large size.

Murillo (Fabriano) ITALY

weight: 360 (163 kg)
surface: medium to rough
process: not indicated
color: cream
size: 27$\frac{1}{2}$ × 39$\frac{1}{2}$ inches (70 × 100.3 cm)
rag content: 25%
widely available

May be too rough for pencil and blurs with pen. Conté reveals a good but even and heavy surface. Excellent for wash and watercolor.

Strathmore Watercolor U.S.A.

weight: approximately 140 (63.4 kg)
surface: medium to rough
process: not indicated
color: white
size: 22 × 30 inches (56 × 76 cm)
rag content: 100%
source: Strathmore Paper Co.

Too rough for conté and pencil, but excellent for wash, watercolor, and pen.

Strathmore Drawing Board U.S.A.

weight: approximately 140 (63.4 kg)
surface: medium soft
process: not indicated
color: white
size: 23 × 29 inches (58 × 74 cm), 30 × 40 inches (76 × 101.6 cm)
rag content: 100%
source: Strathmore Paper Co. (No. 235-62)

Very good for conté—permits a wide range of tones. Excellent for pen, takes wash well. May be too soft for pencil.

Strathmore Drawing Board U.S.A.

weight: approximately 140 (63.4 kg)
surface: smooth
process: not indicated
color: white
size: 23 × 29 inches (58 × 74 cm), 30 × 40 inches (76 × 101.6 cm)
rag content: 100%
source: Strathmore Paper Co. (No. 235-72)

This variety, smoother than the above, is best for pencil and pen. It does take wash, but achieving a variation of tone is difficult. Too hard for conté.

CHAPTER 5

Landscape

In this and the following chapters we shall examine some "problems" representative of age-old concerns of serious artists and the responses of selected students to these problems. If in these examples we continually point to the underlying visual logic of the drawings, it is only to emphasize that the way in which an artist structures space is, in itself, an expressive art.

Two drawings of trees attributed to Leonardo da Vinci can be used to represent the major ideas to be explored in this chapter: the structure of a form itself and the same form as part of an environment. These viewpoints are not necessarily contradictory. They can be combined at will.

The pen-and-ink drawing of a tree reproduced in Figure 93 exaggerates the point of juncture where one branch grows out of another to suggest a joining and growth similar to that in bone and muscle. The gentle, gradual swelling and stretching as one form pulls out of another is constructed almost as if the tree were a human figure. No clear line marks exactly where the tree emerges from the ground. Instead, we feel the roots pulling loose from the earth and spiraling up-

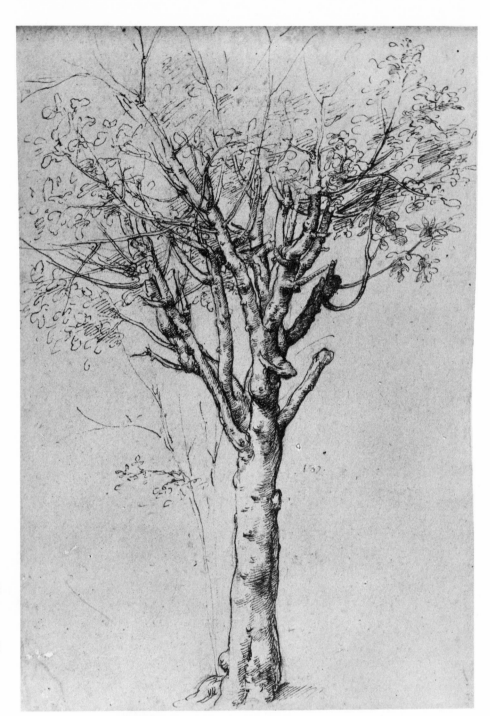

93 Leonardo da Vinci (1452–1519; Italian) or Cesare da Sesto (1480–1521; Italian). *Tree*. Pen and ink over black chalk on blue paper, 15 × 10⅛″ (38 × 26 cm). Royal Library, Windsor Castle, England (reproduced by gracious permission of Her Majesty Queen Elizabeth II).

ward. This sense of pulsation is fostered by clusters of rounded pen strokes at the point where the branches sprout outward into three-dimensional space, suggesting an inverted cone. The same modeling attitude exists in a detail of Dürer's drawing *Two Young Riders* [94] at the point at which the front leg of the horse pulls out of the body. Both examples suggest that drawing is concerned with discovering, then understanding, and finally expressing an attitude toward form.

The second Leonardo drawing, *Copse of Birches* [95], is not an idle, unfinished sketch. The apparent haze through which the trees are seen is intentional, as is the placement of the forms at the top of the composition. The heavy mass produces a particular *spatial experience*, which is another role for drawing. When this work is reproduced in books, the empty space at the bottom is usually eliminated, thus robbing the drawing of its distinctive spatial effect.

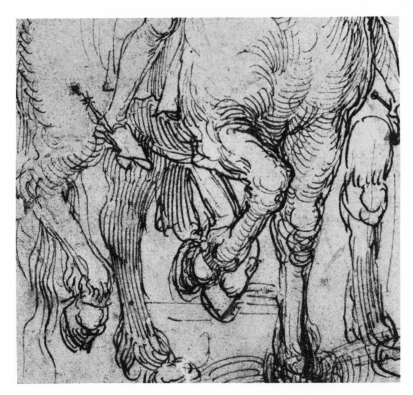

above: **94** Albrecht Dürer (1471–1528;
German). *Two Young Riders*, detail.
c. 1493–1494. Pen and ink, 7 × 6½"
(18 × 17 cm). Staatliche Graphische
Sammlung, Munich.

right: **95** Leonardo da Vinci (1452–1519;
Italian). *Copse of Birches*. c. 1508. Red
chalk, 7½ × 6" (19 × 15 cm). Royal Library,
Windsor Castle, England (reproduced by
gracious permission of Her Majesty
Queen Elizabeth II).

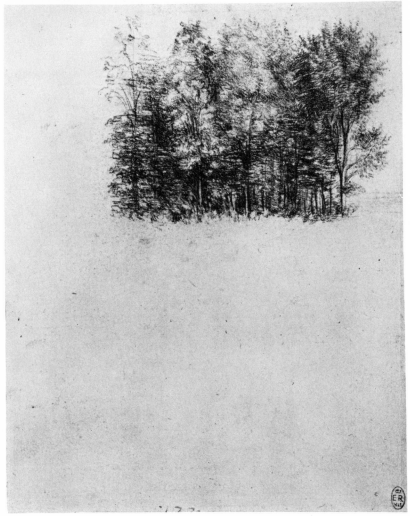

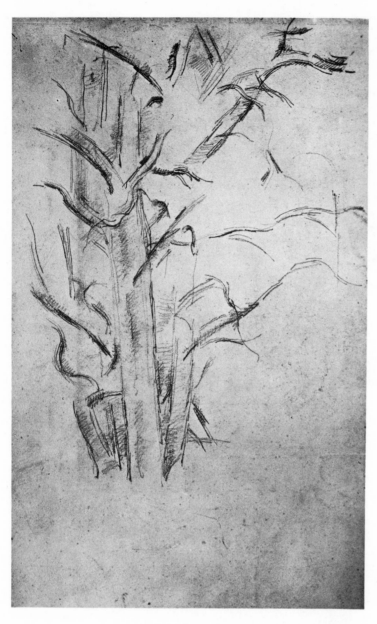

96 Paul Cézanne (1839–1906; French). *Sketch of a Tree*. Graphite pencil. Whereabouts unknown.

Volume is also defined in Cézanne's *Sketch of a Tree* [96], but instead of stressing a sculptural swelling as Leonardo did, Cézanne breaks up the volume of the tree by controlling the contours of its form, opening and closing them at will. Because of this fragmentation, the air around and between the volumes seems as fully modeled as the tree; that is, the empty space becomes as substantial as the object.

In Leonardo's drawing [95] the horizon is suggested by the lower edge of the dark mass, and the sky is revealed only between the top of the page and the upper branches of the trees. By contrast, in John Constable's *Study of Clouds* [97] the horizon hugs the very bottom of the space. Gravity is established at the lower right, where the darkest, clearest, heaviest masses rest. The artist counters this downward pressure by anchoring a large and broken-edged cloud mass to the opposite corner. Between these two opposing masses the amorphous cloud forms, weightless by designed contrast, glide freely in the space of the page.

Yet a third variation in the placement of a horizon is seen in Hercules Seghers' *Landscape with Churches* [98]. Here the horizon line is a fraction above the center, and the trees, constructed in irregular layers, recede gradually to this

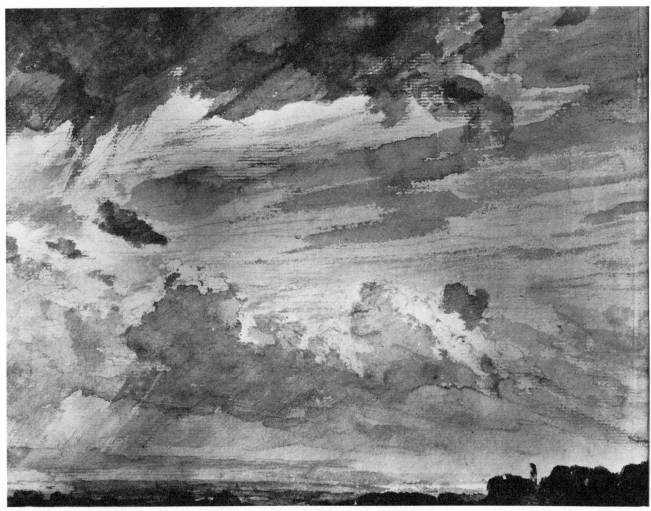

above: **97** John Constable (1776–1837; English). *Study of Clouds*. 1830. Graphite pencil and watercolor, 7½ × 9″ (19 × 23 cm). Victoria and Albert Museum, London (Crown copyright).

below: **98** Hercules Seghers (c. 1589–c. 1638; Dutch). *Landscape with Churches*. Black pencil with brown wash. Kunsthalle, Hamburg.

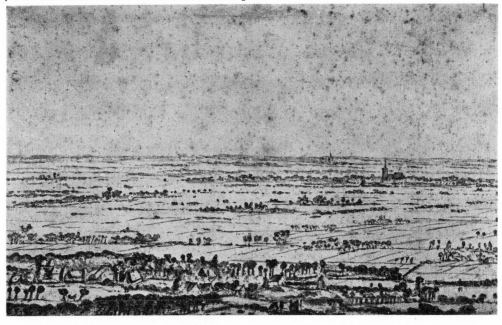

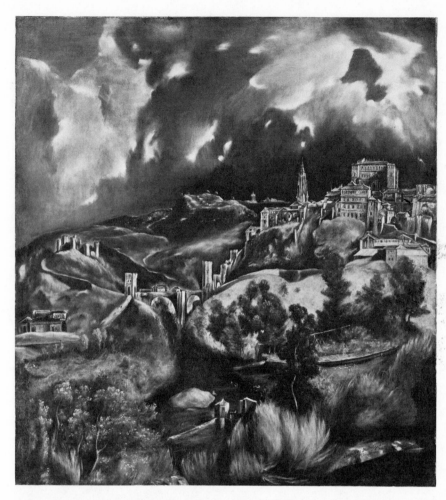

99 El Greco (1541–1614; Spanish [Cretan born]). *View of Toledo.* c. 1604–1614. Oil on canvas, 47¾ × 42¾" (121 × 109 cm). Metropolitan Museum of Art, New York (bequest of Mrs. H. O. Havemeyer, 1929; the H. O. Havemeyer Collection).

100 Claude Lorrain (1600–1682; French). *View of Saint Peter's, Rome, and the Castel Sant' Angelo.* Pen and brown wash, 4½ × 7¼" (12 × 19 cm). Teylers Museum, Haarlem.

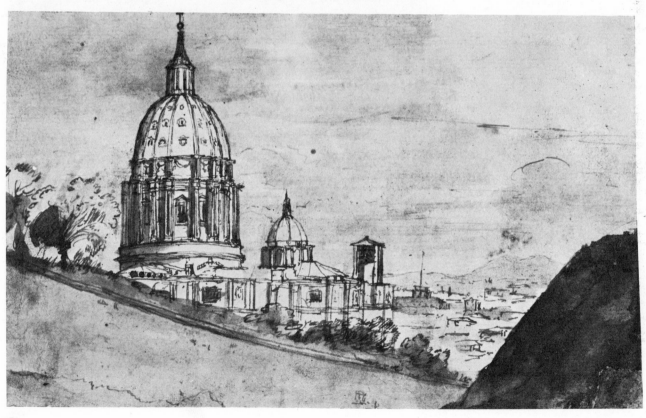

boundary. By controlling the amount of sky that is visible the artist constructs an open, pressureless space. But, as in the Constable drawing, the heavier weight at the bottom establishes gravity.

The location of the horizon in these three examples is not an accident. In each case the artist has made a calculated decision in order to provide the viewer with a particular visual experience.

In El Greco's *View of Toledo* [99], the rhythmic shapes that intertwine throughout the canvas eliminate the horizon as a prime focal point. Instead, planes move *through* the horizon to the light and dark masses in the sky. The dramatic clouds are engineered to give the illusion of moving over one's head, thus engulfing the spectator in the picture space.

Claude Lorrain's *View of Saint Peter's, Rome* [100] presents clearly drawn overlapping planes: the hill on the far right—the darkest, heaviest simple shape—is the closest. In the middle ground the wall with foliage on top clearly overlaps the dome and surrounding buildings. Finally with a few loose strokes we move into the background.

Another approach is used by Raoul Dufy in *Wheat* [101]. Dufy places large, casually spaced pen strokes in the foreground and lets the white of the page establish a frontal plane. He then gradually reduces the size of the strokes to lead the eye backward to the dominant mass of the trees, which vibrates with textural change. The sky behind serves as a backdrop, yet the whole space is quite shallow.

101 Raoul Dufy (1877–1953; French). *Wheat*. Pen and ink. Whereabouts unknown.

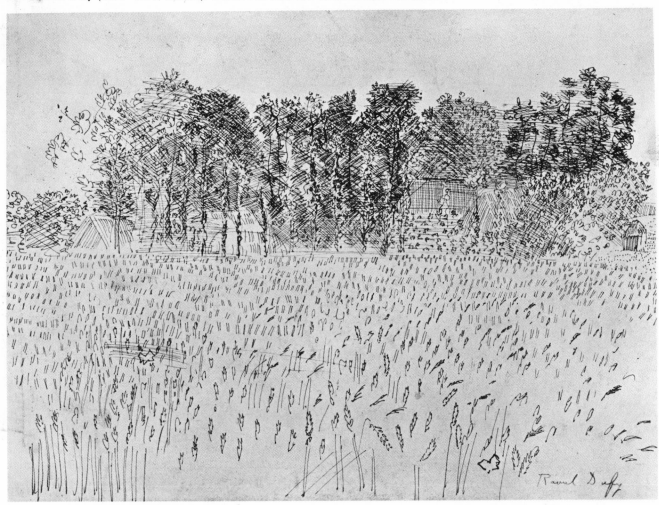

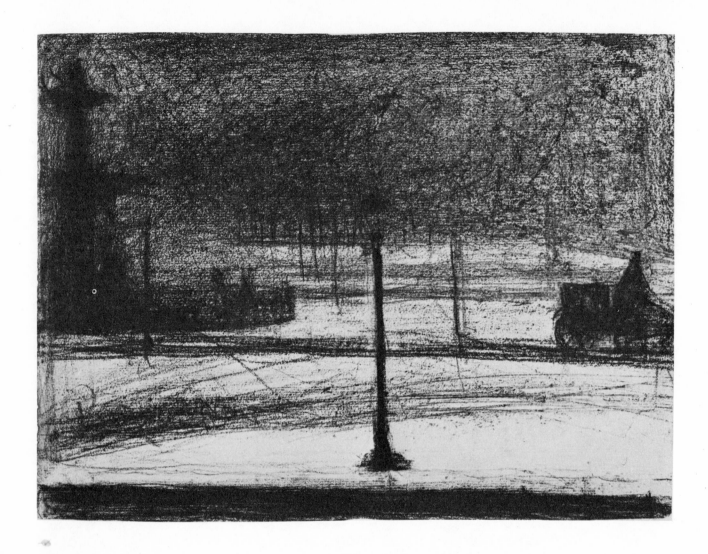

102 Georges Seurat
(1859–1891; French). *Place
de la Concorde, Winter.*
1882–1883. Conté crayon,
9⅛ × 12⅛″ (23 × 31 cm).
Solomon R. Guggenheim
Museum, New York.

Receding space can also be presented by dark frontal masses, as in Georges Seurat's conté drawing, *Place de la Concorde, Winter* [102]. The one dominant vertical is echoed in a casual rhythm throughout the work and is set in tension against the horizon line and other horizontals, thus giving order to the composition. This central vertical, then, is the focus that tightens and particularizes space.

In a pen-and-ink landscape by Claude Lorrain [103], trees and foliage press and stretch against the sides of the page to draw us into the large open ground before us. As the artist opens this space, he takes us on a rolling ride through the hillside—a beautiful, exhausting trip.

The space in *Bamboo* [104], a Japanese folding screen in six panels by Maruyama Okyo, is carried smoothly from one panel to another by the white interspaces between the vertical tree forms. These intervals lead the viewer's eye across the surface of the screen in a directed time sequence from left to right. Short, casually spaced, parallel brush strokes and their interspaces (panel one) become long, assertive strokes and are used to introduce scattered leaf forms in the second panel. In panel three the leaf strokes hover near the top of the composition only, but they assert themselves on the white space and the ghostlike trunk forms below them. The long slender verticals of the trees are echoed again in panel four, this time more delicately, and a few leaf forms are repeated at top and right. In panel five the dancing leaf strokes define a diagonal upward thrust, and the composition is brought to a close in a final spray of feathery strokes in the last of the panels.

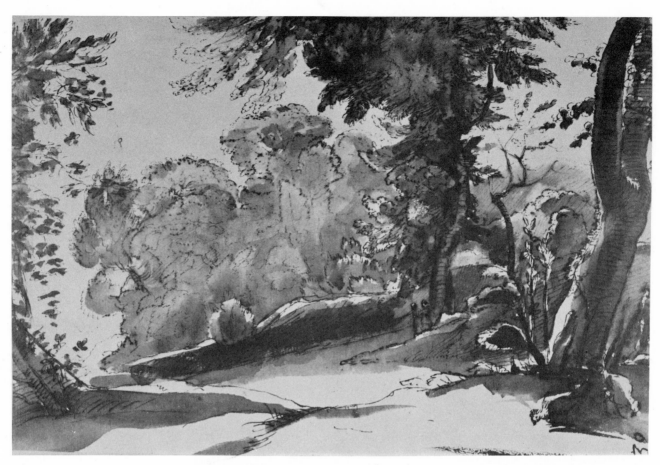

above: **103** Claude Lorrain (1600–1682; French). A *Clearing in a Wood*. 1640–1645. Pen and pale brown wash, 8¼ × 11⅝″ (21 × 30 cm). Teylers Museum, Haarlem.

below: **104** Maruyama Okyo (1733–1795; Japanese). *Bamboo*. Six-panel screen, brush and ink. Kyoto National Museum, Japan.

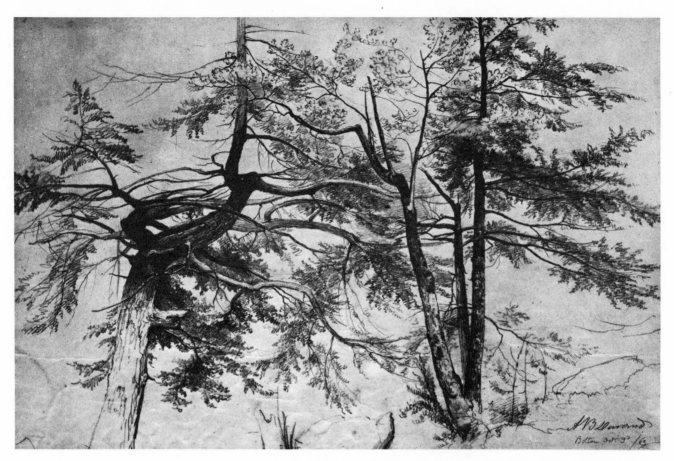

105 Asher B. Durand (1796–1886; American). *Bolton, Oct. 3/63.* 1863. Graphite pencil on paper, 16¾ × 22¾" (43 × 58 cm). New York Historical Society, New York.

A similar motif produces a different physical sensation in Figure 105. The main character, the tree on the left, spins widely through the space as a trio of trees on the right seem to be passive witnesses.

Student Response

The individual tree form

Pulling and stretching are evident in the pen drawing in Figure 106. An accompanying theme is found in the insistent intertwined forms that house volumetric projections. Notice that the artist hides human figures in the trees.

The drawing in Figure 107 presents a tree stripped of its surface bark, the extremities of which pull and stretch in a sculpturally conceived attitude toward form. Each section seems cut, welded, and fitted into place. The student, who is a sculptor, translates the object through his own form preferences.

Landscape space

Two attitudes, rhythm and volume, exist in the complex study in Figure 108. Branch forms entwine to create tension and interlocking rhythms in a space that is relatively shallow. On closer examination we discover one major articulated volume, the large tree form, which is studied as an individual structure, yet exists as part of the allover composition. This sculpted volume merges into the total rhythm of the work. The artist directs his viewer to see first the rhythms and then the sculptural volumes that compose them.

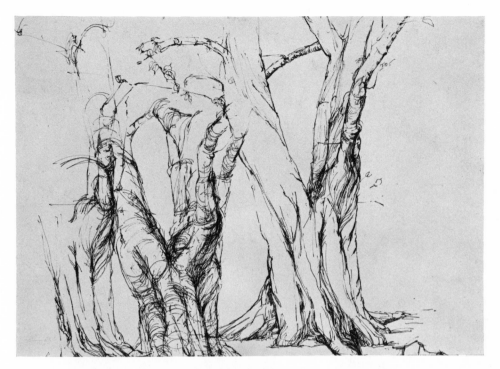

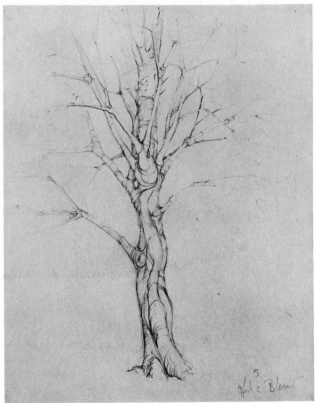

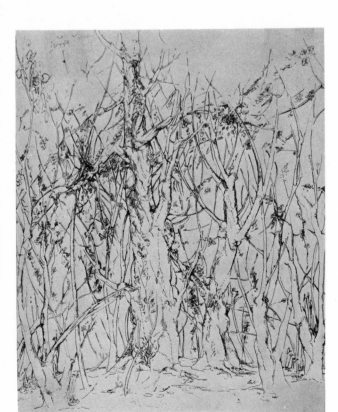

above: **106** Student drawing. *Trees Intertwined*. Pen and ink. Collection Yale University Art Gallery.

left: **107** Kent Bloomer. *Sculptural Tree*. 1960. Graphite pencil. Collection Yale University Art Gallery.

right: **108** Donald Lent. *Trees: Tension and Rhythm*. 1960. Pen and ink. Collection Yale University Art Gallery.

109 Robert Birmelin.
Landscape with Oblique Horizon.
1955. Pen and ink. Collection
Yale University Art Gallery.

The drawing in Figure 109 hurtles us directly into its space. The cut-off wall at the lower right, a sharp diagonal tipped into space, moves swiftly to the countertipped horizon. Its headlong rush is slowed only by dark, amorphous shadows. The high angle of vision, coupled with the tilted horizon and wall, throws us off balance, and to restore our equilibrium we must complete the motion in our minds. By projecting us directly into the composition, the artist makes us create a total environment beyond the picture.

The leaning diagonal tree in Figure 110 also pushes us into the drawing, but by comparison it is only a tentative projection. The form cut off at the top inhibits our passage, and, more important, the projection is immediately counterweighted by a crowding vertical mass. To reinforce this counterweight another vertical tree

form in the center of the composition further reduces the tension of the diagonal. The space itself presses toward the viewer, because the horizon is visible between the two vertical trees and thus seems closer than it should be. The total impression creates sufficient tension to fill the large white area at the right.

Unlike the last two examples, the wash drawing in Figure 111 makes us detached observers of a calm, panoramic scene. The brush strokes start almost halfway up the page and move back in a relatively tensionless retreat. The large

below: **110** Joanna Beall. *Landscape with Diagonal Tree.* 1956. Pen and ink. Yale University Art Gallery.

bottom: **111** John Frazer. *Panoramic Landscape.* 1959. Wash. Yale University Art Gallery.

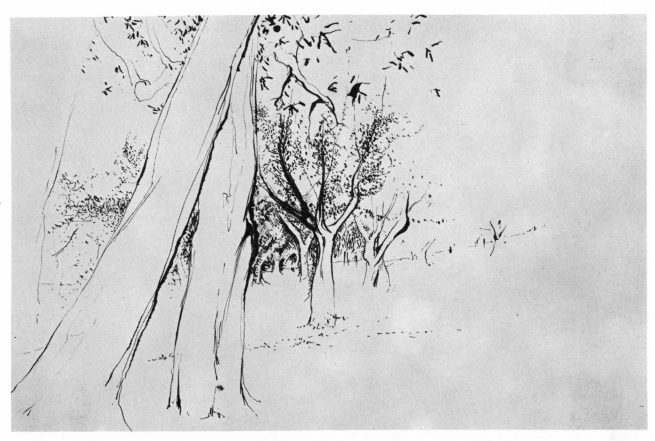

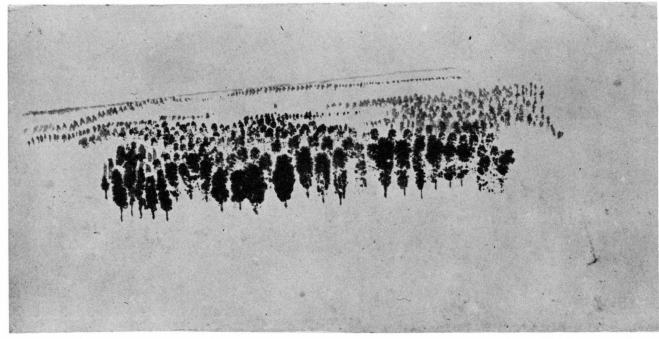

white area at the bottom serves as a frame and also keeps the viewer at a safe distance from the first row of black spots, the symbols of vegetation.

The broken light in Figure 112 derives from shapes (grayed, soft-edged washes) that at first sight do not organize themselves spatially. One notices first the geometric shapes—the dark triangles behind the tree at the extreme left and the same shape repeated on the right. Punctuating the space, they set up what we can term spatial stations, similar shapes answering one another, and the eye tends to group these corresponding shapes. Yet if we deliberately do not concentrate on the triangles, the all-over broken light appears as the main interest. Thus, by focusing differently the viewer may get two readings.

The light in Figure 113 creates space much as in Seurat's drawing [102, page 86]; that is, the shapes in the foreground recede logically but with no tension-producing diagonals. The simple shapes of the opposing horizontal and vertical masses carry the weight of the composition. The lines that define these masses are always exposed, even in the darkest areas. They are neither blurred nor rubbed. These lined planes produce a texture that is a by-product of constructing the masses, not a decorative afterthought. And the vibrating lines in turn become a light-giving force.

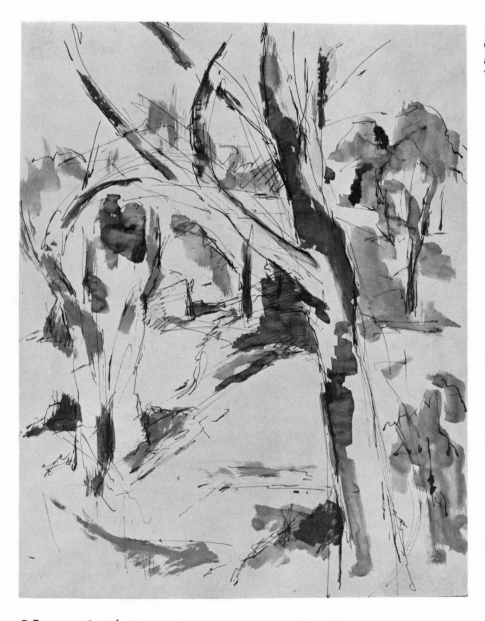

112 Barry Schactman. *Landscape Conceived Geometrically*. 1959. Pen and ink with wash. Collection Yale University Art Gallery.

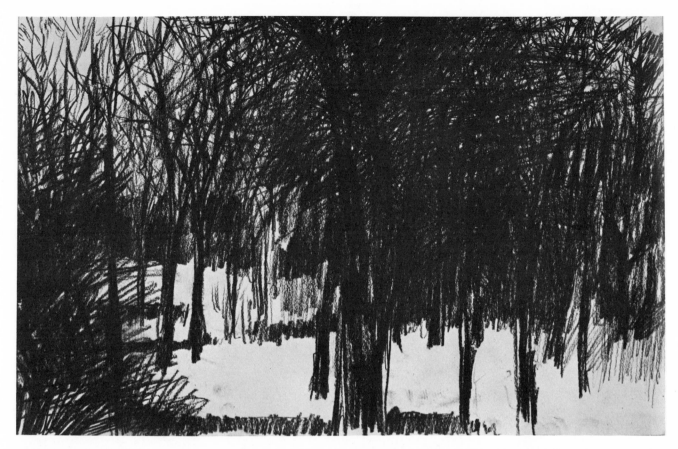

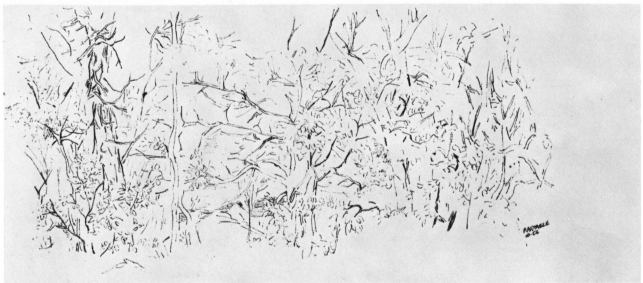

In the pen-and-ink drawing in Figure 114 the white of the paper is used to establish a long horizontal wall of light. This is punctuated with a delicate, economical calligraphy that does not violate the white but rather creates a dialogue with it. These strokes define a slow, tensionless dancing rhythm. The drawing was produced by a careful observation of linear patterns directly in front of the motif and the selection of these elements from an actual landscape. However, this does not necessarily mean that the artist must study nature directly to produce such a visual action. At the time this drawing was done, the student's paintings were quite abstract, but the kinds of rhythms and shapes he preferred in painting he purposely sought in nature and presented in drawing.

top: **113** Michael Chelminski. *Textured Landscape.* 1961. Black conté crayon. Collection Yale University Art Gallery.

above: **114** Joseph Raffael. *Landscape with Dancing Rhythm.* 1954. Pen and ink. Collection Yale University Art Gallery.

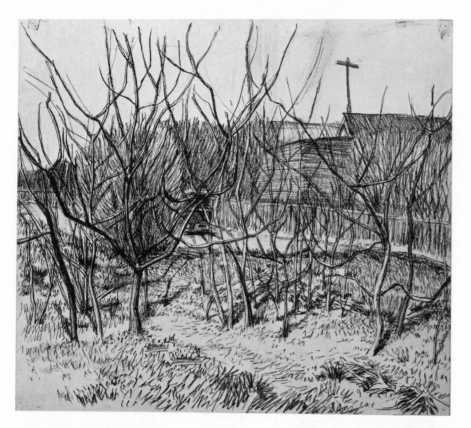

above: **115** Justus Pearson. *Group of Trees.* 1974. Conté crayon. Collection Yale University Art Gallery.

right: **116** Sam W. Dunlop. *Urban Landscape.* 1976. Ball-point pen. Collection Yale University Art Gallery.

117 Eric Sandgren. *Aerial Cityscape.*
1974. Ink wash. Collection Yale
University Art Gallery.

Figure 115 presents a drawing from the end of a long series concentrating on a group of trees. The earlier drawings, not reproduced, were individual studies of one or two trees; a second group dealt with the tonalities of the whole space. Gradually, as the series developed, the artist drew upon both attitudes simultaneously. Of course, either attitude is enough for a successful motif, but in this example the artist sought to explain each individual structure at the same time he controlled the total space and light.

Landscape need not be concerned solely with unspoiled nature. A whole new family of forms and space can be discovered in urban themes. In Figure 116 the figures are poised as if they are moving, yet they seem as firmly rooted as the buildings. The open strokes (in ball-point pen) are constantly moving, weaving a delicate light that engulfs and silences the steady parade of verticals representing lampposts, signposts, figures, and buildings. A contrasting example, the large wash drawing in Figure 117, is at first hard to read in reproduction. We are on the seventh floor looking down at a roof below; gradually we perceive automobiles at the top. The simple, abstracted masses were achieved after several tries at boiling down the actual shapes to their simplest geometric equivalents.

In summary, we must emphasize that each form should be studied from two points of view: the object regarded as a particular volumetric structure and the object used as a compositional tool for a particular spatial expression.

CHAPTER 6

Forms from Nature

For centuries artists have been bringing natural forms into the studio for study. As we might expect, the kind of study varies with the period and the individual artist. Renaissance artists studied twigs and rocks to re-create trees and mountains. Picasso and Braque used still-life subjects as a basis for the shallow, flickering planes of their cubist paintings, and artists ever since have often started from natural forms even when the final work is entirely abstract.

The idle sketching of these natural forms for the sake of play is not wholly worthless. But for this studio problem the uniqueness of the form, its quality of being an *actor* was stressed. The students were asked to assume an attitude toward the forms and to study their character and their volumetric structure as a basis for future interpretation. This was to include an analysis of the artistic use they could make of the forms, as well as a testing of themselves by drawing the forms from memory. The memory drawings are nearly always the best. Memory brings out the essential attitude; detail unnecessary for the particular attitude is simply forgotten. More important, memory drawing helps one realize that drawing is more what is known than what is seen.

Natural forms were introduced to reinforce the ideas expressed in Chapter 5—the creation of landscape space and the articulation of individual objects in

96

the landscape. However, the individual forms have become more complicated, presenting more issues and discouraging the development of a "one style, one medium" approach.

Plants

The difference between Antonio Pisano Pisanello's pen drawing of lily bulbs and other plants [118] and a rendering in an encyclopedia is that the latter is concerned with the characteristic contour-shape for the purpose of identification. Pisanello assumes another approach: the forms seem to be bending, moving, and blossoming sculpturally. The form at upper left, for example, flexes like metallic drapery. The flower form at the center of the page suggests the presence of a

118 Antonio Pisano Pisanello (1397–1455; Italian). *Studies of Flowers*. Pen and ink. Louvre, Paris.

bud moving up through the central cylindrical volume, spreading the protecting leaves apart. In short, each form on the page has an exaggerated characteristic.

Piet Mondrian keeps the focus on the top of the page, leaving the bottom two thirds empty. The heavy weighted edges of the flower make the whole form seem very heavy. How appropriate, then, to leave the bottom open to absorb this weight. The reproduction will not reveal the digging into the paper with pencil strokes at the rims of the curvilinear shapes. These lines seem incised seen in a side light. Yet, despite this emphasis, the central cylindrical volume of the flower is still suggested [119].

left: **119** Piet Mondrian (1872–1944; Dutch). *Chrysanthemum.* c. 1909. Black crayon, 26 × 10″ (66 × 26 cm). Collection Haags Gemeentemuseum, The Hague.

below: **120** Lawrence Fane (b. 1933; American). *Page from a Sketchbook.* 1974. Pen and ink. Courtesy the artist.

A page from a sculptor's notebook [120] lets us read a plant form in terms of the artist's own vocabulary. We witness a form in nature going through an evolution of invention: the plant is dissected, cut into sheets, and bent to suit the materials he has in mind. Materials and invention are placed in the service of a particular image.

The arrangement on the page is in itself expressive. The shapes and interspaces of Van Gogh's *Branches of Feather Hyacinth* [121] undulate in a slow rhythm across the picture space.

121 Vincent van Gogh (1853–1890; Dutch). *Branches of Feather Hyacinth*. 1890. Graphite pencil, reed pen, and brown ink, 16¼ × 12¼" (41 × 31 cm). National Museum Vincent van Gogh, Amsterdam.

above: **122** Sandra Whipple. *Drooping Flower Forms.* 1961. Pen and ink. Collection Yale University Art Gallery.

right: **123** Mark Strand. *Cylindrical Growth.* 1958. Pen and ink. Courtesy the artist.

Forms from Nature

Student Response

Figure 122 is a memory drawing completed in less than two hours. The attitude is evident: The broken-line contours of the form are obviously exaggerated; they droop, float, hang, twist, turn, and seem to die in slow motion in the center of the page. The continuous white border holds them in the space and at the same time serves as a barrier between the viewer and the scene.

The contours in Figure 123 (also a memory drawing) are predominantly open. The modeling was achieved by thinking of the forms as growing from the inside. Although the whole form has been constructed within a gently pointed, diagonal cylinder, the broken light hides this construction and suggests instead lazily spiraling forms. This broken light and the dark patterns are organized to move around the volume. We should note, too, that the light source is invented, not imitated.

Figure 124 (a memory drawing) is not merely a texture study. The texture is used in the service of both light and volume. It is part of the modeling, not a decorative effect. The very tiny pen strokes at the outer edges of each ball form vibrate and act upon the space around them, suggesting energy moving outward. Note, too, the larger white units in the centers, which gradually get smaller. Here again, the leftover white paper acts as a unit within the modeling, not as mere passive space surrounding a form.

124 Mark Strand. *Texture and Volume*. 1958. Pen and ink. Courtesy the artist.

left: **125** Joel Szasz. *Flowers: Space and Interspace.* 1957.
Pen and ink. Collection Yale University Art Gallery.

below: **126** Student drawing. *Patterns of Growth.* Pen and
ink. Collection Yale University Art Gallery.

The same medium—pen and ink—was used in Figure 125 as in the previous two drawings, yet the instrumentation is quite different. The hand seems to have moved simultaneously through the modeled forms and the surrounding space. There is a reciprocal action: both the forms and the space around them seem to be moving together at the same tempo.

The intersections studied in the drawing in Figure 126 attempt to articulate the way in which one form grows out of another. The irregular sequence of these articulations in space, coupled with the peculiar posture of the lower form, gives life to the idea. But the instrumentation here also contributes to the effect: The swiftly drawn pen lines darken sharply at the intersections for further dramatization.

In the pen-and-ink drawing in Figure 127 the individual form gives way to a study of how a group of forms interacts. The placement of the darkest mass establishes both gravity and the plane that is farthest back in space. (If we were to block out the dark, the page would seem to slide.) The pattern of light in the jars suggests solidity and is accomplished without enclosing the forms in firm contours. To achieve the diffuse light that pervades the drawing, it is essential that the lines be left open. If the jars had been firmly outlined, the vibrating, irregular forms of the plants would have taken on a different pattern of light and shadow.

127 Vaino Kola. *Interacting Flower Forms.* 1962. Pen and ink. Collection Yale University Art Gallery.

Roots

By examining root forms at close range we are permitted many kinds of investigation. For some the roots suggest distorted animal-like configurations; others are interested in the velocity at which the forms unexpectedly travel; still others examine the sculptured weights, thrusts, and counterthrusts into space. Yet no matter which attitude or combination of attitudes is stressed, one consideration should be borne in mind: All the extremities that were twisted into strange patterns underground derive from a central core, the trunk. This idea has a parallel in figure drawing, in which arms and legs move from the cylinder of the body.

Student Response

The first two drawings in this section suggest animal imagery. Figure 128 presents the roots in a dramatically staged composition. The actors—the large trunk and root forms—gesticulate at center stage. The lighting and ambiguous background add to this effect.

Each form in the wash drawing in Figure 129 applies weight and pressure on its neighbor in a reciprocal action. The complicated structure is interpreted as a heavy sculpture.

The brush drawing in Figure 130 focuses on speed. Specific details are articulated by the fast line that contains the modeled sections within its flow. Long, looping brush strokes play upon the carefully chosen details. The most detailed areas are the intersections where forms meet in tension.

128 Michael Economos. *Gesticulating Roots*. 1960. Pen and ink with wash. Collection Yale University Art Gallery.

above: **129** Michael Mazur. *Reciprocal Pressures*. 1960. Wash.
Collection Yale University Art Gallery.

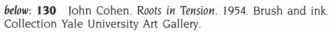
below: **130** John Cohen. *Roots in Tension*. 1954. Brush and ink.
Collection Yale University Art Gallery.

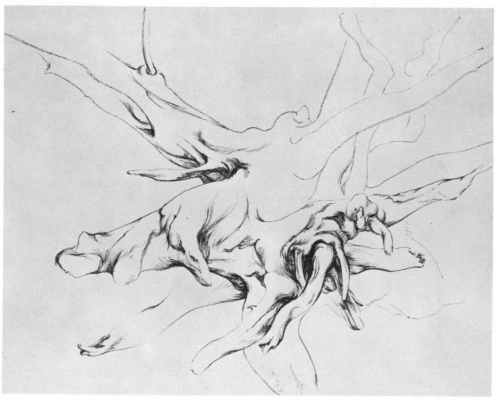

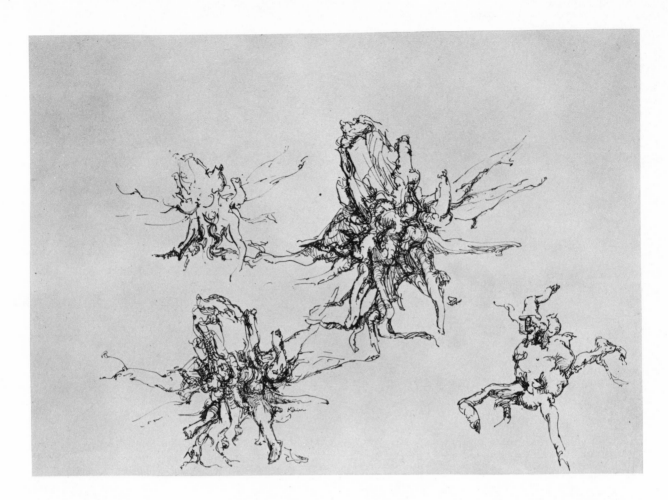

131 Louis Klein. *Postures of Roots.* 1959. Pen and ink. Collection Yale University Art Gallery.

The pen-and-ink drawing in Figure 131 uses techniques similar to those in Pisanello's work [118] to express the actions of roots by accenting their postures. It is a study of poses—the dancing movement of a whole form—and the artist repeats the action across the page to underscore the theme.

Rocks as Mountains

For this problem the students arranged rocks on a table to simulate mountain ranges. The study was related directly to the landscape space ideas that students were working on independently at the same time. The concept to be examined is scale and the problem of constructing large masses within that scale. A person must be considered as an ant in this context. If one merely imitates rock texture, the translation of scale is lost. The models—the rocks—are meant to suggest infinitely greater mass.

Pieter Bruegel presents his *Alpine Landscape* [132] from a high vantage point, so that we look over a level plain far below us toward craggy, tilting peaks of dizzying scale. The masses are simplified, but a winding road leads us partway into the picture, to a point opposite a deep, serpentine ravine in the distant slope. Some students prefer to construct a definite path, while others present the rock forms in a more generalized landscape environment.

Lucas van Valckenborch's *Rocks Overlooking a River* [133] is probably an invention, to judge by the regularity of the spacing and the rather too convenient view of buildings and trees at the upper left as well as the panorama on the right. The graded regularity in the construction of the mountains reinforces this impression. Although invented, the space conveys a strong sense of scale.

above: **132** Pieter Bruegel the Elder (1525/30–1569; Flemish). *Alpine Landscape.* Pen and ink. Louvre, Paris.

below: **133** Lucas van Valckenborch (1530/35–1597; Flemish). *Rocks Overlooking a River.* c. 1582. Pen and watercolor, 11½ × 17¼″ (29 × 44 cm). Louvre, Paris.

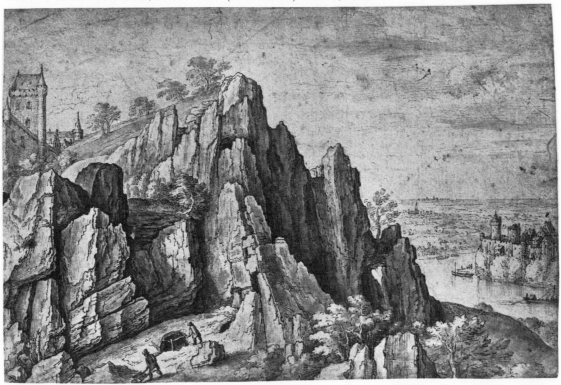

The proportions of the masses, plus subtle accents where forms overlap, give *The Coming of Autumn* by Hung-Jen [134] a feeling of tremendous scale. The winding S-shape trail along the bottom weaves a path that ultimately unites the road and mountain into a consistent rhythm. The vertical trees at lower left are repeated many times as a counterpoint to the rounded, solid mountains, and the tiny house directly behind the trees adds to the illusion of depth and scale.

134 Hung-Jen (1610–1663; Chinese). *The Coming of Autumn.* Hanging scroll, ink on paper, 4′⅛″ × 2′¾″ (1.22 × .63 m). Honolulu Academy of Arts (Wilhelmina Tenney Memorial Collection, 1955).

In Jacopo Bellini's *Baptism of Christ* [135] the sharp, angular mountains seem as architecturally designed as the broken column in the foreground and the castle at the top. As in the Chinese drawing, a sweeping curve leads us into space and winds to the summit. The whole creates a stage for the magnificent drama that unfolds in the center of the composition. The chorus of angels directly behind Christ is delicately and deliberately woven into the rock forms.

In Piero di Cosimo's drawing *Saint Jerome in a Landscape* [136, page 110] we have the opposite kind of structure: dark solid masses play against loose linear movements to produce domelike mountains. Careful scrutiny reveals bridges, buildings, and perhaps caves carved into these large, piled-up forms.

135 Jacopo Bellini
(c. 1400–1470; Italian).
Baptism of Christ. Pen and ink.
Louvre, Paris.

136 Piero di Cosimo (c. 1462–1521; Italian). *Saint Jerome in a Landscape*. Pencil, 24¾ × 21⅛″ (63 × 54 cm). Uffizi, Florence.

Student Response

The viewer's vantage point in Figure 137 is from a high peak overlooking another mountain form. We are invited to inspect the large masses, the possible paths for climbing, and hidden details. Like the crevices and points on the mountain, the tree on the central form contains a variety of rocklike details. These details are not strictly ornamental; they do not divorce themselves from the overall mass. The structure to the right, bare by comparison, still reveals all its steps and turns. The whole drawing is composed of gently tilting masses.

Unlike Figure 137, the drawing in Figure 138 (a memory drawing) invites the viewer's eye to rest on the heavy weights of the central plane. Having been forced to look at this dark, weighted mass, we discover within it a rhythmic, linear theme that moves through to the forms behind. The artist's skill in making us follow this path gives a particular sequence to the drawing.

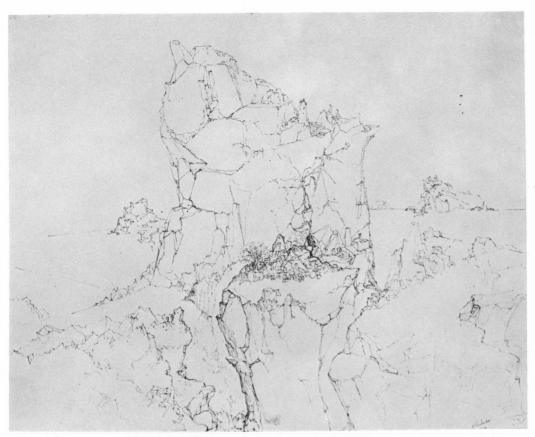

above: **137** Harry Keshian. *Mountains in the Distance.* 1955. Pen and ink. Collection Yale University Art Gallery.

below: **138** Jennette Lam. *Weighted Mountain Forms.* 1955. Pen and ink. Collection Yale University Art Gallery.

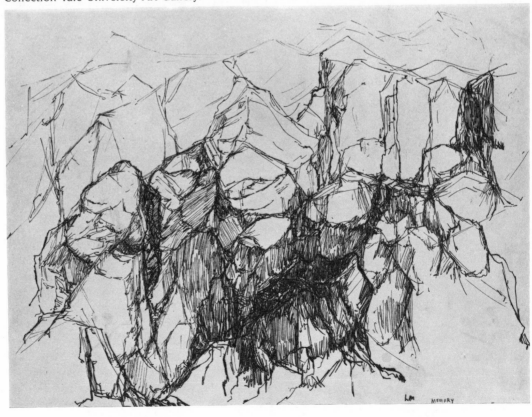

Rocks as Mountains 111

139 Robert Birmelin. *Fantastic Mountain Landscape*. 1954. Pen and ink.
Collection Yale University Art Gallery.

In the memory drawing in Figure 139 the shapes are mountainlike, yet they
appear to be more elastic, more organic than those of the previous drawings. We
seem to be very close to the forms, yet the undercut portion at the center pushes
sharply into the page. We have, therefore, more than one reading. We might
choose to take the trip underneath and then return to the main form, pressed
against a sky mass that seems to be advancing. This drawing, with its fantastically
conceived shapes, provides the viewer with a great number of visual actions and
counteractions.

CHAPTER 7

Interiors
and Objects

Interiors

The artist's reaction to human environments—the settings in which we spend much of our lives—has been a popular subject for centuries. The character of a particular place obliges the artist to perceive definite relationships of scale and light that in some ways parallel landscape space. For example, it is a common error to identify individual objects at the expense of a total spatial organization. But architectural interiors and the inanimate objects that fill them are obviously constructed in different ways. The objects tend to be sharp-edged and geometric, and the direction of light falling on the objects may not be clear.

The work of beginners underlines these problems. Student artists tend to make every object in an environment the subject of a separate portrait, instead of constructing the whole space and forcing the objects to articulate it.

Van Gogh's reed pen-and-ink *Bedroom at Arles* [140, page 114] is composed of furniture and a strongly patterned floor. It is this strong visual vibration of pattern that prevents the description of bed, chairs, and objects from coming into individual focus. The rhythmic lines weaving the floor space are echoed in the objects and make us see the whole drawing simultaneously.

113

above: **140** Vincent van Gogh (1853–1890; Dutch). *Bedroom at Arles*. 1888. Pen and ink, 5⅛ × 8¼″ (13 × 21 cm). National Museum Vincent van Gogh, Amsterdam.

below: **141** Giovanni Battista Piranesi (1720–1778; Italian). *Architectural Fantasy.* c. 1755. Pen and ink with brown wash over red chalk, 14⅝ × 20¼″ (37 × 51 cm). Ashmolean Museum, Oxford.

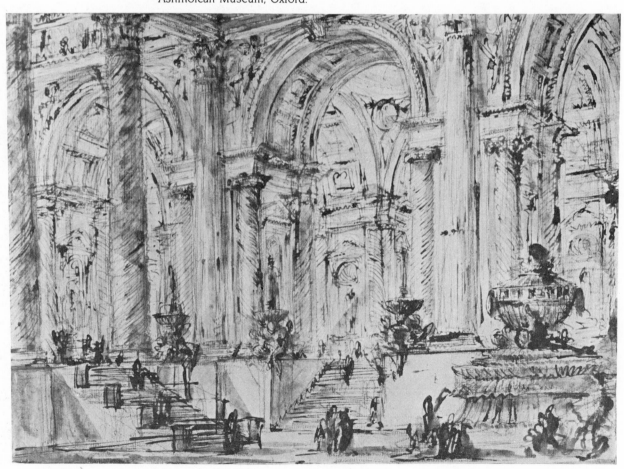

Red chalk (employed initially as a layout) combines with a sepia wash to give Piranesi's architectural fantasy a red-gold glow [141]. The light thus produced softens all the edges and unifies the whole composition. When the drawing is reproduced in black and white, this softening effect shows up as a much harsher series of staccato rhythms, and this distorts the artist's intention. The darkest tones appear only in the lower portion of the drawing—the angular stairs at the left and the various figure groups. These darks give a weight to the floor plane and gradually blend into the lighter, airier washes at the top. The viewer is directed to see first the round form in the lower right, because it stands out more sharply against its background. This form sets up the comparative scale in the overall composition by establishing its relationship to the human figures.

Student Response

The students began this assignment by drawing their own rooms after working in class on very complicated, room-filling still lifes in which the objects were placed haphazardly in all parts of the studio. They were asked not to limit themselves to one or two objects in a given spatial position but to choose objects from the whole room and to invent relationships for them. The choice of media and tools is important, since each student must search for the medium and the tool to express an individual attitude.

The drawing in Figure 142 resembles a Dutch interior in its setting and balance. The viewer is a detached spectator, removed from the light that defines the space and its contents. The vague figure and objects in the strong light are delib-

142 Vaino Kola. *Lighted Interior.* 1960. Pen and ink with wash. Collection Yale University Art Gallery.

erately kept at a distance. Objects balanced on either side of the door are kept in
darkness, and they seem to remove us even farther from the light, for we cannot
recognize them although they are relatively close. Forms are suggested, never
described, so that we cannot easily become involved with particulars. Our interest
is in the arrangement of the light and dark forms in a unified spatial field.

Figure 143 gives quite the opposite effect. We are thrust directly into a space
that is not fully explained, and thus we are forced to complete the environment on
our own and to imagine the source of light. The artist gives us several clues to the
nature of our surroundings. We know, for example, that we are directly behind a

studio easel that, although dramatically cut off at the top, clearly reveals its structure. (The holes at the bottom of the easel, which permit the artist to move it up and down, are easily distinguishable.) A low table or stool at left center is also clear. But the remaining studio furniture and the figure of the artist, whose elbow appears in the strongest light at left, are only hinted at. We are thus engulfed in a dramatically lit space with ambiguous contents. We are forced to construct a whole environment from a few clearly defined forms and the sketchy details that surround them.

In Figure 144 the exaggerated diagonal thrust of the ceiling plane, supported by heavy parallel lines describing pipes, forces us into the low-ceilinged room. Most of the objects in this interior are seen only in profile, and the pattern of darks between these profiles is concentrated in the back-center. Here the dark areas act not only to create "noise" in this silent room but also to set up movements and countermovements. Also, and equally important, they define the plane that is farthest back in space. The naked bulb is set apart from the other elements in the room. It makes us want to lower our heads, again emphasizing the low ceiling. The light bulb adds a contrapuntal note to the rest of the composition and, to some extent, a humorous touch.

In Figure 145 studio furniture—drawing bench, canvas stretcher, portfolios—exists eerily in the half light. It is the light working on the objects, expressively placed at connecting and opposing angles and set in an even-paced tempo, that creates and controls the space. Notice how the only large pure white is on the farthest vertical plane and how it sets up a dialogue with the white on top of the drawing bench in the center of the drawing.

145 Eric Sandgren. *Studio Interior*. 1973. Pencil. Collection Yale University Art Gallery.

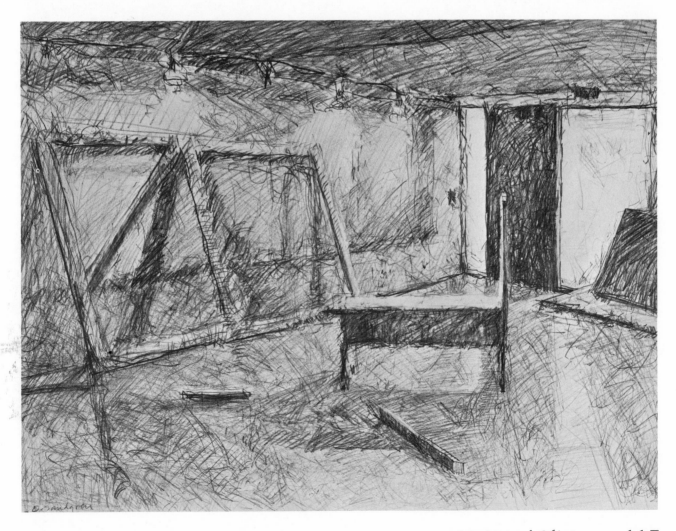

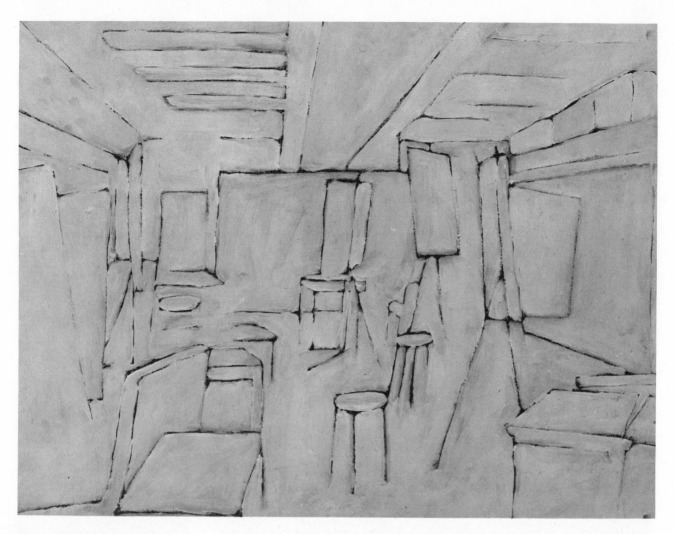

146 Frank Moore. *The Studio in White Light*. 1973. Black and white acrylic paint. Collection Yale University Art Gallery.

Studio classroom furniture is also presented in Figure 146. Thin, delicately poised broken lines are surrounded by pervasive white light that seems to grow constantly stronger, until it melts the weight of the objects portrayed. These tenuous lines are produced in reverse: the paper was first coated with black acrylic paint, then white was applied over this undercoat; the black lines are thus the "leftovers," what the artist left untouched.

Interiors: Indoor-Outdoor Spaces

Draftsmen and painters always have been attracted to themes that combine simultaneously inside and outside spaces. In a drawing by Etienne de Martellange [147] we are outside moving in and out of entrances and exits. We are at the same time inside and outside, on a complicated hill of spatial choices.

Student Response

In Figure 148 we find ourselves in a mysteriously lit passage. We feel crowded by the corner of the wall moving slowly out at us, yet we want to catch a glimpse of the view from the windows. Both effects reinforce an overall tension.

The geometric shapes created by the strong light [149, page 120] on the interior's floor and table are echoed by the window frame and the buildings on the outside. This geometric interplay is the visual engineering that unifies the theme.

118 *Interiors and Objects*

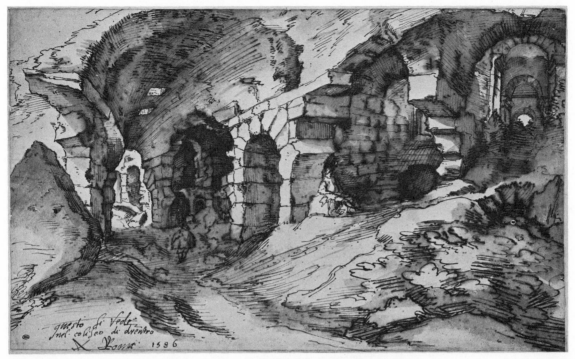

above: **147** Etienne de Martellange (1568–1641; French). *Galleria Interna del Colosseo.*
1586. Pen and brown watercolor ink with a trace of bluish watercolor, 10⅝ × 17⅛"
(27 × 44 cm). Louvre, Paris.

below: **148** Karen Sideman. *Corner in a Passageway.* 1975. Charcoal. Collection Yale
University Art Gallery.

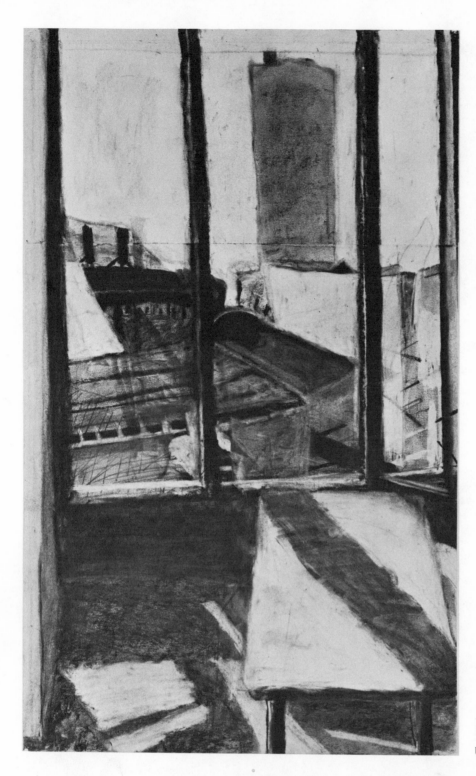

149 Michael Monahan. *Shadows*. 1979. Charcoal. Collection Yale University School of Art.

The vibrant texture of the marks produces an allover light that knits the figure to the spatial environment [150]. In Figure 151 we witness interpenetrating geometric planes whose contoured edges are alternately closed and open. The open edges let the outside air in. Here the verticals of the window frames are echoed by the table legs; the still-life objects echo rounded shapes of shoulders and heads. Within this interplay of verticality and roundness the legs extend diagonally, meeting in a suggested triangular extension. Inside and outside are contained in this orchestration. (For another interpretation of this motif see Figures 85 and 86, page 66.)

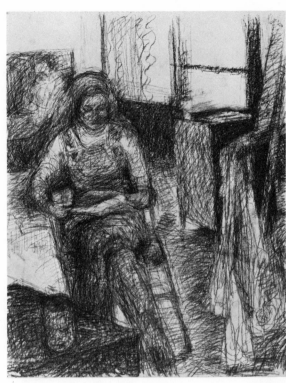

left: **150** Gail Rothschild. *Figure in Interior*. 1980. Charcoal pencil. Collection Yale University School of Art.

below: **151** Jesse Dominguez. *Figures Against Window*. 1981. Graphite pencil. Collection Yale University School of Art.

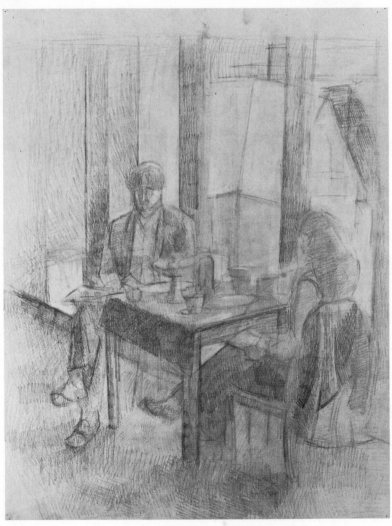

Objects: Shoes and Gloves

The drawing of common objects requires more than journalistic thinking; mere description of a shoe does not probe the layers of individual perception. In its simplest identity the shoe is a unique form mirroring its wearer. But as a subject for artistic expression its uses are much broader. Both Van Gogh and Marsden Hartley saw the shoe as a symbol of poverty and work [152, 153].

Even when shoes are presented as portraits of their owners, we must also pay attention to the structure of the shoe itself—which, after all, is designed to fit a foot with individual toes. In addition, the distinctive shapes and structure of the shoe may be exaggerated to stress its character or that of its owner. As is true with any object, these attitudes do not come from merely looking at the shoe. What we know, what we think and feel, colors our reactions. The artist's experience is more important than an effort to describe an object faithfully. The object—in this case the shoe—should be translated and composed in visual terms, but never in caricature.

Student Response

For this problem the students first attempted individual portraits of shoes; later, the shoes were set up in groups on the floor and works emphasizing the composition of the whole picture space were undertaken. The latter became, as it were, shoe landscapes because of the placement of shoes on the floor below eye level. The space is equivalent to a panoramic vista.

The football shoe in Figure 154 becomes a very aggressive form, filling the whole page. The instrumentation—brusque, almost crude, with many erased

152 Vincent van Gogh (1853–1890; Dutch). *Boots with Laces.* 1886. Oil on canvas, 14⅞ × 18″ (38 × 46 cm). National Museum Vincent van Gogh, Amsterdam.

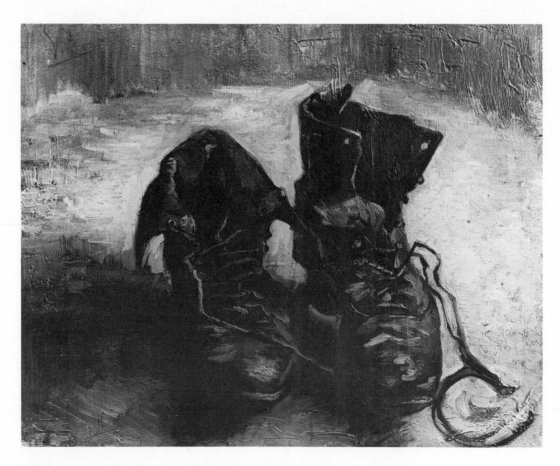

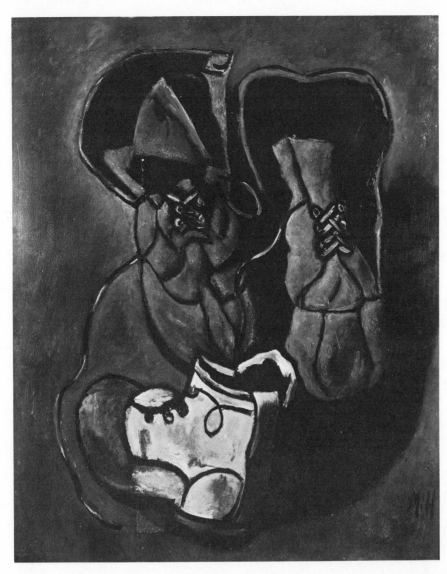

left: **153** Marsden Hartley (1887–1943; American). *Boots*. 1941. Oil on gesso on composition board, 28⅛ × 22¼" (71 × 56 cm). Museum of Modern Art, New York (purchase).

below: **154** Eugene Baguskus. *Football Shoe*. 1962. Graphite pencil. Collection Yale University Art Gallery.

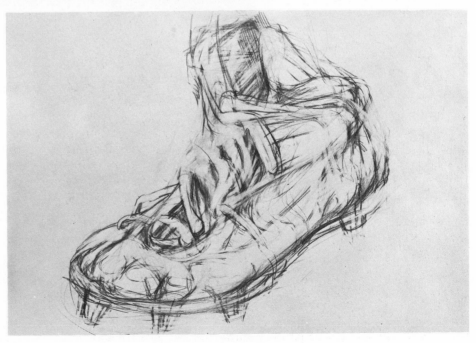

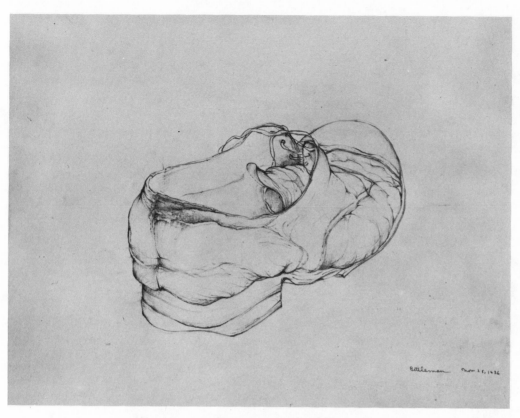

above: **155** Arnold Bittleman. *Slouching Shoe*. 1955. Graphite pencil. Collection Yale University Art Gallery.

below: **156** Student drawing. *Bulging Sneaker*. Pen and ink. Collection Yale University Art Gallery.

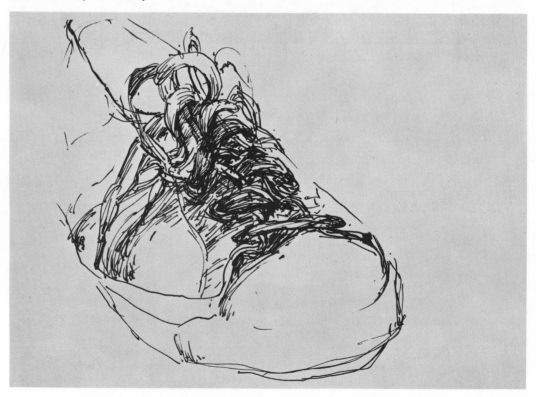

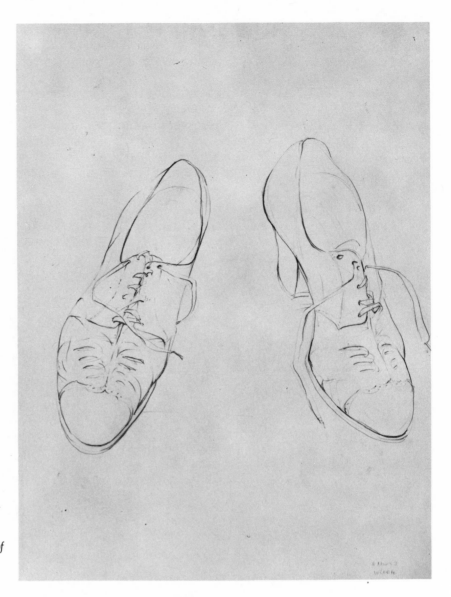

157 William Leete. *Shoes: Expression of Character*. 1953. Graphite pencil. Collection Yale University Art Gallery.

lines—heightens the forcefulness and underlines the artist's expression. This meeting of handwriting and scale produces a compelling portrait. Note that the toes of the football player are strongly suggested.

A quite different attitude is evident in Figure 155. The shoe is isolated in the center of the page like a specimen under a microscope, and layers of construction and destruction acting on one another are clinically examined. The tongue, the eyelets, the counter, and the stitching are carefully detailed. These details are subordinate to the slouching posture of the entire shoe, which absorbs them into its overall quality.

Figures 156 and 157 are both good examples of the expressive use of media and the way in which a distinctive handwriting intensifies a particular attitude.

In Figure 156 the broad, rough scratching with a blunt pen point focuses on the shoelaces of the sneaker. The pen strokes thus underline the character of the model. The wide sneaker bulges toward the viewer and, with the insistent textured strokes, place the viewer face to face with the actor. The restricted space adds to its dimension.

Figure 157 is by contrast a cool whisper in keeping with the fragility of the model. This pair of shoes, purposely elongated to exaggerate their character, creates a distinct portrait.

We do not readily recognize the sandals in Figure 158, for the student does not let us get back far enough to focus. She fills the whole vertical picture surface with a strong rhythmic texture—crisscross strokes that repeat the structure of the shoes.

A single shoe has been moved and placed in characteristic poses to form a rhythmic quartet in Figure 159. The peculiar gestures of the army boot provided the impetus for the study, but the overriding theme is in the gestures or postures that act together. It is the total composition that makes the portrait what it is. There is reciprocal action: the shoes dance together, and these dancing rhythms reorganize the content and transform it.

158 Julia Glass. *Pair of Sandals.* 1975. Pen and ink. Collection Yale University Art Gallery.

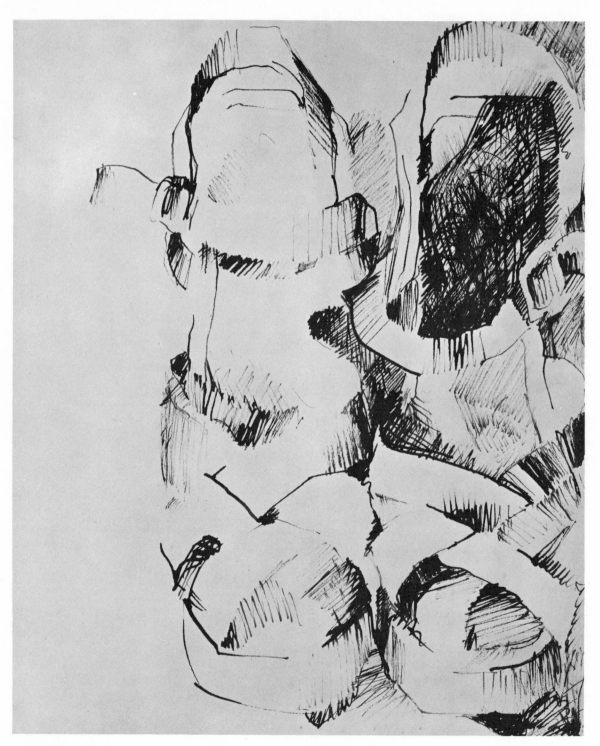

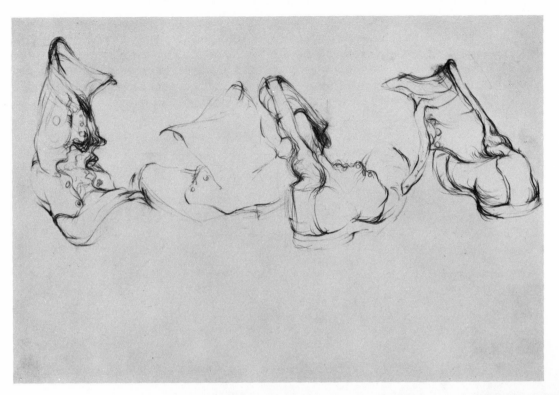

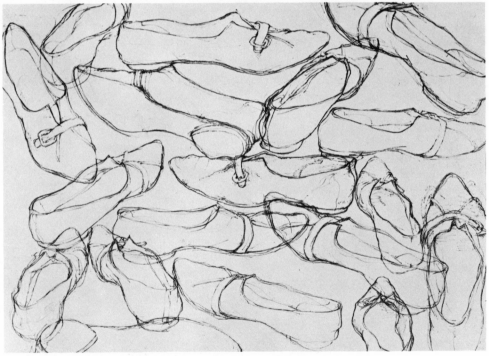

One pair of shoes was the initial subject for the study in Figure 160. The artist used her own shoes, rearranged them in several combinations, and examined their shapes from every possible angle. However, description of a particular form is only the beginning of this study. The artist rendered the shoes transparent and placed one shape over another to create an allover floating arrangement. After viewing the pattern, we may inspect each individual shape, and these well-observed studies are interesting forms in themselves. But the specific character of the shoe must give way finally to the total impact of the drawing, the expression of overlapping planes that make up the whole composition.

top: **159** John Cohen. *Shoe Quartet.* 1954. Charcoal pencil. Collection Yale University Art Gallery.

above: **160** Sandra Whipple. *Overlapping Shoe Forms.* 1961. Bamboo pen. Collection Yale University Art Gallery.

In two studies of gloves [161, 162] the instrumentation carries the mood. Textured lines model the leather drapery, and these surface marks become welded to the expressive gesture of the forms. In Figure 161 the emphasis is on the juncture of finger and thumb. The gestures of fingers, which appear to be frozen in the glove, are violent compared to the pose in Figure 162, in which all the fingers are gently at rest. In the latter case the modeling is appropriately delicate to enhance the intended mood.

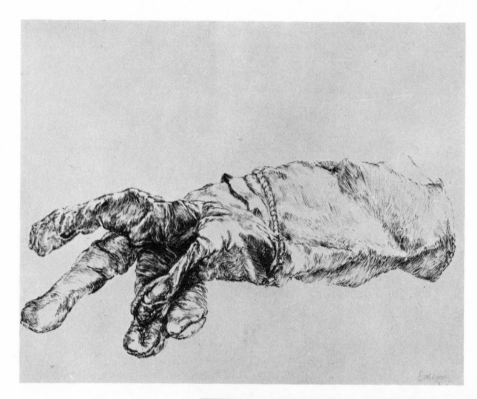

left: **161** Charles Emerson. *Menacing Glove Form*. 1962. Pen and ink. Collection Yale University Art Gallery.

below: **162** Charles Emerson. *Glove in Repose*. 1962. Pen and ink. Collection Yale University Art Gallery.

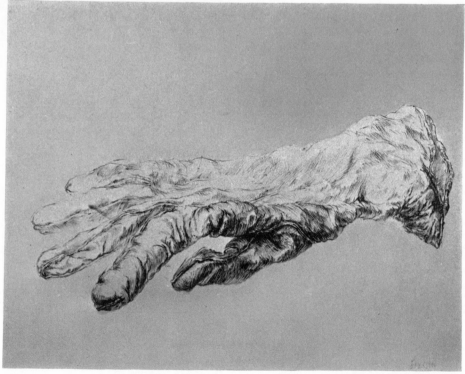

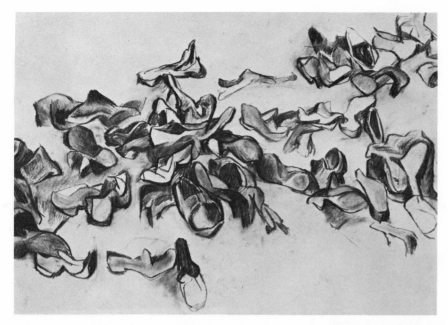

above: **163** Student drawing. *Organic Shoe Forms.*
Charcoal. Collection Yale University Art Gallery.

right: **164** Michael Mazur. *Shoe Landscape.* 1960.
Charcoal. Collection Yale University Art Gallery.

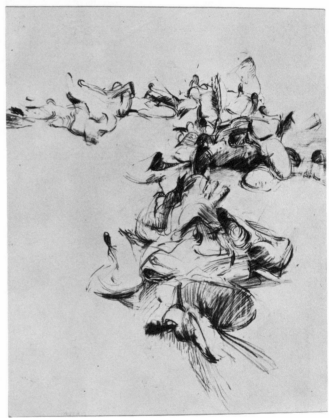

The composition of the whole page is again the overriding consideration in Figures 163 and 164. The shoes are examined not as individual figures but as compositional elements. In Figure 163 the forms act together organically: they crowd, move and rush through the composition. The broad use of the charcoal gives weight to the forms and slows down their movement, while the empty spaces exert pressure on the blocklike units and help define the allover space. In Figure 164 the artist exaggerates the angle of vision. The viewer is high above the floor, and the quick linear charcoal strokes give us an almost impressionistic view of the shoe landscape.

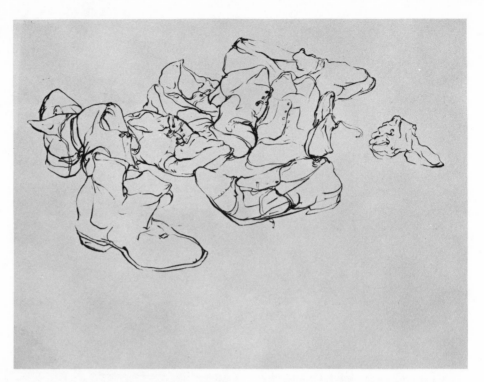

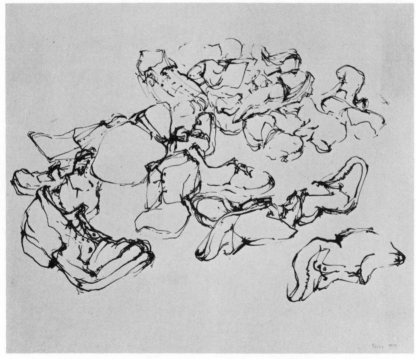

above: **165** Stephanie Kieffer. *Group Portrait of Shoes.* 1957. Brush and ink. Collection Yale University Art Gallery.

left: **166** Deborah Boxer. *Undefined Shoe Forms.* 1959. Brush and ink. Collection Yale University Art Gallery.

The final drawings in this section emphasize line. Figures 165 and 166 are brush drawings. Each exhibits an individual handwriting. It is true that the medium tends toward certain characteristics, but the individual's natural touch modifies the effect of the tool and the material.

In Figure 165 a fine line describes each shoe, yet the group portrait is dominant. In Figure 166 heavier brush strokes identify clearly only the front row of shoes, yet the markings of the brush line, from thick to thin, define overlapping shapes that convey the essence of the shoe form without resorting to obvious description.

Objects: The Paper Bag

As students gain confidence and skill, the subjects presented for study become increasingly complicated. In this problem the varied structure of the forms precludes a single technical approach for, with each new form, the student must search for a new means of instrumentation and perhaps a different drawing instrument.

Paper bags are among the most difficult objects to articulate because of their complicated tracery of folds. Simply to transcribe the folds as they appear produces either bland illustration or confusing focal points. The hierarchy of folds, major and minor, must be perceived and articulated clearly in relation to the overall structure of the bag and its function—to contain.

This problem suggests a study of texture and surface as well as concepts of drapery study. The quality of paper and the way its wrinkles tend to spread and move over the whole surface are important to the structure and must be carefully interpreted in these terms. Abrupt dangling tool marks might express the surface texture of the bag, but they tend to divorce themselves from the architectural configuration of the folds. In short, drawing a paper bag involves perception in the service of concepts; what is known about the object controls what is seen.

The problems involved in articulating the folds of a paper bag are similar to those encountered in drapery studies. Often, the whole character of a drawing will depend upon the way drapery is handled. In keeping with the concepts of the time, the drapery in a fifteenth-century pen-and-ink drawing [167] is hard and

167 Unknown German Master. *Christ in the Temple*. c. 1460–1480. Pen and ink and gray wash, 9⅞ × 7″ (25 × 18 cm). Staatliche Kunstsammlungen, Weimar, East Germany.

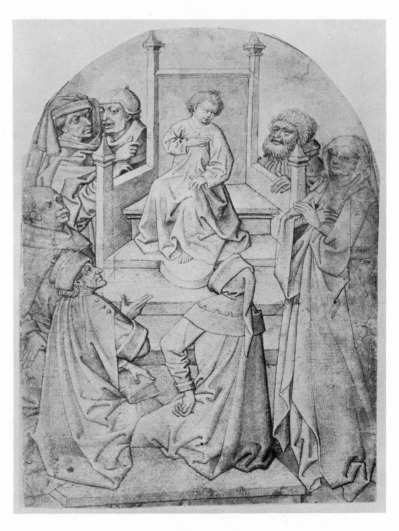

brittle, more like stone sculpture than pliant cloth. The folds, in fact, behave like paper: each crease, minor and major, is interlocked in a chain reaction throughout the whole garment. Each figure's expression is dependent upon the amount of tension in the arrangement of its garments, the way in which they are draped. In fact, each figure in the composition is essentially represented, except for the heads, in terms of drapery. In the two figures closest to the foreground the angular folds in the cloth join the figures together so that they appear as one form. The two figures at upper left are similarly joined, this time in circular movements. This union of forms heightens the singularity of the Christ figure, but even here the artist is tempted to knit the skirt of Christ to the hood of the figure below. A system of interlocking forms changes pace and emphasis as focus shifts from one form to another and keeps the viewer's eye moving at the artist's direction.

Student Response

As with the shoes, we began by studying individual bags and then moved to group studies. Memory drawings were attempted in this exercise as well. In the group studies students were advised not to limit themselves to an established arrangement. Instead, they were asked to invent their own arrangements, picking individual forms from different positions and constructing the total composition according to their needs.

In Figure 168, a charcoal pencil drawing, the bag is posed in center stage and is rendered in terms of light and dark values. When viewed from a distance the strokes of charcoal seem to blend to produce a slick surface, but at close range

left: **168** Edward Kozlowski. *Charcoal Study.* 1954. Charcoal pencil. Collection Yale University Art Gallery.

below: **169** Roy Superior. *Structure of a Paper Bag.* 1961. Graphite pencil. Collection Yale University Art Gallery.

170 Sylvia Reid. *The Opening of a Bag.*
1954. Graphite pencil. Collection Yale
University Art Gallery.

each thin stroke is evident. This surface treatment, which is difficult to reproduce, gives a light glow to the original. The soft and hard edges have an added life. This drawing, which seems almost mechanical, is deliberately representational. However, it can be criticized from another viewpoint; it leaves nothing to the imagination of the viewer. It reminds one of the work of portrait painters who carefully delineate every eyelash, only to lose our interest. A more subtle approach is taken by such masters as Rembrandt, who suggest without clearly describing, thus demanding participation from the viewer.

The author of the pencil drawing in Figure 169 took apart a paper bag and flattened it into one sheet to study its structure. The information he acquired is obvious in this clearly focused study of the bottom and side of a bag. He selects this attitude and houses it in the emphasis on sharply turning planes. This preconceived attitude expresses, too, his own visual reactions to the form.

Similarly, in Figure 170 one corner of the mouth of the bag is in sharp focus. The detailed modeling in this area gradually slips from tone to line. We can see that the subject of the drawing is not the bag itself, but the *opening* of the bag. The remainder of the form acts solely as a support and is of secondary interest.

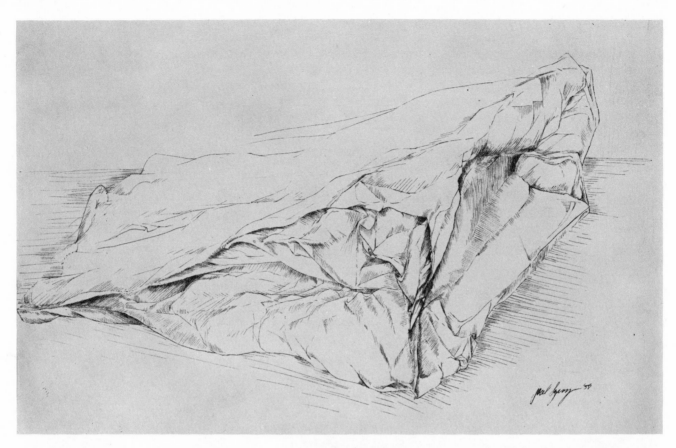

above: **171** Joel Szasz. *Flowing Surface*. 1958.
Pen and ink. Collection Yale University Art
Gallery.

right: **172** John E. Devine. *Valley of Folds*.
1966. Graphite pencil. Collection Yale
University Art Gallery.

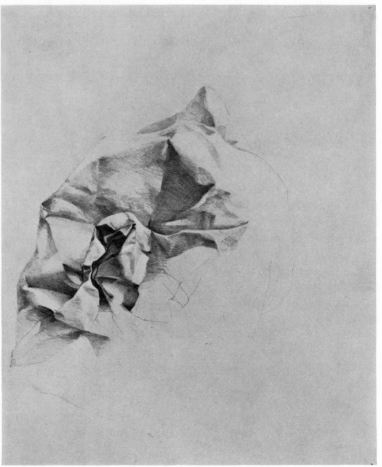

Delicate pen lines in Figure 171 encompass the entire form of the bag. Here the interest is in the flow of the surface, yet the underlying structural character of the container is defined within the free-flowing lines. The corner, which is held in focus, preserves the identity of the object.

In Figure 172 the bag is transformed into a sharply punctuated baroque valley of folds. The drama suggested by a particular paper bag becomes the subject of the study. The shape of the bag itself, lost in the heightened expression, is of lesser importance.

The two drawings in Figure 173 use the blocklike shapes of bags only as the suggestion for a composition. The actual subject of the drawings is the flow of weights and counterweights, tipping and moving diagonally up the page. These masses tumble and finally collapse against the back plane, and this crowding in the background establishes gravity. A second look shows the forms moving in reverse toward the viewer. We have both readings, depending on where we choose to focus.

173 Susan Mangam. *Weights and Counterweights.* c. 1959. Pen and ink with wash. Collection Yale University Art Gallery.

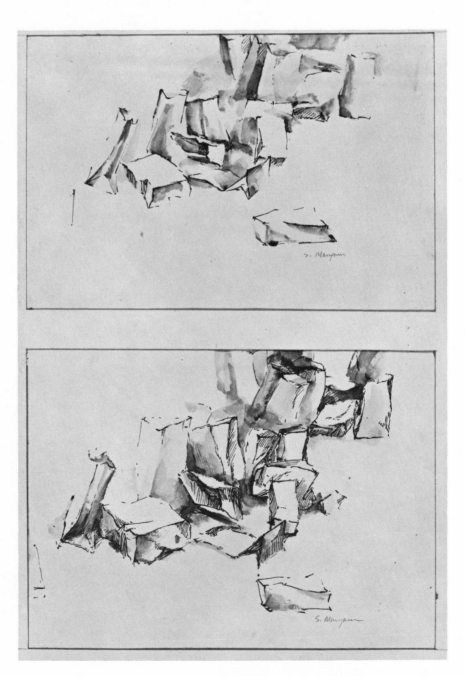

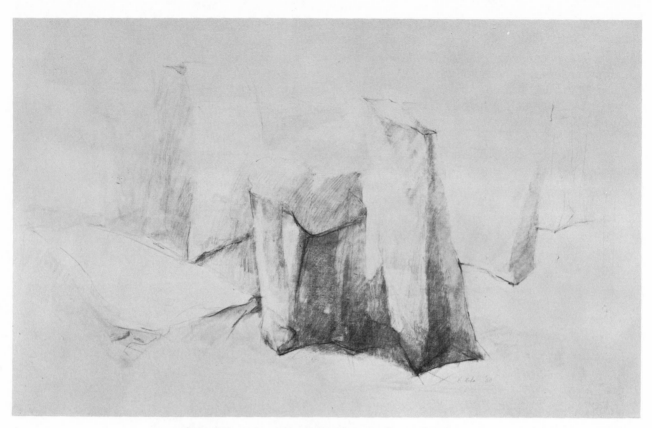

above: **174** Vaino Kola. *Paper Bags: Architectural Form.* 1960. Graphite pencil. Collection Yale University Art Gallery.

below: **175** Donald Lent. *Bags as Mountains.* 1960. Graphite pencil with wash. Collection Yale University Art Gallery.

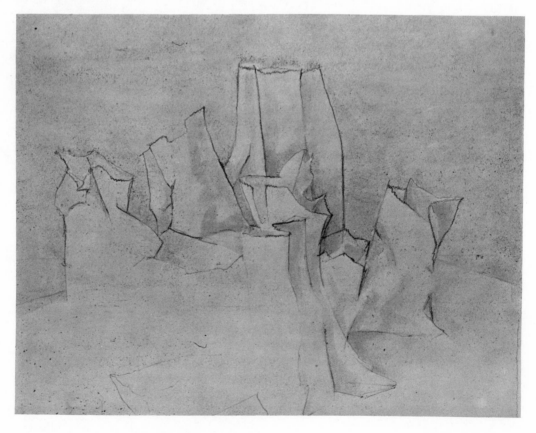

Among the group studies the pencil drawing in Figure 174 achieves an architectural presence and scale. The pattern and flow of the gently modeled and simplified block shapes gives a monumental quality to the paper bag.

Figure 175 is a small pencil-and-wash drawing. The bags are grouped and placed against a backdrop that suggests sky. They are posed as mountains, and the whole spatial arrangement intensifies the idea of a landscape. This small drawing with its large-scale forms thus suggests a limitless space.

In Figure 176 we see the forms through an atmosphere created by a pattern of cross-hatched pen strokes. The subject of the drawing is this textured light. The forms emerging from the pattern are focused in the center, and the light seems to melt them as it spreads down the page.

176 Oswald Mesa. *Atmospheric Haze.* 1962. Pen and ink. Collection Yale University Art Gallery.

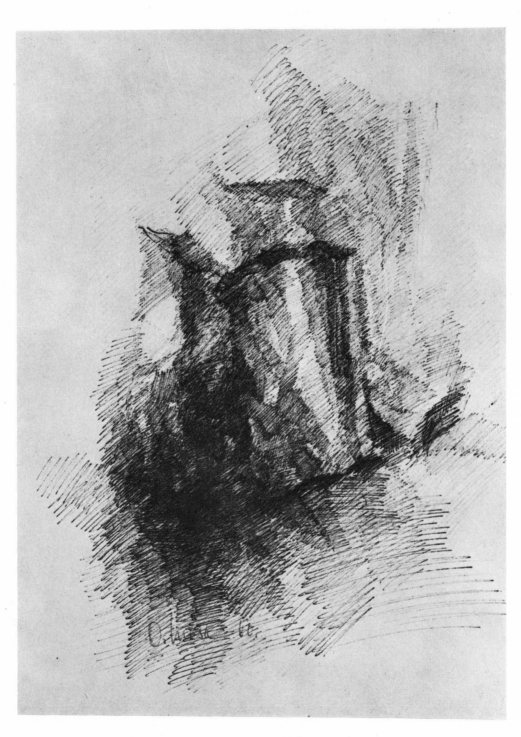

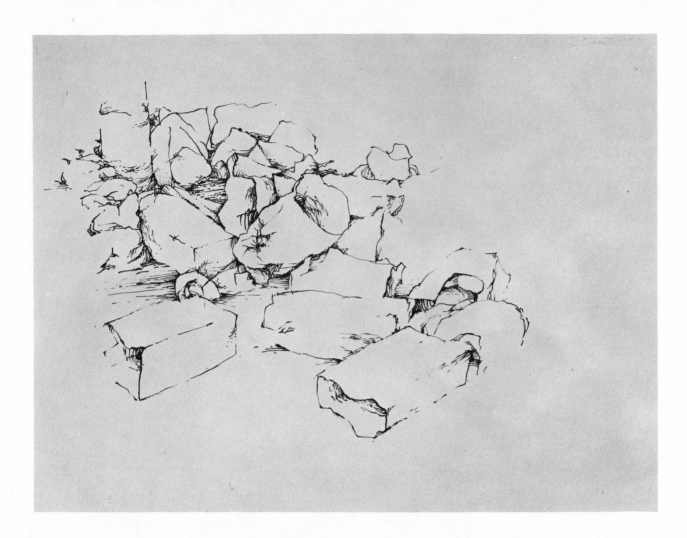

177 W. R. Farrell. *Bags in Panoramic Space*. c. 1958. Pen and ink. Collection Yale University Art Gallery.

Figure 177 presents the bags in a panoramic space similar to that of the shoes in Figures 163 and 164. Individual shapes can be seen standing, leaning on their neighbors, or lying down. The forms overlap each other clearly and remain distinct even as we view the whole arrangement as a coherent space. The ink lines punctuate the points at which each form touches another. This emphasis is clear, but it should be noted that the forms themselves preserve the light weight of the paper bags.

CHAPTER 8

Skulls

Having examined the environment, indoors and out, and having studied inanimate and natural forms, we next undertake a study of human and animal structure. It is a good practice to start two projects simultaneously—a study of animal skulls in the studio and experimentation with self-portraits at home. Comparative anatomy is not the goal, but certain basic structural similarities are apparent. The study of skulls is at first approached on a purely diagrammatic, informational basis. What we feel and observe must take account of this structural awareness as the key to interpretation.

Animal Skulls

The obliquely structured angle of the eye socket in animal skulls is obvious, but much more subtle in human skulls. Figure 178 is a diagram of a typical animal skull seen from the top. The structure housing the eyes moves back at an angle from the center so that the eye has a greater field of vision. What we know about this structure in animals is not easy to observe in a foreshortened drawing. Our

178 Diagram of an animal skull, seen from the top.

personal reactions to the skull form, in terms of drawing, must presuppose this structural knowledge if we want the drawing to be more than an idle sketch. It is conceivable, of course, that the shapes themselves, as perceived by the eye, might inspire a meaningful composition. But, for the most part, awareness of the volumetric structure is the key to using the shapes organically and with authority.

Skulls obviously suggest a death image. When children draw skulls, they invariably produce Halloween symbols with black eyes and nose and outlined teeth. In a studio class of mature students the skulls are objects of horror for some and beautiful sculptured forms for others, according to the individual's frame of reference. One's own reactions to the forms may crystallize or change completely after studying the basic structure, which is stressed purposely at the expense of other values. Several weeks of merely diagraming the skull may elapse before the student is ready to react to the form or to its symbolic content in a personal way.

In this diagraming stage the studio contains the following skulls: horse, cow, dog, pig, goat, deer, rhinoceros, and hippopotamus. During this period proportional characteristics of individual skulls tend to be neglected. The fascination of fitting parts together volumetrically distracts the student's attention from the individual shape of the form to be studied. The choice of media is stressed only after the diagraming stage is completed. As with any other study, one's attitude dictates one's choice.

Student Response

Some students took a clinical attitude, experimenting with individual connections, overlapping planes, and details. Others developed expressionistic studies, and still others examined simple volumetric relationships. The drawings reproduced do not include the two weeks of diagraming; this stage was considered to be purely informational. The change back to the values of drawing with attention to spatial considerations and instrumentation required some readjustment.

In Figure 179, a brush-and-ink drawing of a goat skull, curving, interlocking brush strokes pick up speed and spin away into the empty spaces, so that the whole composition is in motion. The forms are carried to the edge of the page and attempt to move out of the restricted stage. The quick movements of the brush strokes suggest the expression of the jaw, but the speed of the instrumentation permits us only a fleeting impression.

Although Figure 180 presents almost the same view of the goat's skull and employs the same medium, the emphasis is quite different. The form rests in a more comfortable open space, and the edges of the page are at a safe distance.

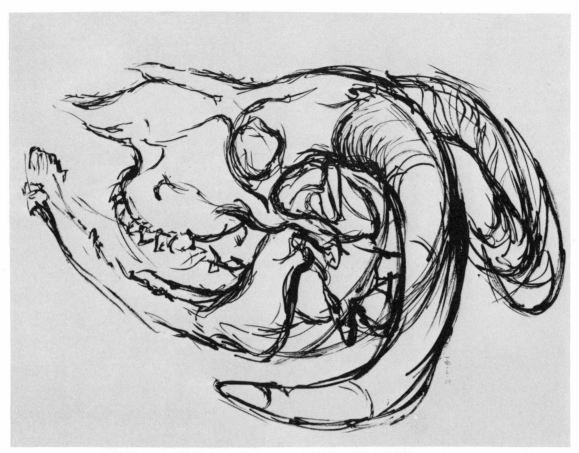

above: **179** Jacqueline Ecklund. *Goat Skull*. 1954. Brush and ink.
Collection Yale University Art Gallery.

below: **180** John Cohen. *Pressure Points of a Skull*. 1954. Ink wash.
Collection Yale University Art Gallery.

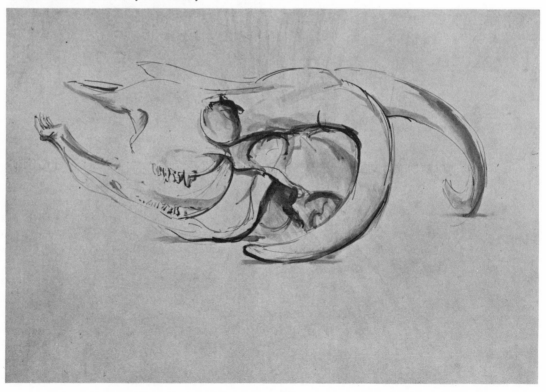

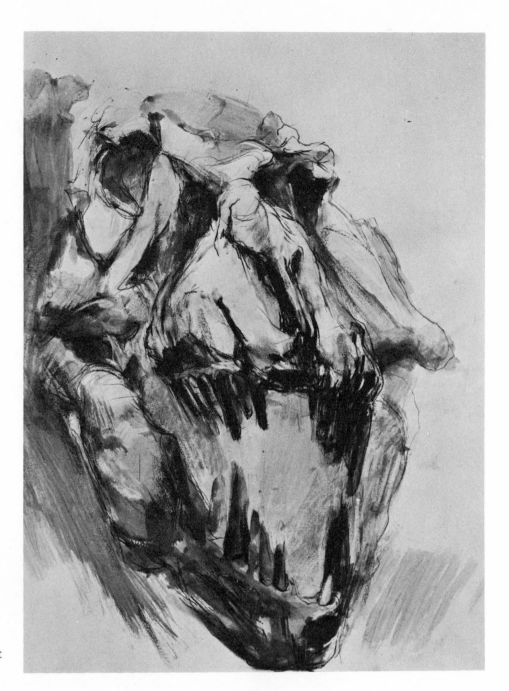

The laughing expression of the jaw is underplayed. Here the emphasis is on inter-secting pressure points, especially below the eye. We work our way back through these intersecting forms that stress changing weights and pressures.

The protruding open mouth of the skull in Figure 181 is projected at an angle toward the viewer. The emphasis is on menacing teeth. We do not have a sense of gravity, but rather the whole form seems to be suspended in air. The expression of the stretching jaws is alive and threatening.

The next illustration is a clinical study—a series of fine-line drawings of the eye structure of a deer skull [182]. The eye socket is seen both as part of the skull and as an individual form, with emphasis on its projected position as a container. The beauty of this form can be isolated from the context of the whole skull.

A back view of a hippopotamus skull is the subject of the chalk drawing in Figure 183. The initial emphasis is on the massive weight of the whole form. Overlapping shapes are seen as elegantly fitted sculptural units. By contrast, the

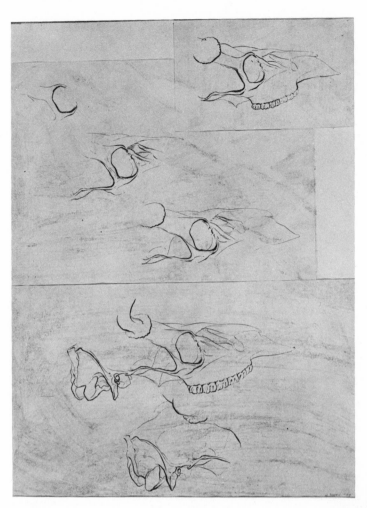

left: **182** Herman Snook. *Deer Skull.* 1955. Brush and ink. Collection Yale University Art Gallery.

below: **183** Fred Marcellino. *Hippopotamus Skull.* 1962. Pencil with black and white chalk. Collection Yale University Art Gallery.

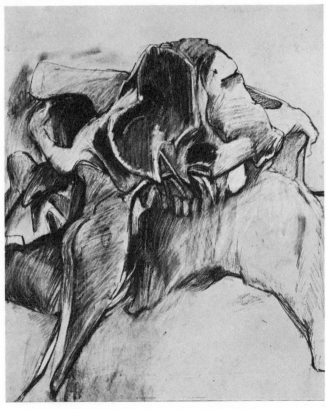

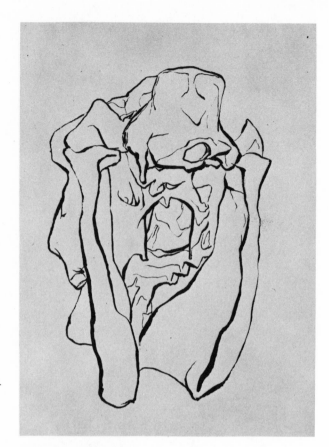

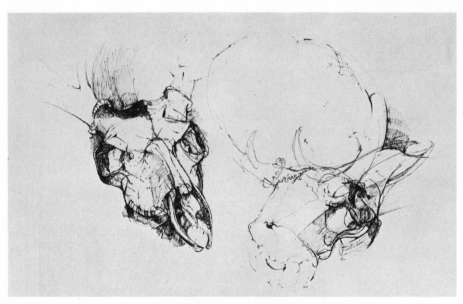

right: **184** Sybil Wilson. *Skull of a Horse*. 1958. Brush and ink. Collection Yale University Art Gallery.

below: **185** Arnold Bittleman. *Sculptural Essence of the Skull*. 1955. Pen and ink. Collection Yale University Art Gallery.

rear view of a horse's skull [184] focuses not on the hulking weight or gravity of the form but on an undulating linear movement created by the continuous brush strokes that depict interlocking parts. The line itself is emphasized as it moves through space and flattens the whole form.

In Figure 185 the skull (at left) is reduced to its sculptural essence. The forms of the lower jaw and the forehead are not mere descriptions but are transformed into simplified masses. Stress points where one form joins another are in focus and, particularly where the nose meets the eye, are tightly forced. This attitude gives a tautness to the whole form.

The Human Skull

During the period of animal skull study, as mentioned, the class began self-portraits on their own time. The project was started before the introduction of human skulls into the studio. This was done in order to test before-and-after concepts and to prove that what is known determines what is seen. The first portraits, made before study of the human skull, invariably stressed the individual features—mouth, nose, eyes, and ears—at the expense of the skull underneath. The students did not at first realize that the skull's structure is essential to the portrait's likeness.

In the early portraits the relationship of upper skull to lower mask is usually distorted and fullness of the back of the skull often reduced, thus giving an apelike appearance to the drawings. With the introduction of the skull in class, together with the study of live models, the relationships become clearer. In a woodcut by Andreas Vesalius [186] the skull at upper left represents the "natural" head; the others are variations on the model.

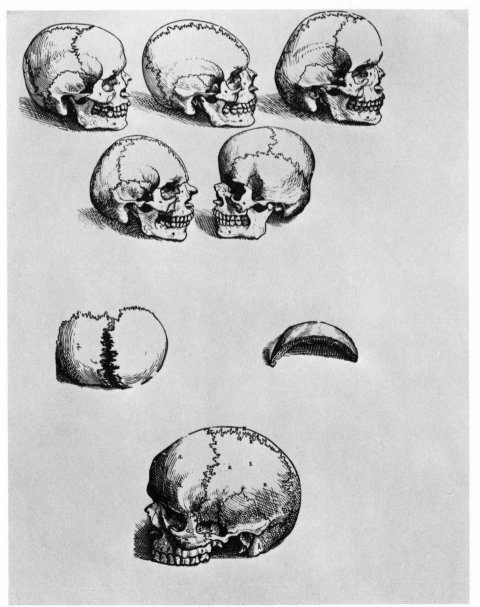

186 Andreas Vesalius (1514–1564; Belgian). *Skulls*. Woodcut.

above and right: **187** Two detail views of a portrait
statue of Ka-aper from his mastaba, Saqqara.
c. 2400 B.C. Wood, height of entire statue
43″ (109 cm). Egyptian Museum, Cairo.

We can learn about the volume of a skull from Egyptian sculptors, who were able to place the features on a beautifully simplified volume, as we see in two views of a carved wooden head [187]. In the profile we see the fullness of the back of the skull. Picasso follows this sculptural idea with an elegantly modeled simplified *Portrait of Olga* [188]. However, here the influence is from Greek sculpture. Picasso had a continuing dialogue with the art of the past [53, page 43].

188 Pablo Picasso (1881–1973; Spanish). *Portrait of Olga*. 1921. Charcoal, ink, and pastels, 19¼ × 25⅛″ (48 × 63 cm). Formerly in the artist's collection.

above: **189** Leonardo da Vinci (1452–1519; Italian). *Head of a Child (Maxim Sforza).* Conté crayon. Milan.

right: **190** Leonardo da Vinci (1452–1519; Italian). *Head of a Child.* Black chalk. Louvre, Paris.

In a child's head the mask (which contains the features, eyes, nose, mouth) is clearly much smaller than the top and back of the skull; in an adult they are of equal size. These proportions of a child's skull are plotted by Leonardo in profile [189]. The little dots along the contours reveal that the drawing was pierced with a sharp instrument and thus traced for transfer onto a panel. In the other child's head [190] Leonardo seems to be emphasizing the pliable flesh of a baby.

The structure of the planes of the skull is celebrated in Giacometti's *Self-Portrait* [191], and this structure forms the basis of the expression. In this work the features are only suggested. The skull is arched, and the plane from the back of the jaw to the chin is thrust into space diagonally. The lower portion of the drawing is empty, and this void creates a frontal plane that pushes the whole structure back into space.

191 Alberto Giacometti (1901–1966; Swiss). *Self-Portrait*. 1937. Graphite pencil, 19¼ × 12¼″ (49 × 31 cm). Courtesy Pierre Matisse Gallery, New York.

192 Auguste Herbin
(1882–1960; French).
Self-Portrait. 1909.
Chalk, 21½ × 16½"
(55 × 42 cm). Rijksmuseum
Kröller-Müller, Otterlo,
Holland.

Auguste Herbin also celebrates the planes of the skull in his self-portrait, but with larger simplified modeled planes that catch the light [192].

In his tiny (7½ × 4¾ inches; 19 × 12 cm) pencil portrait [193] Velázquez seems to be able to see through the features to reveal the skull underneath—a haunting image.

A similar goal seems to be contained in an etching by Anthony van Dyck [194] that was probably considered unfinished but that affords us a unique look at a master's process of organizing linear strokes to create texture. Skillful transitions between textures represent hat, nose, cheeks, eyes, clothing, and hair in a flow of open and closed contours. The etching features as well a subtle X-ray of the skull—a virtuoso performance by the artist.

left: **193** Diego Velázquez (1599–1660; Spanish). *Cardinal Borgia*. Black pencil on yellowed white paper, 7½ × 4¾″ (19 × 12 cm). Real Academia de Bellas Artes de San Fernando, Madrid.

below: **194** Anthony van Dyck (1599–1641; Flemish). *Erasmus*, detail. Etching. Collection the author.

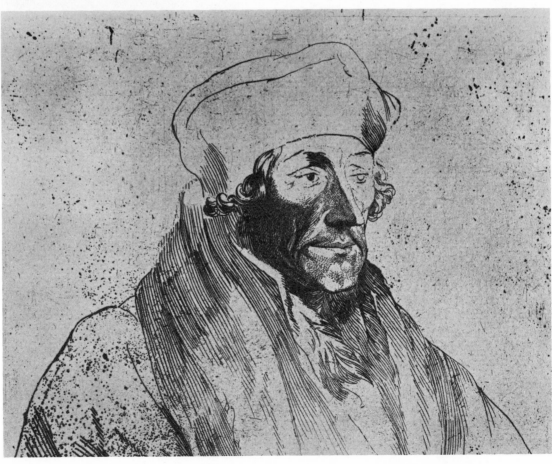

above: **195** Attributed to Antonio Pollaiuolo
(c. 1432–1498; Italian) and Piero Pollaiuolo
(c. 1441–c. 1496; Italian). *The Martyrdom of Saint
Sebastian*, detail. 1475. Wood. Entire altarpiece
10′¾″ × 7′¾″ (3 × 2.1 m). National Gallery,
London.

right: **196** Philip Grausman (b. 1935; American). *Head of
a Woman*. 1974. Graphite pencil. Courtesy the artist.

In the detail from a painting attributed to the Pollaiuolos [195] the analysis of the structure of the eye sockets, as seen from below, creates the agonized expression.

In *Head of a Woman* by Philip Grausman [196] we see again that the artist's vision produces the manner, the technique. A sculptor who works directly in metal, Grausman pulls and stretches the linear thrust in the same way that he hammers and stretches metal. Also following a sculptor's vision, he simplifies the ear form and tucks it into the head so that the two elements become one form.

Student Response

While Vesalius' exercise [186] illustrates the basic shapes of human skulls, our study in class emphasized the volumetric projection of masses. The students drew skulls and immediately invented features to fit into and over them. Reversing this procedure, they drew from the model and projected the skull underneath.

Figure 197 is a page of studies made directly from a model. A kind of X-ray vision is the frequent product of this type of study. In the large head the artist attempts to locate particular features in the skull simultaneously, so that we do not feel a sense of overlapping. In other studies on the page the skull and individual parts are examined separately.

197 Michael Mazur. *Parts of the Skull.* 1960. Graphite pencil, pen and brown ink and wash. Collection Yale University Art Gallery.

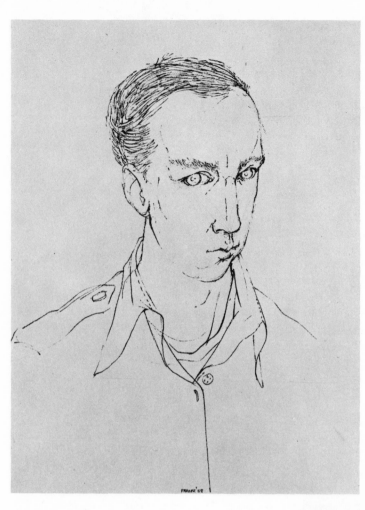

left: **198** John Frazer. *Self-Portrait*. 1958. Pen and ink. Collection Yale University Art Gallery.

below: **199** Stephen Barbash. *Self-Portrait*. 1960. Graphite pencil. Collection Yale University Art Gallery.

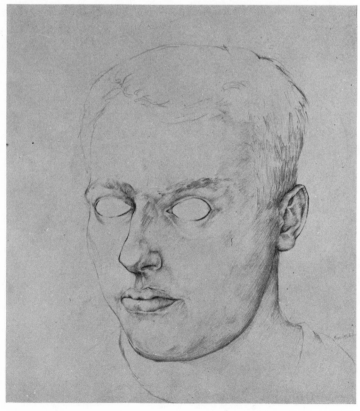

Figure 198 is a self-portrait, in this case with the shape of the head gently attenuated. From the lips down the form cuts back into an extremely foreshortened jawline. The collar of the shirt pulls forward to enhance the effect of the foreshortened chin.

A second self-portrait [199] emphasizes the surface movement of the skin. We sense muscles rippling underneath the tightly stretched contours of the mouth. This pulling of the skin is a counterpoint to the boniness of the nose.

In a third self-portrait the goal is clarity, the clarity of individual features and their relationship to the skull's structure [200].

200 Meryle Belfor. *Self-Portrait*. 1981. Red pencil. Collection Yale University School of Art.

The Human Skull 155

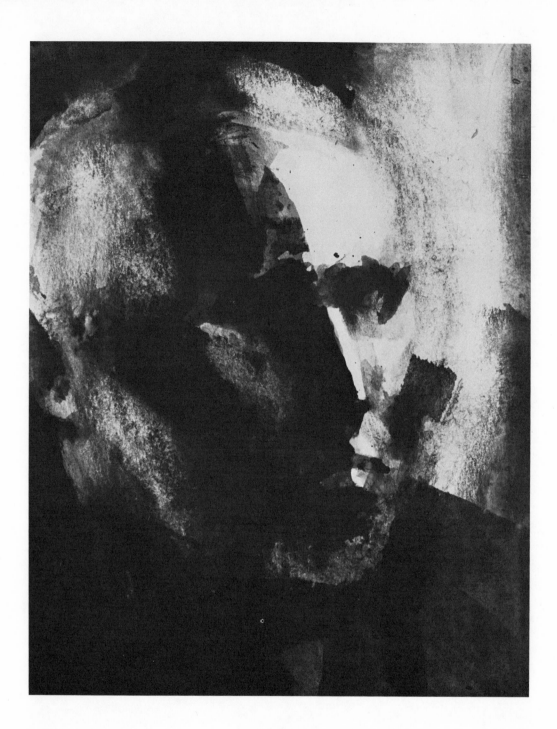

Figure 201 focuses on the planar structure of the head in directed light. The light is sharp as it hits the major planes at the right, but it is clearly stated as well in the soft darkness of the nearest plane. We sense space in front of the form, freely moving around the head and finally anchored in the soft, dark stripe at the extreme right of the composition.

Figure 202 was drawn from a model in class. The angle of the glasses is thrust against the protruding lower jaw and countered by a flowing ear form. Pencil strokes that define these opposing masses are used in a liquid manner that is beautiful in itself.

In Figure 203 the essential compositional device is three ovals representing (from top to bottom) the head, the slouching back and the shoulders, and the chair. Within this linear framework, in a broad and direct attack, the student accounts for the shifting weights in space.

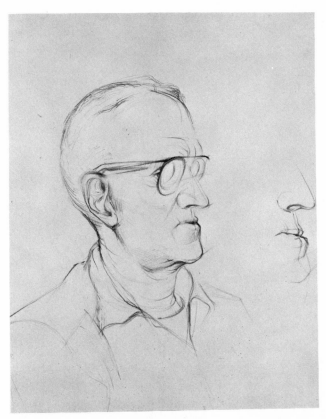

above: **202** Peter Milton. *Study from a Model.* 1960. Graphite pencil. Collection Yale University Art Gallery.

right: **203** Jacqueline Austin. *Back View of a Seated Figure.* 1975. Graphite pencil. Collection Yale University Art Gallery.

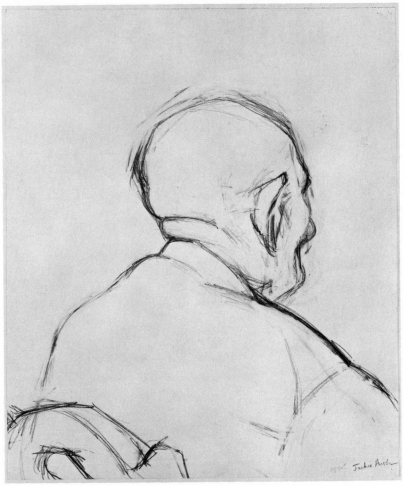

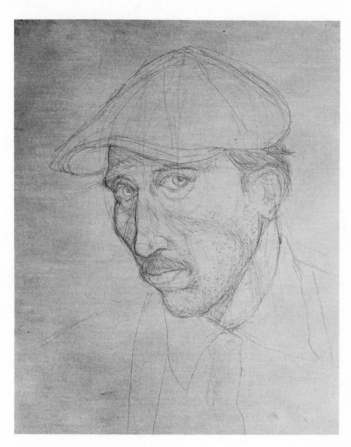

left: **204** John M. Hull. *Self-Portrait in a Hat*. 1976. Silverpoint. Collection Yale University Art Gallery.

below: **205** Blair Dickinson. *Head Looking Down*. 1973. Graphite pencil. Collection Yale University Art Gallery.

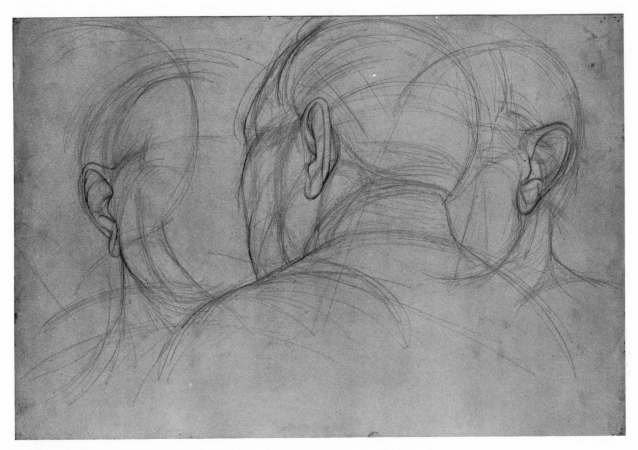

206 James McElhinney. *Multiple Views of a Head.* 1975. Graphite pencil. Collection Yale University Art Gallery.

Silverpoint, as mentioned in Chapter 4, is a medium that does not allow for erasure. The artist must build up the forms deftly. In the self-portrait illustrated in Figure 204 the student subtly handles the foreshortening from the eye bridge to cheek and then sharply down to mouth and chin. Head and neck form a single large mass anchored by the underpinning of shirt and shoulders; the linear hat is form-fitted to the skull. Knowing that silverpoint will not permit a dark gouge, the artist has slowly built up the simplified head in light gray lines.

Following Giacometti's example, the author of the drawing in Figure 205 wants to account for all the planar movements. Not satisfied with just the major planes, she tries to trace each secondary plane within the large spherical thrust.

Figure 206 presents multiple views of the way ears fit onto the skull. The artist also examines the character of those particular ears in what could be called an "ear portrait." The format of the whole page, with its staging of interlocking circles, becomes part of the visual experience.

At the end of our studies of individual heads, the students worked from a clothed model for several weeks and attempted a number of experiments. They tried to draw the whole figure in a room without putting features on the head in order to stress the feeling of a particular space rather than the structure of the form. This permitted a concentration on the unique shapes of the whole figure in a given room. In a similar experiment the students drew only the space of the room around the figure. These exercises were designed to develop an awareness of spatial composition in conjunction with individual structures.

CHAPTER 9

Animals

An exercise devoted to animals used mounted skeletons to further the examination of bone structure as a prelude to figure study. The class worked for several hours in a natural history museum, which automatically restricted the size of the drawings and the choice of media. It also made possible a spontaneity of drawing performance.

The project emphasized locomotion and articulation, the character of individual species, and economy of means. Locomotion and articulation were stressed to give the feeling that the parts of the total structure fit together and form an interdependent mechanism that can move in a certain manner. Character was defined as the peculiar proportions and posture of the whole animal. It was pointed out that the goal of economy is *essence*, rather than simplicity of presentation.

Economy is evident in Rembrandt's quill-pen drawing *Camels* [207], where the structure of the head, almost a caricature, is reduced to its essence. The underlying planes of the skull, projected in two views, are masked by the artist's search for particular facial expressions. This is accomplished in a direct, rather offhand and whimsical manner.

In Figure 208 Delacroix studies the profiled head of a lion with particular emphasis on the structure of the eye socket. This feature is brilliantly diagramed in a fluid penmanship.

160

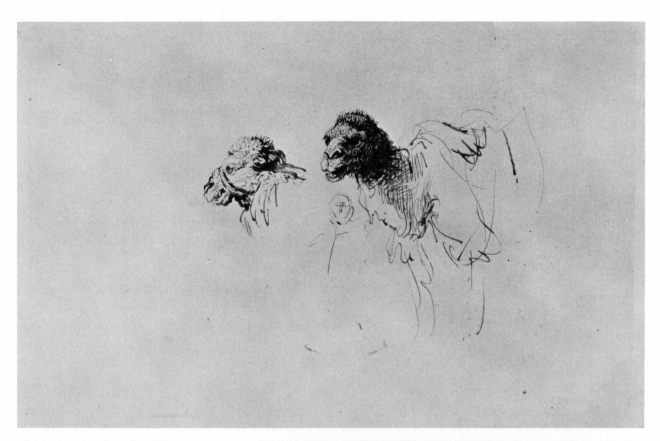

above: **207** Rembrandt (1606–1669;
Dutch). *Camels*. Quill pen and ink.
Kunsthalle, Bremen (destroyed in World
War II).

right: **208** Eugène Delacroix (1798–1863;
French). *Head of a Lion, Profile*. Pen and
ink, 7⅞ × 6⅜" (20 × 16 cm). Private
collection.

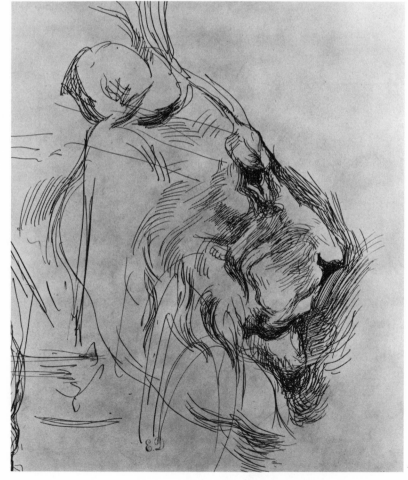

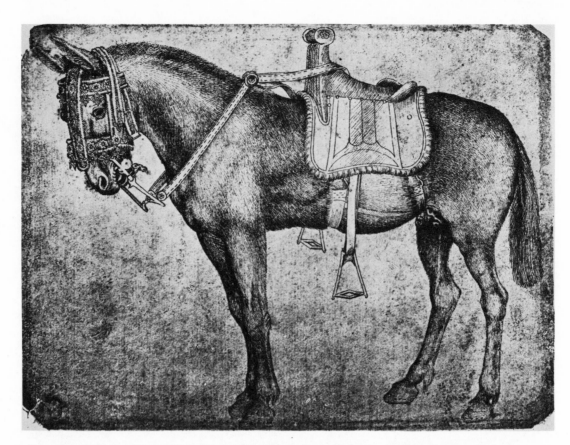

above: **209** Antonio Pisano Pisanello (1397–1455; Italian). *Mule.* Pen and ink. Louvre, Paris.

below: **210** Katsushika Hokusai (1760–1849; Japanese). Drawings from *Quick Lesson in Simplified Drawing.* 1812. Brush and ink. Museum of Fine Arts, Boston (gift of William Sturgis Bigelow).

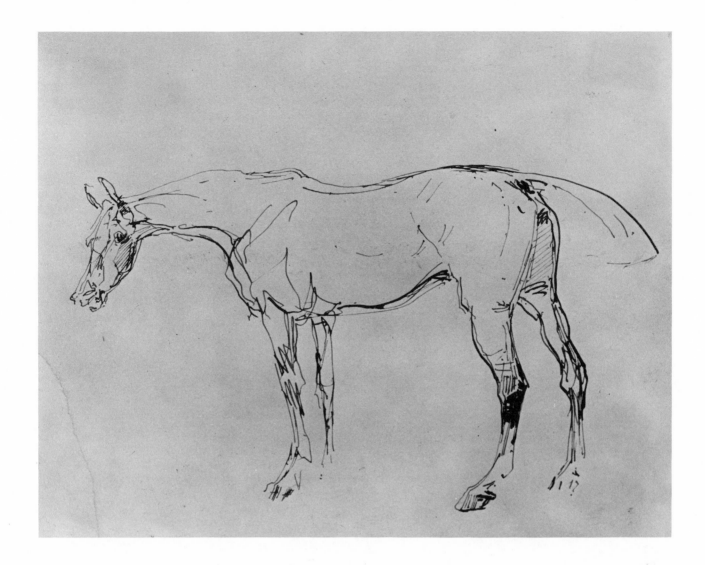

Articulation is illustrated in Pisanello's *Mule* [209], where the tight, short strokes of the pen serve two purposes. They show textured hair on the animal's hide—the way it moves and grows on the surface; and, more important, in describing the rippling coat they reveal the animal's bone and muscle structure. The skin is pulled so tight that it becomes transparent. We are made to see the inner structure and the outer covering simultaneously.

Hokusai's didactic diagrams of projected volumes illustrate a timeless lesson in seeing geometric substructure [210]. The method could still be used today, although without Hokusai's graphic elegance.

A sense of locomotion is brilliantly portrayed in a notebook sketch by Toulouse-Lautrec [211]. The individual shapes of each part of the horse—head, neck, torso, and widespread legs—are interlocked to give an instantaneous transcription of a unique posture.

Jacob Jordaens' *Goat* [212, page 164] has been drawn in chalk with touches of wash, probably accomplished by deftly wetting the chalk. The humorous rear view, the animal's stance, the articulation of the joints, and the placement of the form so that it fills most of the space all contribute to a brilliant characterization. Notice, too, the tonal range of the black chalk, from light, gentle, open-contoured strokes along the right front leg to the dark punctuations in the head and hooves. The darks along the bottom also serve to anchor the form in the absence of a drawn ground plane.

211 Henri de Toulouse-Lautrec (1864–1901; French). *Standing Horse.* Before 1880. Pen and ink, 4⅛ × 7¼" (11 × 18 cm). Print Department, Boston Public Library.

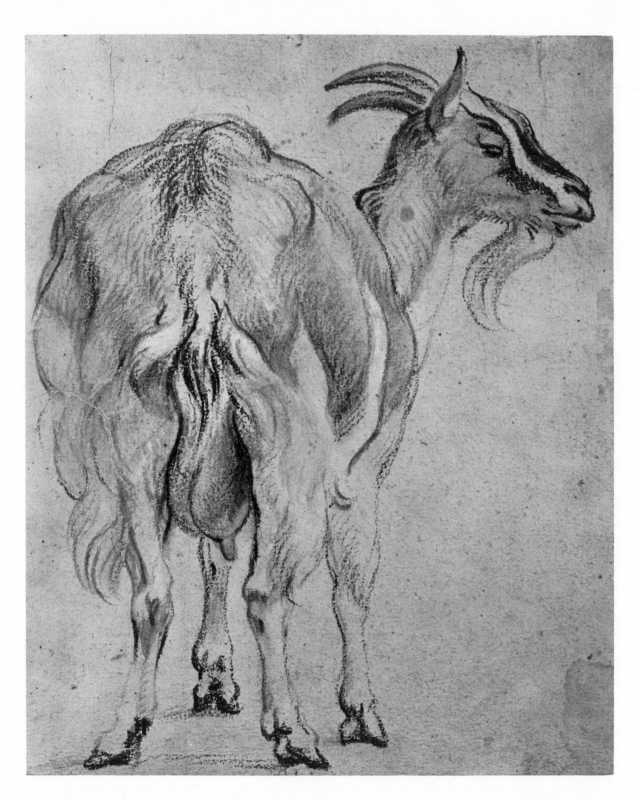

212 Jacob Jordaens
(1593–1678; Flemish). *Goat*.
Red, black, and yellow chalk,
9¹⁵⁄₁₆ × 7⅞″ (25 × 20 cm).
Collection Yale University Art
Gallery (Everett V. Meeks, B.A.
1901, Fund).

The character of Cranach's *Black Wild Boar* [213] is expressed in the menacing silhouette of a dark shape against a white background, coupled with the triumphant pose and open jaws. This creature may be seen as an invention of horror or of humor (or a combination of the two), depending on one's interpretation. The dashing white lines of the fur suggest speed, but the dominant shape of the animal suspends this action.

A close-up of *Head of a Wild Boar* [214] repeats the symbol, but the execution in watercolor of the pattern of the fur has a special rhythm.

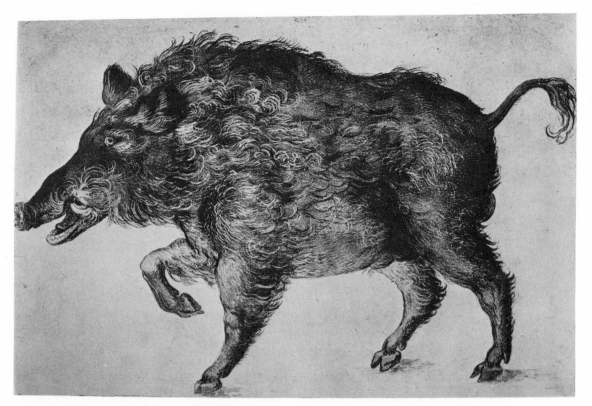

above: **213** Lucas Cranach the Elder (1472–1553; German). *Black Wild Boar Facing Left*.
1525/1530. Pen and ink with watercolor, 6¾ × 10″ (17 × 25 cm). Kupferstichkabinett,
Staatliche Kunstsammlungen, Dresden (missing since 1945).

below: **214** Wybrand Hendriks (1744–1831; Dutch). *Head of a Wild Boar*. Watercolor,
13 × 20″ (34 × 50 cm). Teylers Museum, Haarlem.

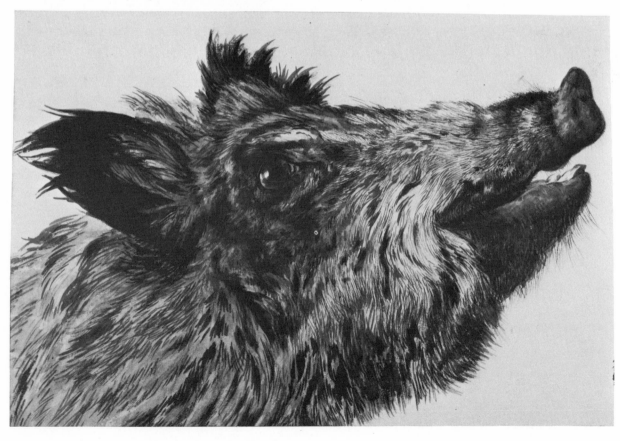

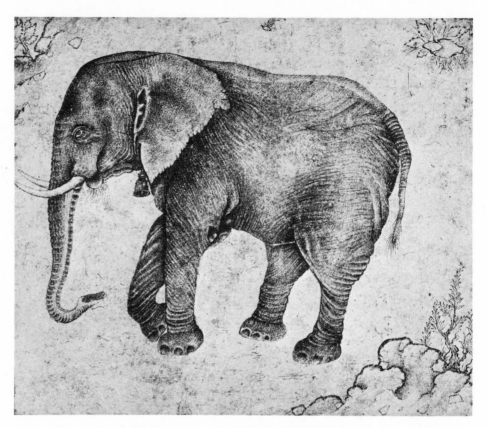

above: **215** Persian drawing. *Elephant.* Late 15th–early 16th century. Drawing on paper, 3⅝ × 4¼" (9.2 × 10.8 cm). Museum of Fine Arts, Boston (Goloubew Collection).

below: **216** Rembrandt (1606–1669; Dutch). *Elephant.* c. 1637. Black chalk, 6 × 9" (15 × 23 cm). British Museum, London (reproduced by courtesy of the Trustees).

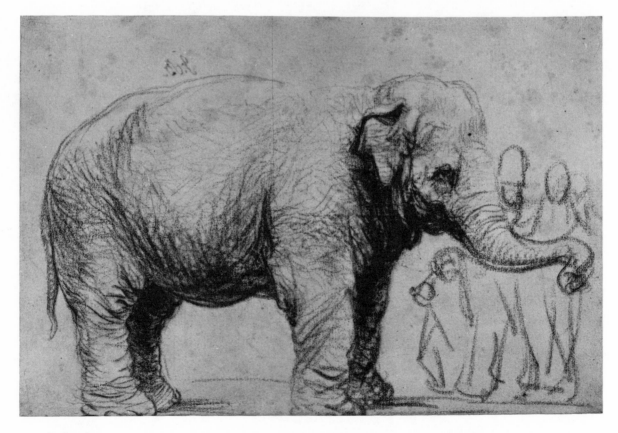

The Persian drawing in Figure 215 seems, at first glance, similar to Pisanello's rendering of a mule's skin [209, page 162], but in the latter the surface suggests foreshortening, gravity, bone and muscle. The Persian drawing, on the other hand, presents the skin as a beautifully designed arabesque of drapery. This does not imply praise or criticism of either drawing. It merely points out that each culture sets its own values and its own frame of reference.

Rembrandt's *Elephant* [216], with its comical, awkward hulk, might be mistaken for a portrait of a man in an elephant suit. The tensions and articulation of the skin are generalized to preserve the characterization, which is the point of the drawing. This attitude toward the elephant is in keeping with Rembrandt's total vision as an artist. Each work of art is produced by a form attitude, which in turn is produced by a larger artistic culture.

Dürer's knowledge of the structure of the ox [217] is the hidden subject of this drawing. He shows us the bones and muscles contained in a volume in space. What he knows about the structure in front of him is at least as important as what he sees.

217 Albrecht Dürer (1471–1528; German). *The Ox.* 1508. Pen and ink. Formerly Collection Ljwow Library, Ukrainian Academy of Sciences (missing since World War II).

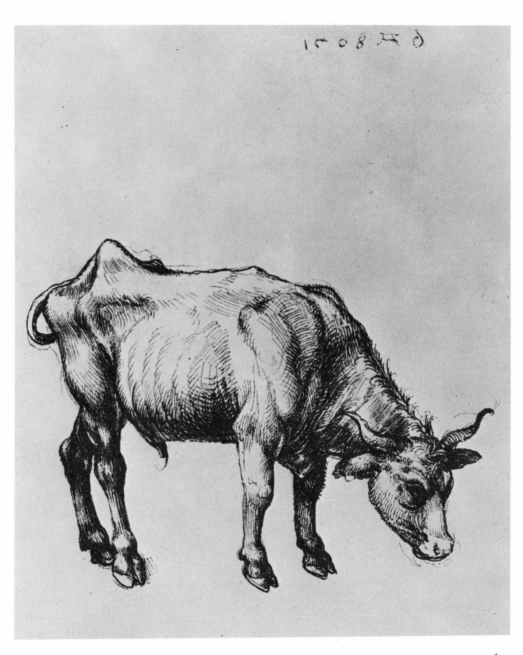

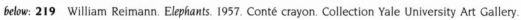

above: **218** Patricia Coughlin. *Study of Animals.* 1960. Graphite pencil. Collection Yale University Art Gallery.

below: **219** William Reimann. *Elephants.* 1957. Conté crayon. Collection Yale University Art Gallery.

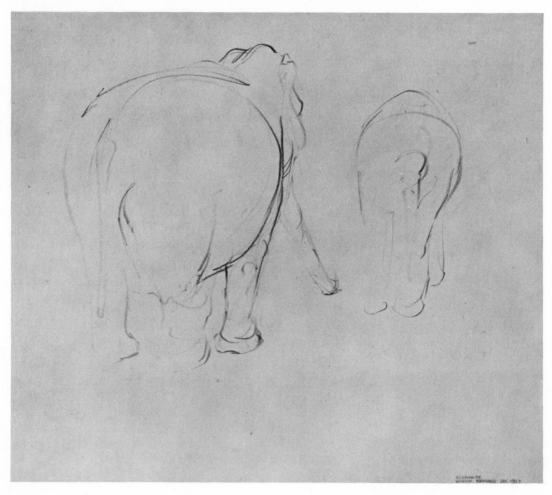

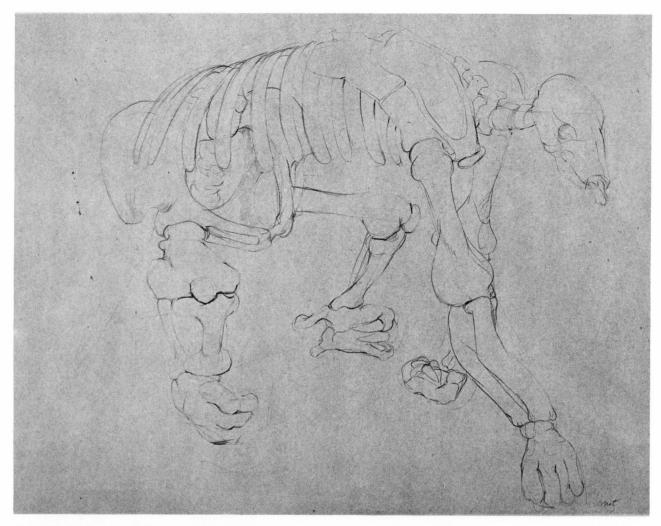

220 Elizabeth Matz. *Skeleton of a Ground Sloth.* 1959. Conté crayon. Collection Yale University Art Gallery.

Student Response

Although articulation, locomotion, character, and economy of means are the broadly defined goals, it is the student's responsibility to pinpoint individual interest, for the ultimate end, as we have constantly reiterated, is the development of a personal attitude.

In the pencil drawing in Figure 218 the organization of the whole page is considered, as is each animal's characteristic posture and articulation. The animals move as a group, and our focus is directed from one to another, yet as we pause to examine each one, we sense its individual locomotive mechanism.

The conté drawing in Figure 219, done at a zoo, owes an obvious debt to Rembrandt's elephant studies [216]. A student's response to the work of the masters is at least as important as working from nature, for masterworks permit us to see nature in a new way. In the large figure at left the weight, gravity, and stance of the elephant is expressed in the tension between the accented half circle, representing the body, and the contoured volume of the front leg. This junction is the focus of the work.

An angle of vision that places all four extremities in a tilted projection gives added life to the drawing in Figure 220. Without this volumetric exaggeration the detailed information and the carefully articulated joints are merely descriptive.

The hippopotamus in Figure 221 stands, in a fixed, dumb trance, directly in the center of the drawing. The animal is quickly sketched with an X-ray vision, but the shapes of the head, body, and feet are nevertheless clearly represented and readable.

In Figure 222 the skeleton of a dinosaur inspired an interest in the rhythmic intervals of the spinal column. The line, which in turn darkens and disappears with the alternating pressures of the pen, carries us along as it moves between bone

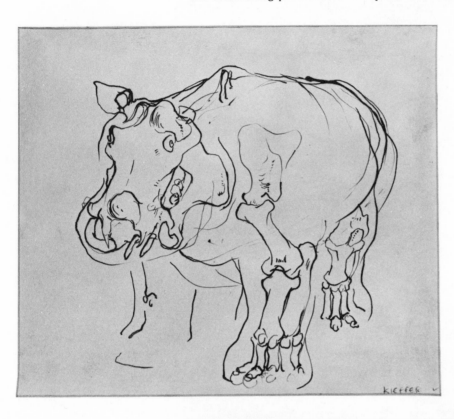

left: **221** Stephanie Kieffer. *Hippopotamus*. 1957. Pen and ink. Collection Yale University Art Gallery.

below: **222** Susan Draper. *Skeleton of a Dinosaur*. 1956. Felt-tipped pen. Collection Yale University Art Gallery.

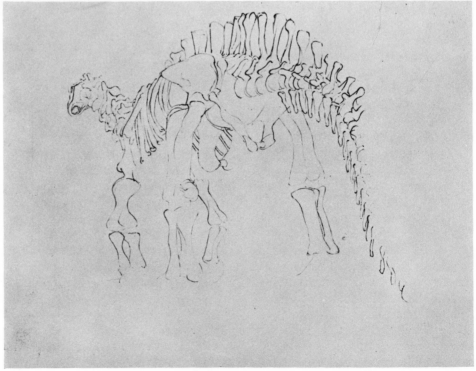

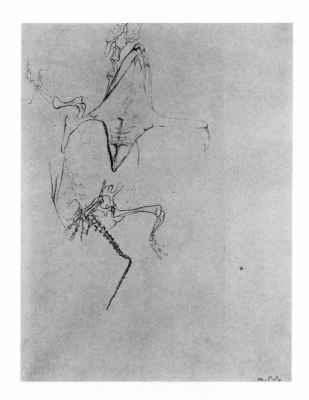

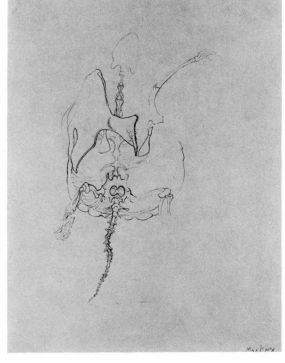

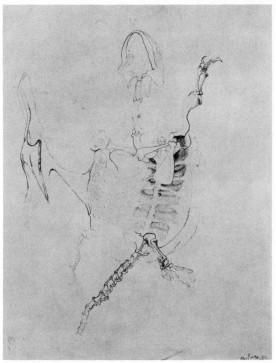

223 Ronald Markman. *Studies of a Turtle*. 1956. Graphite pencil. Collection Yale University Art Gallery.

shapes and interspace. This instrumentation, with its undulating movement, directs us on our visual journey and becomes, in a sense, as important as the subject.

Figure 223 consists of three studies of one turtle, drawn on separate pages and matted together. Each study focuses on a separate aspect of the form—unlike a scientific illustration, which would concentrate on a clear and equal description of all parts from one point of view. Here the forms are composed and stressed by choice, and they therefore take on a visual life.

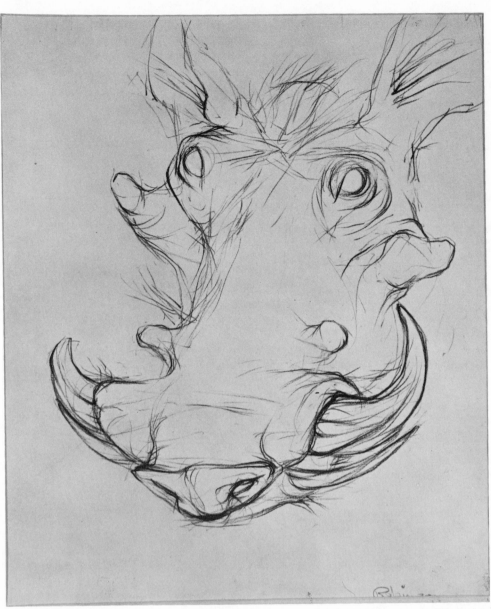

224 Elton Robinson. *Head of a Warthog*. 1956. Charcoal pencil. Collection Yale University Art Gallery.

The portrait head of a warthog takes up most of the space in Figure 224. The forms of the upper jaw, with its protuberant nostrils and teeth, are darkened and pulled forward in an exaggerated perspective. The instrumentation distorts and stretches these threatening forms in an elastic tension. In this respect it is similar to that in some of the studies of roots in Chapter 6. These tensely drawn forms italicize the author's attitude; they are not simply a technical device.

CHAPTER 10

Introduction to the Figure

Although many of the celebrated painters and sculptors of the recent past and the present deal with the figure, it is no longer the focal subject of art. The academies of the past, reflecting the official artistic cultures of their time, considered the figure the center of interest. Each academy represented a different ideal and featured its own style of presentation.

With the proliferation of art reproductions—one of the results of the technological revolution—we have access to many cultural heritages, and we can study and make use of their special form vocabularies. We have learned, in short, to regard nature, including the human body, in a new light. Furthermore, we have learned to see our own Western tradition in terms of fresh concepts.

Western figure drawing centers on gravity—volumes and weights adjusting themselves to a solid floor plane seen in perspective. Within this framework, individual masters have re-created the human figure in a variety of ways, each according to a particular vision. It is through study of these interpretations that we begin to formulate our own preferences and attitudes in seeing and, ultimately, in drawing.

To begin, one must learn to locate forms spatially within the frame of vision. For example, in Figure 225, Dürer presents the figure from a rather unusual point of view: the navel is set at eye level All the forms below the navel are seen in a foreshortened downward perspective, and these foreshortened volumes are reduced to their simplest forms. The stomach protrudes like a sphere, while the cylindrical forms of the legs move down and back from the frontal plane of the page. The musculature of the legs is reduced to a minimum in order to accent the downward thrust further. Sharp, contoured edges define the junctures of thigh and knee, and the entire weight of the figure is thrown on these tension-filled joints. All the forms above the navel are seen from a low vantage point. The head in particular looks down at us, reinforcing the logic of the fixed eye level. Volumes are strongly modeled at the point one form intersects another, and the line continually changes from contour to modeling and back again.

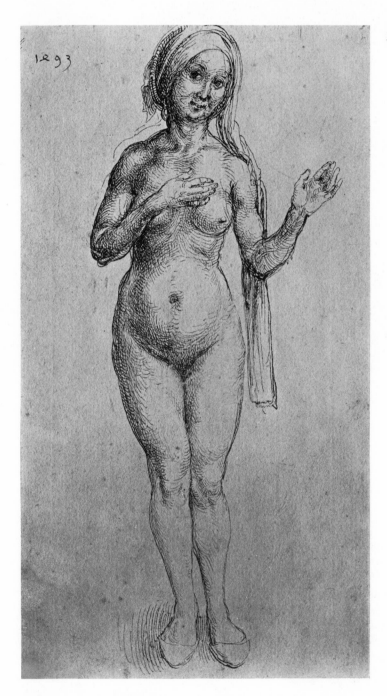

225 Albrecht Dürer (1471–1528; German). *Nude Woman.* 1493. Pen and ink, 10¾ × 5⅞" (27 × 15 cm). Musée Bonnat, Bayonne.

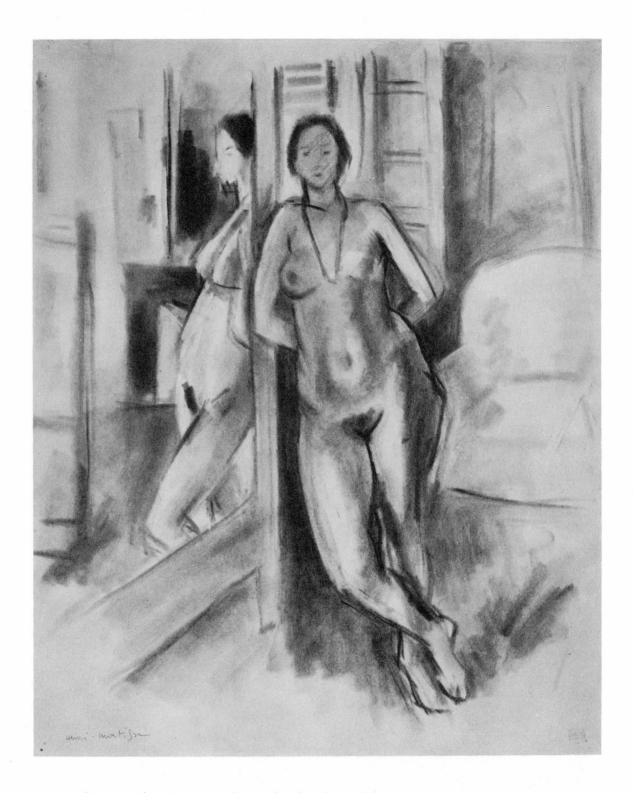

In Matisse's *Reflection in the Mirror* [226] the eye level is about the same as in the Dürer. But the leg that holds the weight (on our right) is pulled down into a foreshortened position; from hip to knee we see the underlying structure—the base of a cone thrusting its point, its weight, into the knee joint. This physical action establishes the weight of the figure in space.

The foreshortening is severe in Degas' *Dancer* [227, page 176], for the artist pushes the head far behind the fan. This becomes obvious when one covers the fan. The dancer's head is then seen as sharply back from the right arm. Below the fan the arms establish the middle space of the page. The feet, which are the most

226 Henri Matisse (1869–1954; French). *Reflection in the Mirror*. Charcoal on paper, 20 × 15¾″ (51 × 40 cm). Metropolitan Museum of Art (Robert Lehman Collection).

Introduction to the Figure 175

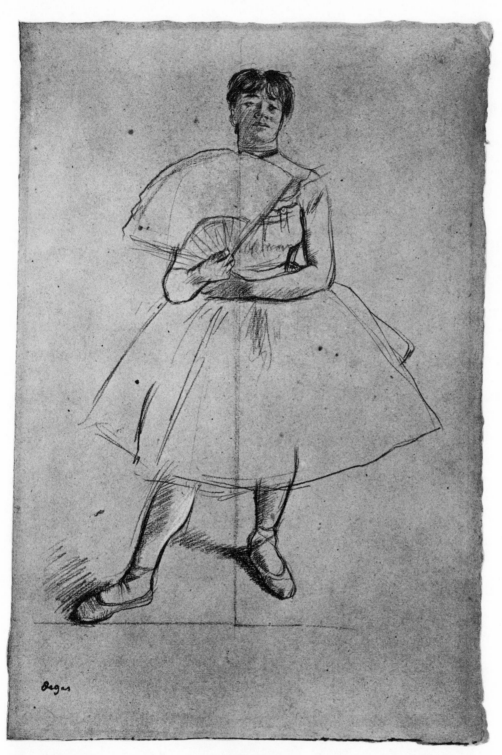

227 Edgar Degas
(1834–1917; French). *Dancer.*
1878–1880. Chalk,
19¼ × 12⅝″ (49 × 32 cm).
Museum Boymans-van
Beuningen, Rotterdam.

clearly outlined forms, define the frontal plane while setting up a strong gravitational pull. The sense of foreshortening is intensified by a reverse reading—from feet to arms to head—which further illustrates how far back the head is placed.

Dufy's pen drawing *Back View of a Nude* [228] is a virtuoso performance in the use of line, which is employed here to contain dramatic shifts of weight. The posture of the figure is more exaggerated than in Dürer's nude. Dufy persuades us that line can express weight without modeling—or, more precisely, that line may be another kind of modeling. He makes rapid corrections in contour in this swiftly executed but convincing study.

228 Raoul Dufy (1877–1953; French). *Back View of a Nude*. Pen and ink. Courtesy
Galerie Louis Carré, Paris.

229 Jean-Auguste-Dominique Ingres (1780–1867; French). *Seated Female Nude*. c. 1841–1867. Graphite pencil, 12⁷⁄₁₆ × 8″ (32 × 20 cm). Baltimore Museum of Art (Cone Collection, formed by Dr. Claribel Cone & Miss Etta Cone of Baltimore, Maryland).

In Ingres' *Seated Female Nude* [229] the volume of the model's back is described by a soft, contoured pencil line. The back, full and gently arching, is countered by the thrust of the protuberant stomach. Subtle shading emphasizes the curve of the abdomen, thus providing a shift of weight from the line of the back. Other dark areas separate the arms from the torso; the shading against the back arm defines the contour, hidden by the arms, that joins the line of the abdomen. The pressure caused by the weight of the whole figure is centered in the buttocks, which rest on a surface that is implied but not actually visible, and a delicate line across the legs further describes this unseen resting place.

In Piero Buonaccorsi's *Study for the Dead Figure of Christ* [230] we are concerned, as in all the drawings here, with the exaggerated posture of the figure. The contour of the long arc, from head through neck to shoulder and finally to arm, has an elegant swelling curve. This graceful arc continues through the crossed legs and position of the other arm.

Exaggeration is carried even further in a drawing of *The Three Graces* by Jacopo Pontormo [231]. In this drawing Pontormo, influenced by Dürer, takes a satirical view of a classical theme, which in traditional art implied a symmetrical harmony of smoothly poised forms. Where the pose was graceful, Pontormo makes his version awkward; where articulation of limbs was even and predictable, he renders the joints heavy; where rhythms should be smooth, he disrupts the surface. Proportion, harmony, and symmetry are dictated not by conventions but by personal vision.

above: **230** Piero Buonaccorsi (1501–1547; Italian).
Study for the Dead Figure of Christ. Red chalk,
11⁹⁄₁₆ × 15⁹⁄₁₆″ (29 × 40 cm). Louvre, Paris.

right: **231** Jacopo Pontormo (1494–1556; Italian). *The
Three Graces*. c. 1535–1536. Red chalk, 11½ × 8¼″
(29 × 21 cm). Uffizi, Florence.

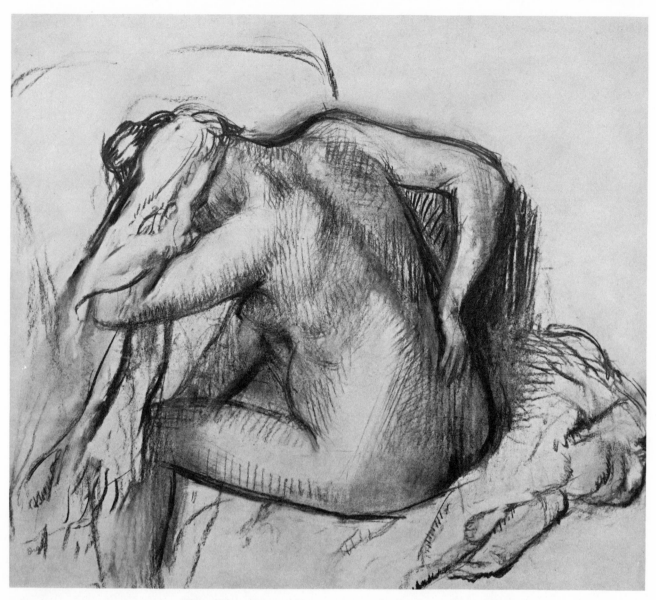

232 Edgar Degas (1834–1917; French). *Woman Drying Her Hair*. c. 1890. Charcoal, 23½ × 26¾" (60 × 68 cm). Courtesy Paul Rosenberg & Co., New York.

In Degas' charcoal sketch [232] the figure is beautifully enclosed in the space of the page, or, to put it another way, the page itself seems to hold the figure rather than remaining a neutral backdrop. The background space is a partner. The main shapes of the figure are boldly set, with contours varying from dark and heavy to soft and open. The fusion of form and surrounding space also houses another event: a slowly constructed search for the gently pulling forms of the back. We are gradually directed to see the back forms being coaxed out of the housing.

In Georges Rouault's *Filles* [233] flesh takes the form of simplified sculptural masses that shift dramatically from hip to torso to breast to shoulder. The dominant impression in this drawing is, of course, the strong message implicit in the subject, and this message is dramatized by the artist's structuring of the forms and of the whole composition. The figures dominate the space; they are compressed and stand in a frontal plane with light savagely raked across them. All of these devices intensify the form and give visual life to the message.

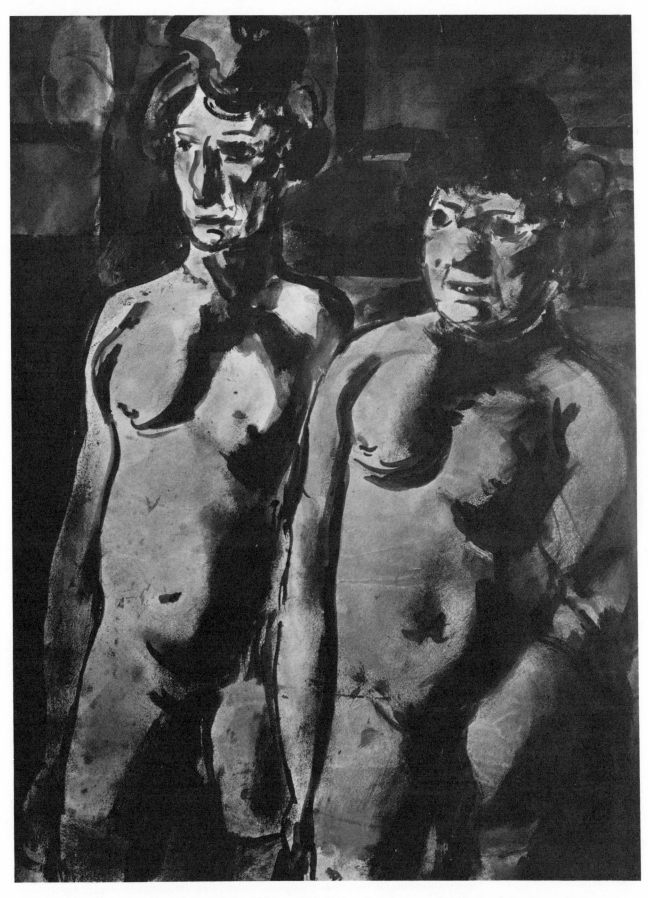

233 Georges Rouault (1871–1958; French). *Filles*. c. 1906. Watercolor. Courtesy Galerie Bernheim-Jeune, Paris.

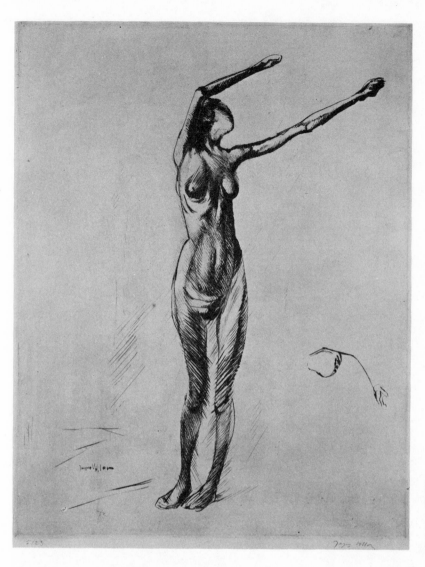

234 Jacques Villon (1875–1963; French). *Standing Nude with Arms in the Air.* 1909. Drypoint, 21⅝ × 16¹¹⁄₁₆″ (55 × 42 cm). Museum of Fine Arts, Boston (Lee M. Friedman Fund).

Jacques Villon's nude [234] reminds one of a sculptor's armature with bundles of wire mapping out the tensions between masses. Each mass seems to stretch independently, yet all move in complementary shifts of weight.

The total environment is the subject of Giacometti's *Nude in a Room* [25, page 21]. The space of the room is investigated both around and through the figure. We are led into the room by lines along the bottom and these lines turn sharply to make a ruglike floor plane below the feet, which acts as a pedestal for the figure. The room is dissected by transparent objects and interspaces, and the figure, the clearest object in the composition, interacts with the objects and the space. All elements are woven together and rotate constantly, yet their relationships are maintained by the seemingly casual sketched lines.

Student Response

It was stressed in Chapter 8 that basic structural facts must be taken for granted during the period when personal attitudes toward form are developing. In the academies of the past this anatomical awareness was taught through drawings of sculptural casts and the study of charts and diagrams, but in recent years both practices have increasingly been seen as of limited value. True, charts such as Figures 235 and 236, which reveal sectional diagrams, and Figure 237, which

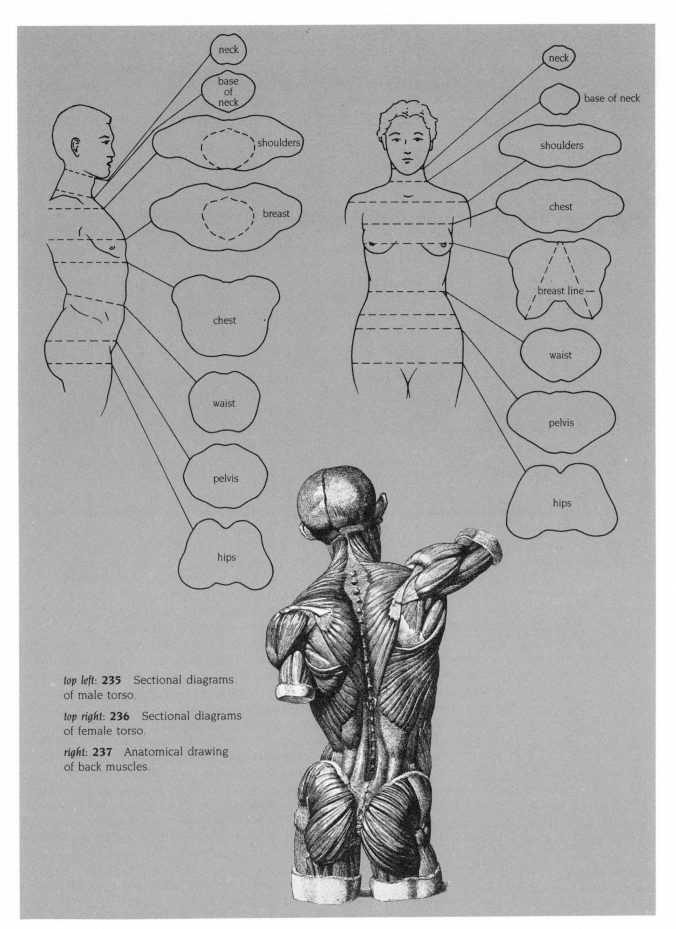

neck

base
of
neck

shoulders

breast

chest

waist

pelvis

hips

neck

base of neck

shoulders

chest

breast line—

waist

pelvis

hips

top left: **235** Sectional diagrams of male torso.

top right: **236** Sectional diagrams of female torso.

right: **237** Anatomical drawing of back muscles.

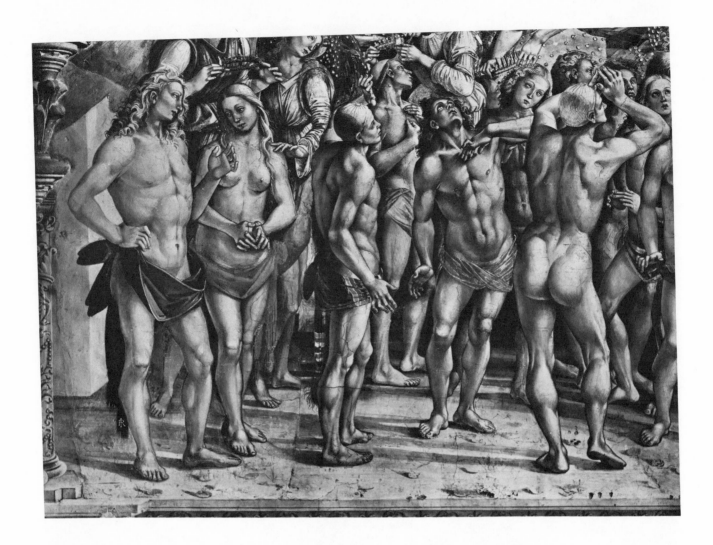

238 Luca Signorelli (1441?–1523; Italian). *The Calling of the Blessed*, detail. 1499–1502. Fresco. San Brizio Chapel, Orvieto.

shows the location of the muscles, have some use, but to stress the beginnings and endings of muscles has, in our experience, led to surface ornamentation and away from the most difficult and vital goal—volumetric foreshortening. It takes an artist like Signorelli to expose the muscles and bones on the surface while projecting the figure in space, as seen in Figure 238, a detail from a fresco.

In order to combine the knowledge of the structure of skeleton with volumetric projection an exercise was begun with studies from the human skeleton, both alone and in combination with a model. The skeleton was arranged in simple sitting and reclining poses, while the model assumed the same poses, and the students were asked to draw the two simultaneously. Some drew them side by side, others combined their perception of both in one figure. The choice was left to the individual student. The goal here was not simply a diagram showing the outer skin with the skeleton neatly placed inside. Instead, students were asked to assume the responsibility for studying the articulations they personally did not understand. Two ideas were stressed: the foreshortened simplification of volumes and the fixed-eye-level viewpoint as in Dürer's nude [225, page 174]. This requires that all diagraming and note-taking be performed within a three-dimensional approach; all bone and muscular connections must be conceived in terms of volumes moving in space.

To follow this exercise, a difficult test is worth pursuing without time constraint. Each student was asked to select either a drawing, a painting, or a piece of sculpture and create a skeleton to fit the figure either by drawing the skeleton into the drawn copy or superimposing it on a piece of tracing paper. One student, with

a sense of humor, picked *Bathers* [239], a painting by Renoir containing soft, fleshy figures with few hints of muscular or skeletal structure, and then translated these figures into skeletal forms [240]. For the study in Figure 241 (page 186), the same student selected a very difficult painting by Correggio—difficult because the figures are posed in exaggerated perspective. Both these studies test what the examination of bone and muscle charts and frontal diagrams cannot teach: the knowledge required to foreshorten the structure of the figure. The ability to do this, particularly from memory, is a fundamental necessity to figure drawing.

left: **239** Pierre Auguste Renoir (1841–1919; French). *Bathers.* 1918. Oil on canvas, 3'7¼" × 5'3" (1.1 × 1.6 m). Jeu de Paume, Paris.

below: **240** Jean Farquhar. *Study after Renoir's Bathers.* 1973. Graphite pencil. Collection Yale University Art Gallery.

241 Jean Farquhar. *Study after Correggio*. 1973. Graphite pencil. Collection Yale University Art Gallery.

The pursuit of this difficult test of conceptual thinking makes us realize that the skeleton must be either enlarged, elongated, or diminished in order to fit these masterworks. The student perceives that these figures are inventions, not imitations of what the eye sees. Each master is seen as the creator of a new kind of structure—a variation of the norm. For example, the student copying a massive Rubens back [242] soon realizes that this structure represents a race of giants. The invented skeleton reflects this fact [243]. In these two drawings the student patiently knits groups of pliable soft pencil marks to paraphrase the master drawing and invent an appropriate skeleton. Note that the same student (in Figures 261, 262, and 263, pages 201–202) adopts a different *technique* to re-create figures seen in rapid gestural movements. We see here that a forming *attitude* is created by the demand of an idea.

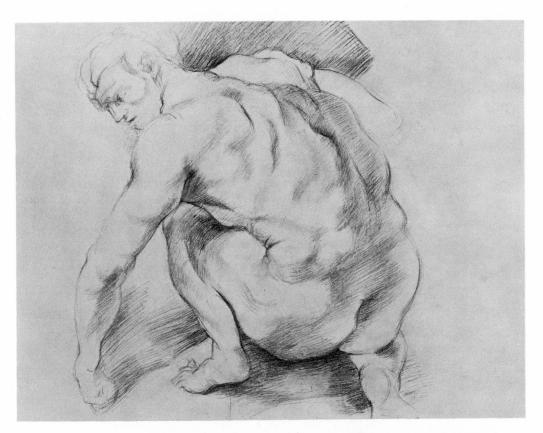

above: **242** Ian Hughes. *Copy after Rubens.* 1980. Graphite pencil. Collection Yale University School of Art.

below: **243** Ian Hughes. *Skeleton after Rubens.* 1980. Graphite pencil. Collection Yale University School of Art.

above: **244** Raphael (1483–1520; Italian).
The Three Graces. 1516. Black chalk (?).
Royal Library, Windsor Castle, England
(reproduced by gracious permission of
Her Majesty Queen Elizabeth II).

left: **245** Annette Cyr. *Copy of a Raphael*.
1980. Graphite pencil. Collection Yale
University School of Art.

Introduction to the Figure

An ingenious copy of the Raphael drawing in Figure 244 adds the feet where there are none [245] and skillfully inserts the invented skeletons with incisive lines [246]. The high level of invention in these examples is masked by this relaxed, flexible yet clear line which makes both the copy with its addition and the constructed skeletons seem flowing and natural.

246 Annette Cyr. *Skeletons after Raphael.* 1980. Graphite pencil. Collection Yale University School of Art.

A nude invented by Cézanne, here seen in a student copy [247], with an awkward pose and almost Gothic proportions is presented with an appropriately stylized skeleton [248]. One must be able to follow the lead of the master to achieve the *particular* skeleton. Having reference charts is not as helpful as having the skeleton in front of you and making it bend organically to the form peculiarities of the master.

247 Judith Spacks. *Copy after Cézanne*. 1979. Brown pencil. Collection Yale University School of Art.

Introduction to the Figure

above: **249** Raphael (1483–1520; Italian). *Apollo Playing a Viol*, study for *Parnassus*. Pen and ink, 10⅝ × 7⅞″ (27 × 20 cm). Musée des Beaux-Arts, Lille.

right: **250** Robert Kinneary. *Copy after Raphael*. 1981. Charcoal pencil. Collection Yale University School of Art.

Another Raphael [249] with a beautifully foreshortened leg is first copied [250] and then presented with a skeleton to match [251]. The fast-moving, almost sketchy marks give the movement of the figure (and skeleton) an added rhythmic vibration.

This exercise is worth pursuing even though the results are not always encouraging. Other exercises not as difficult are also suggested. The same pose was seen from four angles, the model making a quarter turn on the pedestal after each twenty-minute pose. All four poses were to be composed on one sheet [252]. Another problem required that the students study the model without drawing for as long as they wished and then leave the room to do the actual drawing from memory.

251 Robert Kinneary.
Skeleton after Raphael. 1981.
Charcoal pencil. Collection
Yale University School of Art.

Introduction to the Figure 193

right: **252** Joseph Slate. *Four Views of a Nude*. 1960. Pen and ink. Collection Yale University Art Gallery.

below: **253** Miriam Bensman. *Figure Composition*. 1978. Graphite pencil. Collection Yale University School of Art.

Introduction to the Figure

In still another exercise the model was asked to pose spontaneously in four different places in a prearranged space within a two-hour period. Here, too, all the poses were to be drawn on the same sheet of paper, with emphasis on the composition of the total page. Fitting each pose to the others is the obvious problem [253]. Similarly, for the study in Figure 254 the model posed around a ladder in three places. The action of the grouping of the figures convinces us that this is a group seen together in one space rather than three separate figures occupying separate spaces. Finally, the students drew the whole room with the same figure

254 Jean Farquhar. *Figures with Ladder.* 1972. Brush and ink. Collection Yale University Art Gallery.

above: **255** Gordon Chase. *Nude in an Environment.* 1967. Bamboo pen and ink. Collection Yale University Art Gallery.

right: **256** William Cudahy. *Masses and Joints.* 1960. Pen and ink. Collection Yale University Art Gallery.

257 Robert Birmelin. *Overlapping Forms.* 1955. Graphite pencil. Collection Yale University Art Gallery.

considered only one object in the space [255]. These last three exercises again stress the dual approach to form studies in the volume—both the structural and the compositional attitude.

In Figure 256 the transition from one connective joint to another is presented as a series of gliding masses that strongly suggest locomotion. The student examines connections between masses with a focus on the joints. Flesh is seen as tightly pulled over the bones and muscles, yet both of these structural elements are visible. The outer contours appear and disappear in the tracery of fine lines.

A motion-picture effect is created by the drawing in Figure 257, in which the hand on the hip is repeatedly drawn across the page, sometimes clearly stated, sometimes as a ghost. The artist had a double interest—the composition of the whole drawing and the study of individual parts—and these two ideas combine to produce shapes that echo across the page.

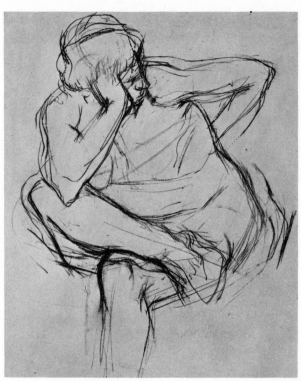

left: **258** Michael Economos. *Seated Nude*. 1959. Conté crayon. Collection Yale University Art Gallery.

below: **259** Langdon Quin. *Model Undressing*. 1976. Charcoal. Collection Yale University Art Gallery.

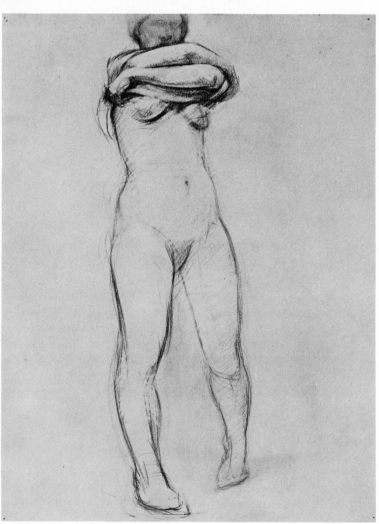

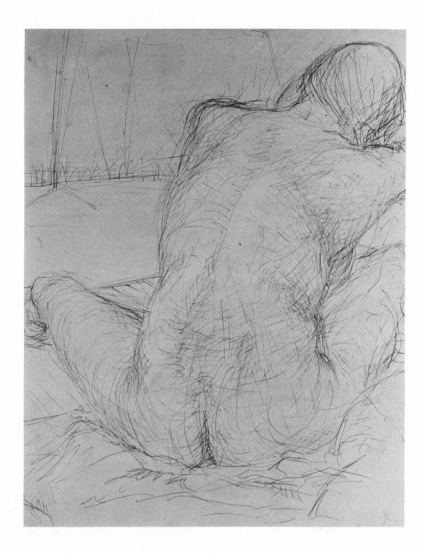

260 Sam W. Dunlop. *Seated Nude from the Back.* 1976. Graphite pencil. Collection Yale University Art Gallery.

The emphasis in Figure 258 is on the angularity of the pose. Intersecting and opposing planes are presented in a directed sequence: We see first that the movement of planes where the knees cross is pushed forward, representing the most frontal plane; the hand, head, and right shoulder come to our attention next, in one unit, as they push back into space; the left hip is pulled farther to the right in an attempt to locate it in space. This set of spatial tensions, which we are made to see in a particular order, is not intended to be a faithful description of details but is rather the visual theme of the drawing.

Although in Figure 259 the weighty legs are constructed to respond to the gravitational pull of the floor plane, the visual focus is held by the turning arms of the disrobing model. This focus suspends the weight of the figure by visually emphasizing the content: the act of removing the dress.

The motif of Figure 260 is the total space as well as the figure it contains and controls. The gentle turning of the head is maneuvered into a continuous flowing relationship with the stretching shoulders and firmly anchored hips—all fixed in the limited space by subtle horizontal space divisions.

One's initial response to the drawings in this chapter might be "These do not look like real people." This may be true, but it is important to remember that figure drawing concerns itself with the search for visual structures, real or invented. When the search is successful we may see bodies in real life in a new way. In drawing, as in art generally, great inventions make us look at nature with fresh insight.

CHAPTER 11

Individual Projects

Each of the five preceding chapters explored a specific, dictated problem in terms of the studio class. We discussed the experience of master artists and presented the student response. This type of directed learning experience is valid and necessary for the beginning artist, but there is a point beyond which it produces diminishing returns. In large studio classes the potential for dialogue between teacher and student is reduced, as is the opportunity for group interaction—the individual criticism and group discussion that can create a true environment for learning. The purpose of this chapter, then, will be to record the experiences of nine students in advanced individual projects, outside the formal classroom setting.

For these projects each student chose a particular theme that was to be explored in depth for a full year or for one semester. The course was structured as a tutorial seminar: Each student met with the instructor alone once a week, and members of the group criticized each other's work several times during the year. All the students were college undergraduates majoring in studio art. Aesthetics and technical problems were not discussed beforehand, but were dealt with as they arose during the development of each project.

Such a course permits a close association between teacher and student. In this presentation of the projects the attempt will be made to illustrate the dialogue the seminar created and to explain the way in which free but serious interaction can affect the development of an idea.

Project I *The Sculpture Studio*

It is natural to start with one's own environment—in this case an art school. Some of the activities of a sculpture studio—modeling and casting—were recorded in a small sketchbook during one semester. From these rapid sketches the student enlarged a dozen drawings, three of which are reproduced here. The task was to preserve the immediacy of the energy of group activity encompassing the individual body postures.

The angle of the projection of the work tables is used to establish the space. For example, in Figure 261 the oblique angle of the top of the table pushes the huddled preoccupied figure on the left into space and gently locks the figure into the sensitively light strokes that establish the back plane. This activity releases us to look at the figure at right, who, with arms swaying, seems to be having a conversation with the sculpture.

By contrast, in Figure 262 (page 202) the balance is more relaxed, the figures less tense; there is a silent slow-paced beat of verticals.

In Figure 263 (page 202) we return to a tense figure leaning and lifting a sculpture during the casting process. Again the diagonal thrust of the work-table tops sets up the space.

The artist has caught an immediacy of action in these examples. The means, the rapid charcoal strokes, contribute to this immediacy. Instrumentation merges with intention.

261 Ian Hughes. *Sculpture Studio* I. 1979. Charcoal. Collection Yale University School of Art.

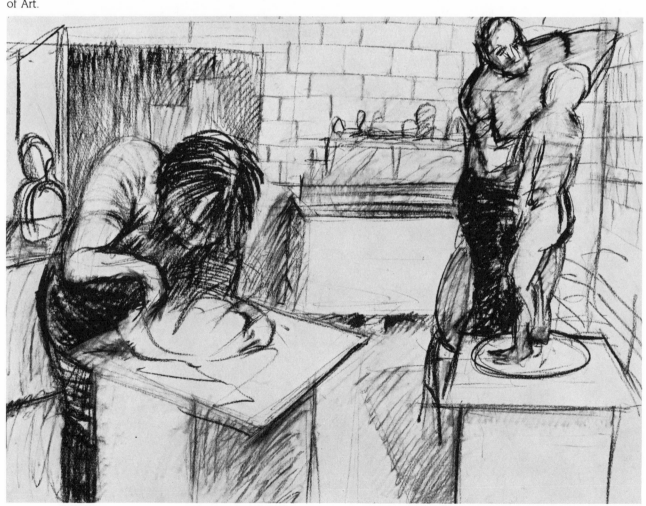

above: **262** Ian Hughes. *Sculpture Studio* II. 1979. Charcoal. Collection Yale University School of Art.

right: **263** Ian Hughes. *Sculpture Studio* III. 1979. Charcoal. Collection Yale University School of Art.

Project II *Insects*

In this project, which lasted a full year, the student produced nearly a hundred drawings. Those that have been chosen for reproduction represent pivotal points or changes in direction in the student's progress.

The study of insects began with casual anatomical note-taking through a microscope. In a sense it was an almost playful investigation. The artist produced many small group drawings, such as the one illustrated in Figure 264.

Next, the student used the information obtained through the microscope to create a series of works in pen and wash [265, page 204]. The insect forms became anthropomorphic, yet they appeared as mounted specimens in a glass case, seen from the top, against a shallow, dark backdrop.

Still working from the initial notes, the student produced some single figures in charcoal, which explored the psychological possibilities. The insects, severely cropped at the edges of the page, dominate the space to produce a nightmare image [266, page 204]. Both the artist and the instructor felt that the psychological emphasis was a little forced.

The student returned to note-taking under the microscope to make himself still more familiar with the insects' forms. At this point he decided to change his instrument to brush, which he employed almost exclusively during the remainder of the project. Individual insect figures looming as large as 30 inches (76 cm) were

264 Mark Fennessey. *Insects* I. 1965–1966. Pen and ink. Collection Yale University Art Gallery.

above: **265** Mark Fennessey. *Insects* II.
1965–1966. Pen and ink and wash.
Collection Yale University Art Gallery.

right: **266** Mark Fennessey. *Insects* III.
1965–1966. Charcoal. Collection Yale
University Art Gallery.

set against the glare of absorbent white paper in direct brush strokes [267]. The criticism of this group of works was that the placement of the figures was a bit self-conscious, drawing attention primarily to the forms themselves at the expense of the composition. It was suggested that the scale of the drawings be reduced so that the swift brushwork would be less forced and more directly related to the interaction of forms on the page.

In response to the criticism, the student produced a series of small drawings, three of which are reproduced [268, 269, 270; page 206]. Here the life of the page, the brushwork, and the symbolic content were more balanced.

267 Mark Fennessey. *Insects IV.* 1965–1966. Wash. Collection Yale University Art Gallery.

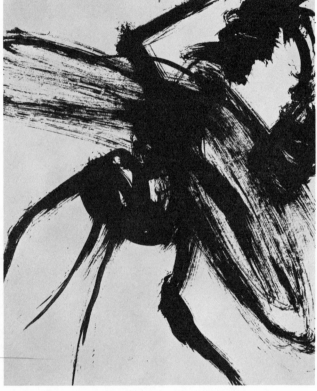

top left: **268** Mark Fennessey. *Insects* V. 1965–1966. Brush and ink. Collection Yale University Art Gallery.

above: **269** Mark Fennessey. *Insects* VI. 1965–1966. Brush and ink. Collection Yale University Art Gallery.

left: **270** Mark Fennessey. *Insects* VII. 1965–1966. Brush and ink. Collection Yale University Art Gallery.

Figure 271, a brush-and-wash drawing on a hard, resistant paper, initiated a change in spatial concepts. The basic idea—crowds in a panoramic space—was sparked by studying the work of James Ensor, Jacques Callot, and, especially in this drawing, Goya's landscapes with figures. By this time the student, with his acquired experience, was able to compose more naturally.

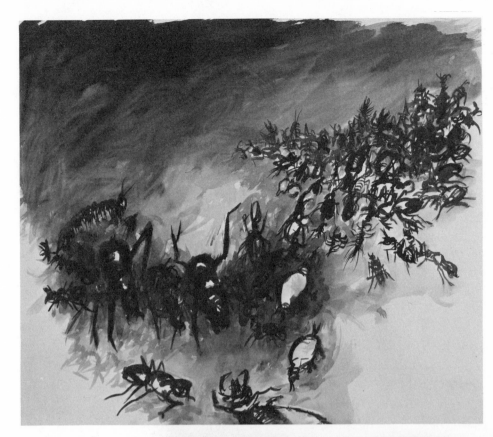

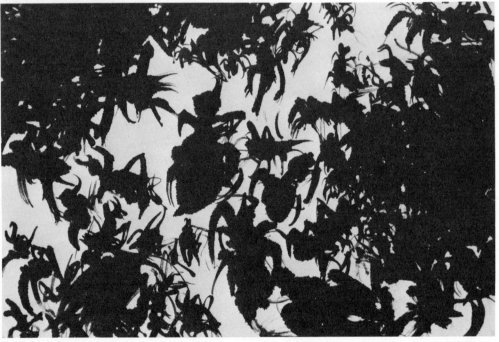

The final group of drawings, done on rice paper, translated the insect-in-landscape theme into very dark brush groups in a less obviously propped-up space [272]. There is no discernible foreground, middle ground, and background. The forms are closer to the viewer, yet as they move across the page they seem to be leaving the arena of the composition. The insect forms themselves are more wedded to the brush strokes. Thus the entire effect is less descriptive and more suggestive and therefore seems more real as a visual experience. The handling of the medium is more direct and the menacing symbolic content is stronger.

Project III A *City Square in Winter*

We leave fantasy and return to our physical environment for this project. These drawings are large—over 40 inches (102 cm) wide—and were done entirely on location. The artist, inspired by the revealed triangulation of the city square after a snowstorm, was also affected by the snow's light and the shadow of the trees. In short, the changing light adds to the geometric floor planes; the results reflect a unique sense of place.

The working process started with a diagramatic sketch, Figure 273, which simply maps the space. However, the finished charcoal drawing [274] reveals elongated triangular strips that merge and yet seem to pull and stretch in opposing directions. This stretching effect is enhanced by the figure on the left who is leaving—pulling us out of the picture space.

Figure 275 presents a familiar railroad-track perspectival device that draws us straight into the space, yet the strong long semidark horizontal shadows of the trees cut up the floor plane dramatically, countering the illusion of perspective. Again figures are leaving our area in the corners, this time two; this placement enhances the horizontal banding.

273 Grier Torrence. *City Square Sketch*. 1981. Charcoal. Collection Yale University School of Art.

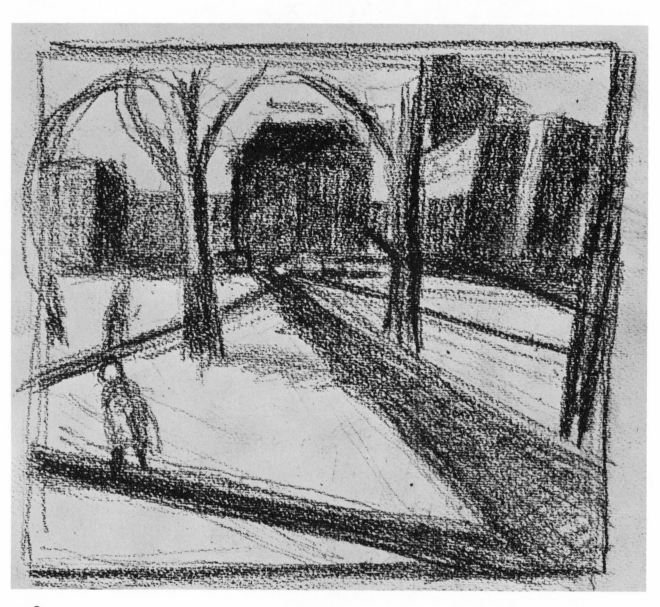

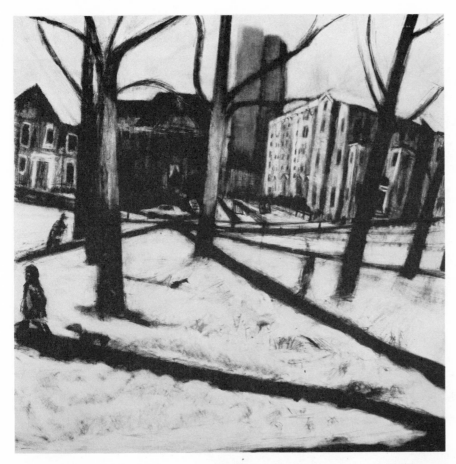

above: **274** Grier Torrence.
City Square I. 1981. Charcoal.
Collection Yale University
School of Art.

right: **275** Grier Torrence.
City Square II. 1981. Charcoal.
Collection Yale University
School of Art.

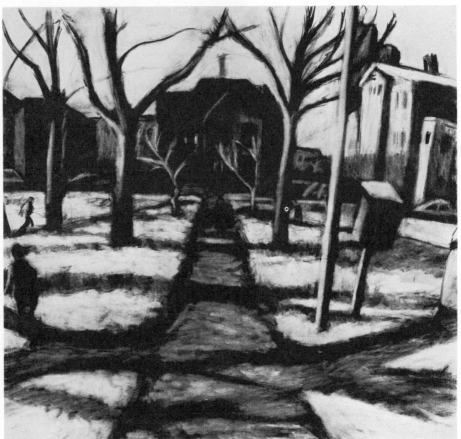

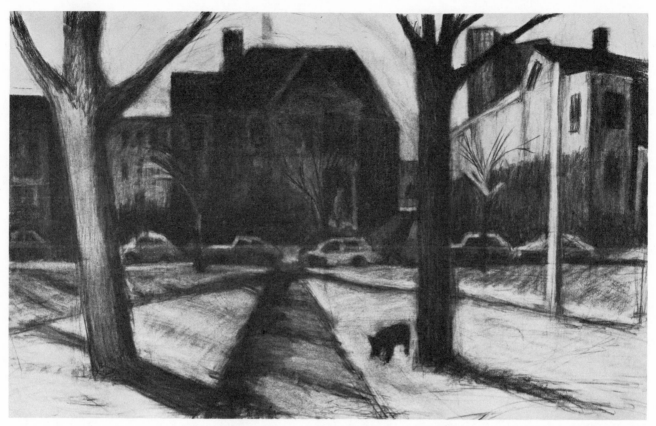

above: **276** Grier Torrence. *City Square* III. 1981. Charcoal. Collection Yale University School of Art.

below: **277** Grier Torrence. *City Square* IV. 1981. Charcoal. Collection Yale University School of Art.

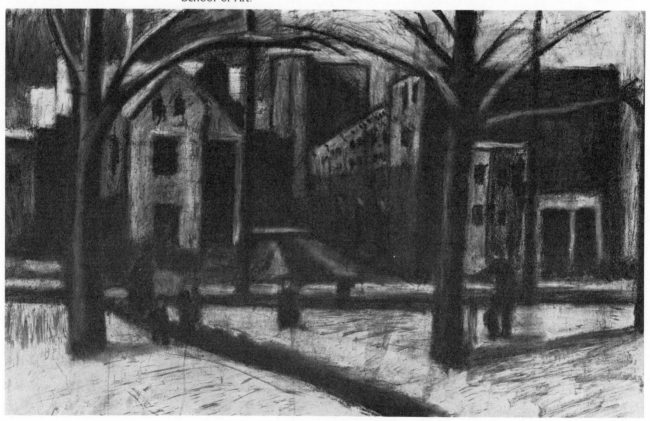

In Figure 276 we are in the same area but we are moving down the path; the two trees that appear beyond midspace in the last drawing are now twin balancing sentinels framing the dark house beyond. The other theme, time of day, is revealed by the late bright spot of light on the building on the far deep right—and by the softer graying shadows.

In Figure 277 the effect of the silence of approaching darkness is accomplished by the exaggeration of the darks of the doors and windows in this twilight. Notice, too, that the buildings are framed by the connecting bending arch of the trees. As our eyes get used to the dark we feel the small figures are moving slowly in the quiet dusk.

Project IV *Objects in a Room*

In this cluttered room the artist makes us work hard to move through his space. In Figure 278 objects slow down our movement into the room, even trip us as we try to get through the narrow passages. The clearly constructed and richly textured masses have a wide tonal range. This is accomplished here and in the two examples that follow with black, gray, and white pastel on a black ground. The strokes that build these forms and spaces show their marks, and this tactile effect makes us experience the process of construction.

278 Tim Schiffer. *Objects in a Room* I. 1974. Pastel. Collection Yale University Art Gallery.

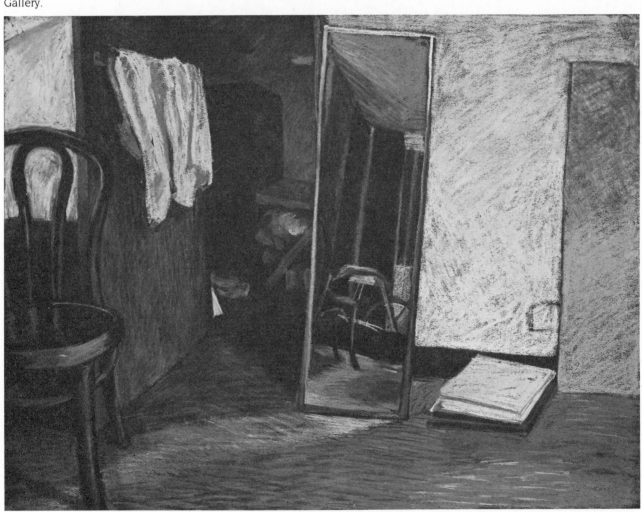

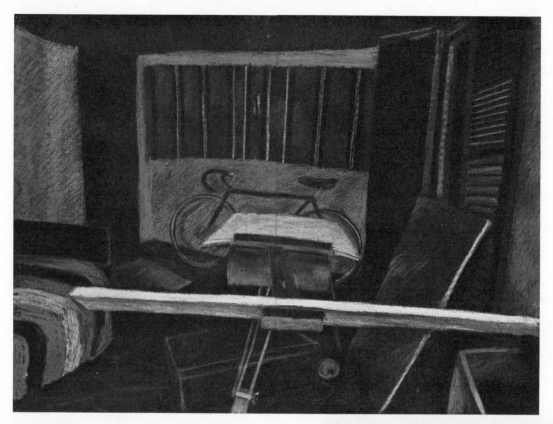

above: **279** Tim Schiffer. *Objects in a Room* II. 1974.
Pastel. Collection Yale University Art Gallery.

right: **280** Tim Schiffer. *Objects in a Room* III. 1974.
Pastel. Collection Yale University Art Gallery.

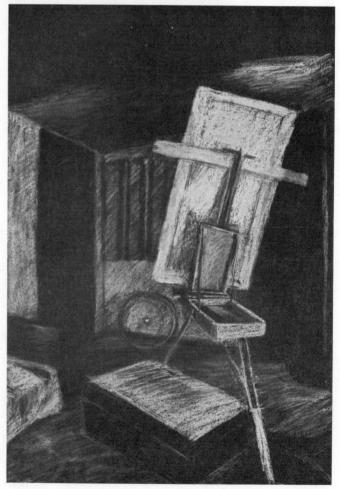

In Figure 279 the stretching form of part of the artist's portable easel cuts horizontally through the space, creating a frontal plane that bars us from walking through. Stopped against this sharp white barrier, we can gradually make out objects in the room beyond our reach.

Figure 280 shows another view of the easel, which this time gesticulates obliquely into the surrounding space. All the forms play variations on this angularity.

Project V *One Landscape*

In this project the student restricted himself to one place, one tool (brush), and one medium (tempera—in this case one of the new commercially prepared plastic acrylic temperas). He drew directly from the landscape, and, in the course of the year, passed through three distinct stages. In stage one he elected to stretch the limits of the amount of dark or light in any one composition. He produced many very dark, almost black pictures and some very light ones.

Figure 281 is one of the relatively dark drawings, though it does not approach the limits of darkness. The effect of light playing across the page is housed in a clearly readable space. The heavy trees in the foreground recede gradually through size diminution to the background wall of foliage. However, beyond this

281 Robert Ferris. *Landscape* I. 1965. Brush and wash (acrylic tempera). Collection Yale University Art Gallery.

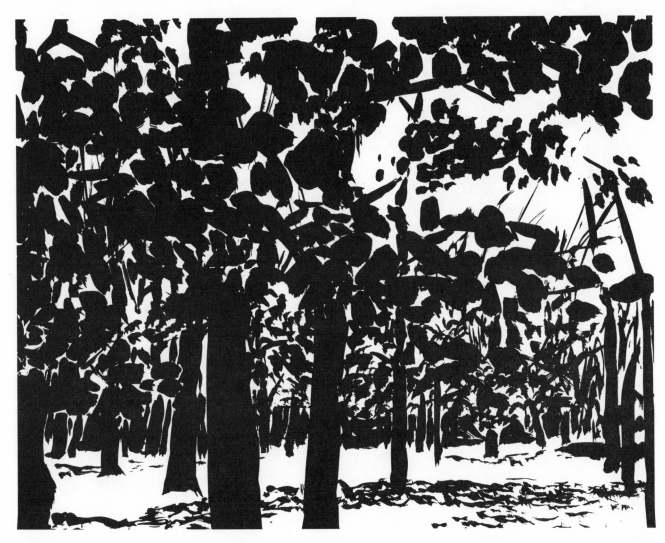

obvious spatial plane the life of the drawing lies in the action of strokes grouping together and opening to the light from the back plane. The white interspaces do not act as a flat background; instead, the white opens to suggest light in upper right and acts as a plane of gravity in the lower portion. The white further serves to set off the foliage.

This drawing was one of the best efforts of several months' work. Conversation during this period dealt with amounts of light and the use of white interspace as line, light, and plane. Beyond this, discussion focused on the limitations of the physical space to be portrayed: How much? How far back? How close to the viewer?

The second phase was concerned with a restricted, close-up space for foliage-inspired brush strokes [282]. It was during this period that the student explored Japanese and Chinese landscapes from the point of view of controlling the directed sequence of events on a page [104, page 87]. While studying this concept of controlled sequential reading, the artist was faced with the problem of imitating a master's brush strokes. To copy another's handwriting actually prevents one from developing one's own natural style. Yet it is the masters we admire who direct our growth in one direction or another.

In stage three the emphasis was on one aspect of Western spatial concepts—the idea of bisecting and intersecting planes that set up tensions. We are conditioned to this kind of construction from studying some of Cézanne's work,

282 Robert Ferris. *Landscape II*. 1965. Brush and wash (acrylic tempera). Collection Yale University Art Gallery.

283 Robert Ferris. *Landscape* III. 1965. Brush and wash (acrylic tempera). Collection Yale University Art Gallery.

and more recently the work of Max Beckmann, John Marin [39, page 32], and Franz Kline. The heavy tree forms in Figure 283 shift the weight of the drawing to the left, yet balance is maintained by the broken, amorphous shapes at lower and upper right.

Project VI *Architectural Fantasy*

Inspired by Piranesi [37, 38; pages 31, 32], the student, an architecture major, embarked on a semester's search to create invented structures seen in changing light conditions. He created a sense of atmosphere with his use of charcoal—changing the technique to suit the desired mood.

These inventions, each about 30 inches (76 cm) wide, group themselves in three categories. In the first series, Figure 284 (page 216), weight and the fitting together of structures dominated: Blocks, cylinders, cubes, and arches were constructed and reconstructed not only to fit together logically and imaginatively but also to produce the sense of the pressure of heavy masses. Wide contrasts of light dramatize the effect, but equally important is the sense of scale, which if not considered simultaneously with the issues discussed above would not produce convincing drawings. A technical note: notice the use of a kneaded gum eraser to create white lines.

above: **284** Paul Rosenblatt. *Interior* I. 1981. Charcoal. Collection Yale University School of Art.

below: **285** Paul Rosenblatt. *Interior* II. 1981. Charcoal. Collection Yale University School of Art.

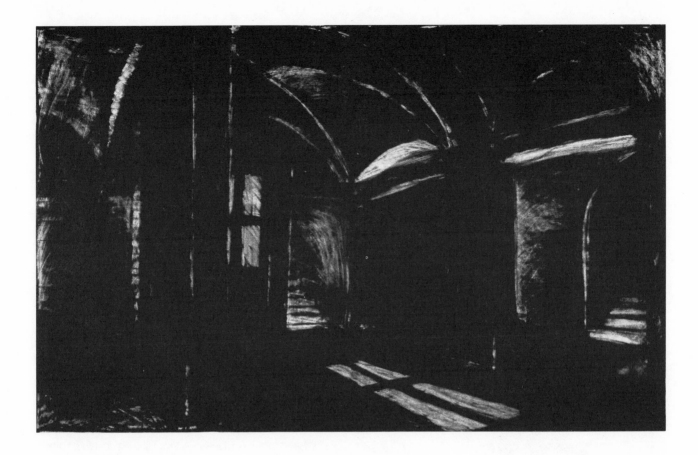

In another group of drawings [285], the pressure of weight gives way to a delicacy of light and airiness. Notice here the gently rubbed areas and the light touch of the charcoal which creates the mood.

Finally the artist experimented with different proportions [286] and the mystery of partially lit structures whose forms must be deciphered.

286 Paul Rosenblatt. *Interior III*. 1981. Charcoal. Collection Yale University School of Art.

Project VII *Polo*

The four ink-and-wash drawings reproduced here represent a small part of more than thirty drawings on the theme of polo produced in this project. First, the student had to work out her own system of transcribing the action. She found she could not make finished or even half-finished drawings in this arena of swift movements. She gradually developed gestural, fragmented sketches of movement that were such personal scrawls only she could decipher them. After each of these note-taking sessions, she began to reconstruct the visual events that stimulated her, inventing configurations based on her sketches and her newly learned skill of memorizing actions.

In Figure 287 (page 218) horses, players, and mallets spin clockwise and counterclockwise around a central core—an invented construction. Figure 288 (page 218) shows the three horses moving in different directions. The focal point that holds together all the movements is at the top, where the two mallets touch. The central player in Figure 289 (page 219) twists to the right, countering the main thrust of the horse shooting up and out to the left. The second horse and player continue a circular movement with the first player. Finally, Figure 290 (page 219) consists of a row of repeated circular and semicircular forms representing players and horses moving in a narrow elliptical space. The angular linear thrust of the mallets plays a separate but interlocking game with the circular motion.

above: **287** Lisa Gelfand. *Polo* I. 1974. Pen and ink with wash. Collection Yale University Art Gallery.

below: **288** Lisa Gelfand. *Polo* II. 1974. Pen and ink with wash. Collection Yale University Art Gallery.

above: **289** Lisa Gelfand. *Polo* III. 1974. Pen and ink with wash.
Collection Yale University Art Gallery.

below: **290** Lisa Gelfand. *Polo* IV. 1974. Pen and ink with wash.
Collection Yale University Art Gallery.

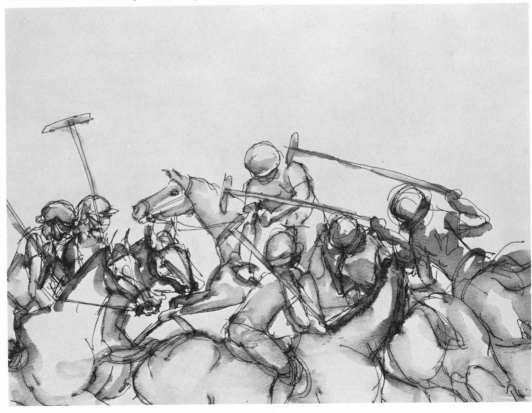

Project VII *Polo* 219

Project VIII *One Tree*

The curving posture of one particular tree was the attraction for the student in this single-semester theme. He employed charcoal in Figure 291, as throughout the series, to pull together the whole arched form of the tree in an arrangement of broken planes. At first the rhythmic interruptions were too obviously balanced, which tended to make the sections cancel out one another and produced a relatively tensionless space.

In Figure 292 the entire structure of the tree becomes one rounded, spreading volume. The darks, which were used to create drama, were not quite in harmony with the forms and the space around them. Some dark sections, in fact, look

above: **291** H. Turner Brooks. *Tree I*. 1965. Charcoal. Collection Yale University Art Gallery.

right: **292** H. Turner Brooks. *Tree II*. 1965. Charcoal. Collection Yale University Art Gallery.

left: **293** H. Turner Brooks. *Tree* III. 1965. Charcoal. Collection Yale University Art Gallery.

below: **294** H. Turner Brooks. *Tree* IV. 1965. Charcoal. Collection Yale University Art Gallery.

as though dust has been sprayed on top. It was emphasized that the darks must act in and with the forms that are being presented.

The student was prompted by the criticism to present the same form arrangement with more reliance on linear elements. In Figure 293 the manner is not so highly stylized, forms are more clearly stated, and the white interspaces between and around the lines function to support these lines in a less obviously designed attitude.

In Figure 294 the broken-plane idea returned, this time with a sweeping rhythm that again suggested a single sculptured volume. Here the student was very self-critical. He felt that the "style" produced an almost stained-glass effect and that the flowing movement was too obvious. Discussion centered around the

idea that transparent planes suggesting synthetic cubism—wherein all the facets of each plane are visible simultaneously to produce an allover surface tension—must not appear to be tacked on top of an image. Instead, the "system" should carry the image.

Figure 295, the final drawing in the series, is an invention based on the actual experience of the tree. The tension-filled traffic points in the center gradually expand to hold a plane very close to the viewer. This frontal plane is represented by the largest dark strokes circling the edges of the composition. Here the technique and the constructed space are made to merge.

In this project the student was obviously influenced by Mondrian's studies of trees [7, page 6]. Nevertheless, he has faced issues of design concepts.

Project IX *Concert Theater*

To construct a personal portrait of a large space is an ambitious project. The student in this project became involved in this theme after being frustrated by his inability to find a satisfactory motif in his own room.

The problem he had at first was technical and took place before the successful examples reproduced here. The initial drawings in red conté crayon, a medium used throughout the series, were too heavy, too generous in their use of plastered darks that seemed to balance and cancel each other. His strokes, applied with the side of the crayon, gave out little energy. They were merely filled in.

Reacting in Figure 296 to the above criticism, the artist went out of his way to control the darks and, by means of constructive markings, to show the flow of the curving ceiling and the outer wall of the theater. This technical decision—this method of controlling and building up the strokes—is completely in harmony, indeed integral to the theme of moving around this curvilinear space.

In the next drawing, a view of the rear of the theater [297], the artist, more relaxed and at peace with the criticism, worked out a greater tonal range with various textures acting in concert.

above: **296** Konrad Marchaj. *Concert Theater* I. 1976. Conté crayon. Collection Yale University Art Gallery.

below: **297** Konrad Marchaj. *Concert Theater* II. 1976. Conté crayon. Collection Yale University Art Gallery.

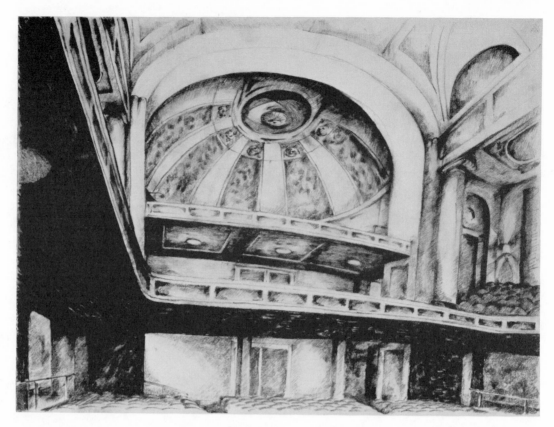

above: **298** Konrad Marchaj. *Concert Theater* III. 1976. Conté crayon.
Collection Yale University Art Gallery.

below: **299** Konrad Marchaj. *Concert Theater* IV. 1976. Conté crayon.
Collection Yale University Art Gallery.

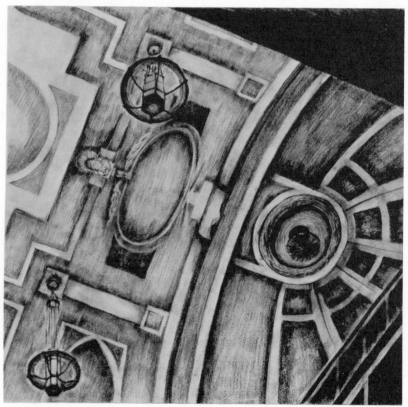

Figure 298 places the artist and viewer in the middle of the theater. He takes us first to the top, where a strong light moves down to the balcony. Next we move down to the main force, the dark underside of the balcony constructed with strokes that direct us into and around the space. This energy is controlled in its sharp L-shaped movement so that it does not drop out of the picture plane. Finally, the artist directs us to the bottom, with its quiet, soft chair forms. He is able to take us on a journey from light at the top, through dark strong movement, to bottom whispers. This wide tonal range is held in full control.

In the last of the series [299] he makes us turn our heads upward to see the ceiling pattern, contained by the dark angles at top and bottom right.

You will notice that we have selected projects that vary greatly in instrument, instrumentation, and aesthetic direction. But this consideration was ours and not that of these nine students who worked to find their own answers to their own problems and produced more than twice the work possible in an ordinary class-room situation. Their personal search deepened their own attitudes, and they found it easier to learn what they did not know, for they discovered their own deficiencies and tried to master them. The point at which a student takes the lead marks the transition between the need for dictated problems (which unavoidably reflect the personal tastes of the instructor) and the beginning of individual devel-opment.

CHAPTER 12

Instrumentation

Buying a brush or a new pen can be an exciting event for an artist. One gets the "feel" of the instrument through making idle surface marks and learns how to play the instrument. This random sketching is often a sensuous experience in itself, and ultimately an image is born that accommodates the experience. Although a concept may dictate a certain tool, the artist must always imagine future work within the context of familiar tools and materials. *Instrumentation*—the way in which we make particular marks with a tool—is shaped by the demands of both the desired image and our natural handwriting. The dialogue between the instrument and instrumentation is, for some artists, a broad one [see 93, 95; pages 80, 81], but for others the choice is narrow. Obviously, it is not the range of virtuosity that measures the value of a drawing or of a particular artist.

If "technique" is seen as the interaction between instrument and instrumentation, then, in the finest sense, technique works in the service of a concept and does not act as a detached or added element. On the other hand, technique in its worst sense is the search for a surface treatment that becomes the main interest of the artist and of the viewer. Tools and their marks, if they are not to become the subject of the drawing, must remain always subservient to the artist's vision, for if we see how a drawing is made before we perceive the life of its forms, we are seeing only technique.

Many of Rembrandt's drawings exhibit the most spectacular free-flowing surface marks, yet one does not at first see how he made the drawing, for the strokes always function primarily as carriers of form and composition. In this chapter we will study a series of master drawings and explore the ways in which a particular instrument or the artist's instrumentation was used to serve a vision. We will also discuss the advantages of "copying" a masterwork, not to produce a facsimile but instead to *paraphrase* its particular graphic language as we study its compositional structure. In this process we will extend our study of instrumentation to make a logical bridge from wash drawing to water-base acrylic painting.

226

Technique at the Service of Vision

The surface quality in Georges Seurat's At the "Concert Européen" [300] derives from the marks of conté crayon that seem rubbed or forced into the fine vertical ribs of the textured paper. This texture breaks down the light into small particles, and at first glance the effect is similar to that in Seurat's painting, where dots of various colors give an additive effect (for example, red and blue appear as purple when seen from a distance). The surface treatment actually produces a light that seems to be emanating from the white figure at center stage. Here tool and mark serve naturally the visual drama of repeated circles in a darkened foreground set against a lighted background. The vertical bar at right stabilizes the composition and helps define the space between the heads and the background space. The tilted, wavy line at the bottom of the composition defines the frontal plane.

Most master drawings have a tendency to reveal their tool marks—even in flowing washes—rather than disguising them by blending. Seurat's work is a rare exception, for the tooth of the paper takes the role of the mark.

300 Georges Seurat (1859–1891; French). At the "Concert Européen." c. 1887. Conté crayon, 12¼ × 9⅜" (31 × 24 cm). Museum of Modern Art, New York (Lillie P. Bliss Collection).

above: **301** Jean François Millet (1814–1875; French). *Fagot Carriers.* Conté crayon, 11⅜ × 18⅜″ (29 × 47 cm). Museum of Fine Arts, Boston (gift of Martin Brimmer).

below: **302** Matthias Scheits (1625/30–1700; German). *Peasant Carnival.* Conté crayon. Kunsthalle, Bremen (destroyed in World War II).

303 Jean-Antoine Watteau (1684–1721; French). Study for *Les Charmes de la Vie*. Black chalk, graphite pencil, and touches of red chalk. Louvre, Paris.

In Jean François Millet's *Fagot Carriers* [301] the crayon marks all are visible and produce a broad stage for groups of sticks. These strokes engulf the figures at right, so that they become part of the background. The broken-light effect, made by the conté crayon strokes, forms a backdrop for the central figure, which is presented with the same stroking, thus keeping the whole drawing in a uniform atmosphere of light.

Matthias Scheits' *Peasant Carnival* [302] was produced with the same kind of tool—chalk or conté. In this work the use of the instrument is clearly dictated by the compositional demands of the theme; allover activity requires a rapid criss-crossing of energy and light.

In Watteau's *Les Charmes de la Vie* [303] study the figures move across the page in a cinemalike sequence. One postured gesture blends into another as we read from left to right. The figures seem to exist in a strong sidelight, which is kept constant. This light causes abrupt dark shadows and highlights in the drapery, and these are depicted with sure, economical marks that stay in place on the form.

Pen lines cannot easily be erased. Thus we do not usually connect pen drawings with "searching"—that is, drawings that may be rehearsals for formal works in other media or which reveal the quest for the particulars of a form or for its spatial location. However, there are exceptions to this rule.

Pollaiuolo keeps the contours of his forms open and flexible as the swift, darting instrumentation of the pen probes the expression and articulation of

right: **304** Antonio Pollaiuolo (c. 1432–1498; Italian).
Saint John the Baptist. Pen and bistre ink, 11 × 7¾"
(28 × 20 cm). Uffizi, Florence.

below: **305** Liberale da Verona (1451–1536; Italian).
Mother Nursing Her Child. c. 1480–1490. Pen and bistre
ink, 8¼ × 11" (21 × 28 cm). Albertina, Vienna.

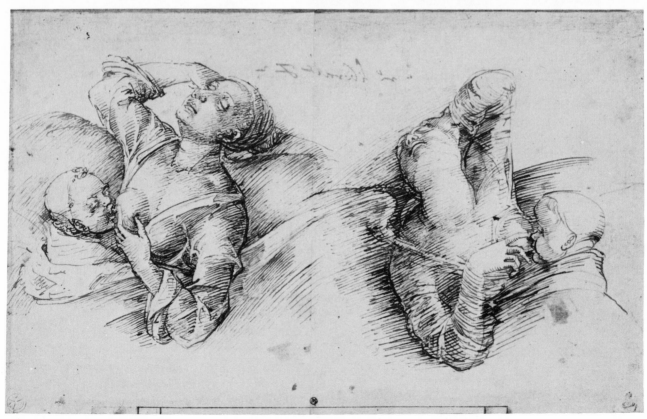

limbs in the study reproduced as Figure 304. The artist repeats the hands up and down the page in his search for the exact gesture.

Mother Nursing Her Child [305], a steel pen drawing by Liberale da Verona, suggests another attitude. The forms are as sharply defined as those of an engraving, with its demand of total commitment to a line; the strokes forming the rounded forms also suggest the use of a steel burin, the engraver's tool that is employed literally to dig the line out of the metal plate.

Corot also employed a steel pen in *Environs of Albano* [306]. But here the loose rhythmic interlocking of tree forms, rocks, and small figures at the right sets up a patterned vibrating light throughout the whole page.

306 Jean Baptiste Camille Corot (1796–1875; French). *Environs of Albano.* 1826–1827. Pen and ink on beige paper, 12 × 13″ (30 × 32 cm). Formerly Collection Henri Rouart (courtesy Léonce Laget, Paris).

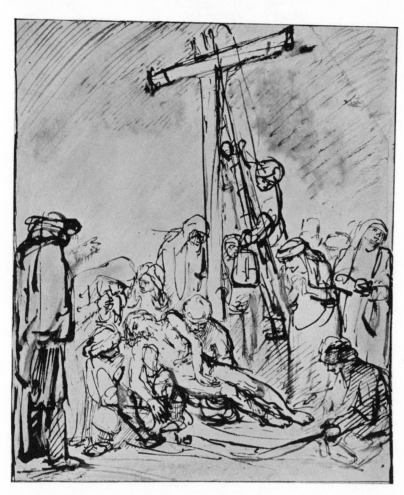

307 Rembrandt (1606–1669; Dutch). *The Deposition from the Cross*. c. 1647–1650. Pen and wash in bistre ink with white body color, 10⅜ × 8⅜" (26 × 21 cm). Kupferstichkabinett, Staatliche Museen, West Berlin.

Rembrandt used a different pen, a quill, and a different kind of instrumentation in a *Deposition from the Cross* [307]. The flowing manipulation of alternately scratchy and fluid, thick and thin lines sets up a hierarchy of focus. Broad heavy strokes create the strongest focus in the heavy columnlike figure that hugs the left edge and establishes the gravity of the whole composition. This figure is closest to us and acts as a curtain to frame the drama. It is balanced by the cross and the triangle below containing three fairly dark figures. Between these clear spatial stations the central drama unfolds, in which strong light created by lighter lines with broken contours seems to melt the top sections of the main actors. This is a brilliant staging produced by pen strokes that organize space and direct the focus rather than calling attention to their own virtuosity.

In Delacroix' reed pen *Study After Rubens* [308] we witness a strong virtuoso work based on another artist's design. These sensuous yet functional tool marks are not separate from the action of the form. The violent round strokes on the upper leg (far left) force the eye into an upward spiral movement. The experience of copying, discussed later in this chapter, is well illustrated here, for the artist is reacting to the forms studied in order to heighten his own sensation rather than rendering the original surface markings.

Magnanimity of Scipio Africanus by Anthony van Dyck [309] returns us to the searching attitude of Pollaiuolo [304]. This drawing resembles a notebook sketch in which the artist is testing the positions of shifting and flowing masses to find the most successful arrangement for a finished work. We sense this sequence of forms, because the instrumentation is in turn delicately slow and rhythmically fast. As in all the drawings reproduced, the instrumentation, beautiful in itself, is the product of the intention—a search for the clear staging of the actors.

above: **308** Eugène Delacroix (1798–1863; French). *Study after Rubens.* Reed pen and ink. Whereabouts unknown.

below: **309** Anthony van Dyck (1599–1641; Flemish). *Magnanimity of Scipio Africanus.* Pen and ink with wash. Kunsthalle, Bremen (destroyed in World War II).

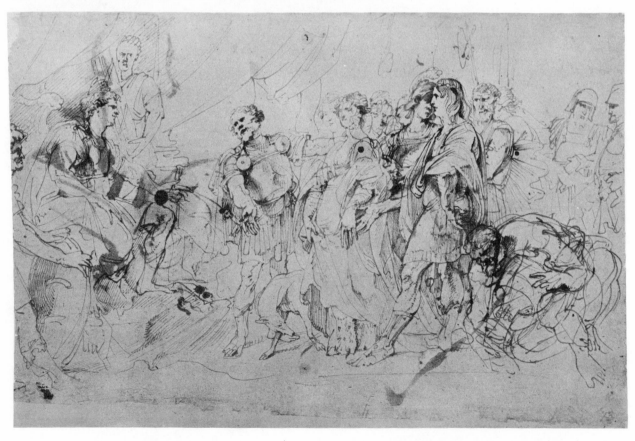

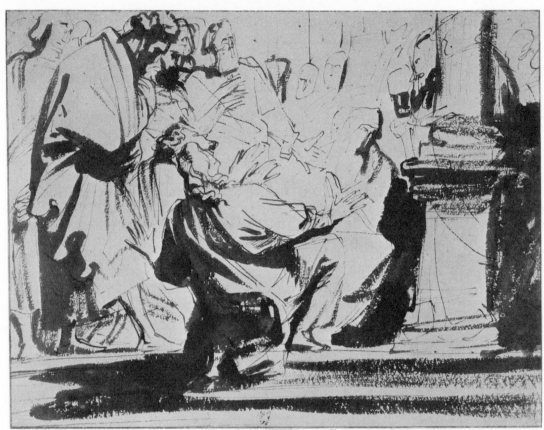

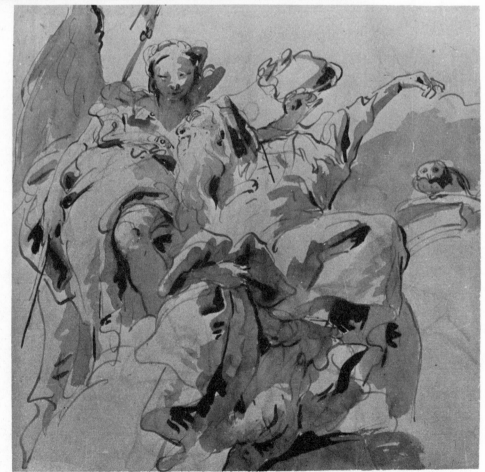

above: **310** Anthony van Dyck (1599–1641; Flemish). *Miracle on the Day of Pentecost.* Brush and ink, 9 × 11½" (23 × 29 cm). Staatliche Kunstsammlungen, Weimar, D.D.R.

right: **311** Giovanni Battista Tiepolo (1696–1770; Italian). *Virtue Crowning Wisdom.* Pen and wash with traces of black crayon on white paper, 10⅛" (26 cm) square. Metropolitan Museum of Art, New York (Rogers Fund, 1937).

Van Dyck's *Miracle on the Day of Pentecost* [310] uses a different tool, a brush, to achieve a different purpose. The drawing is not tentative. We do not sense the possible shifting of masses, but it is nonetheless a spontaneous performance. The brush strokes are sometimes dry and dragging across the frontal space, sometimes more fluid as they suggest figures in what seems to be an instant freezing of a dramatically lit situation. Van Dyck instinctively picked the most appropriate tool for each concept.

Giovanni Battista Tiepolo's *Virtue Crowning Wisdom* [311] is also a brilliant performance. Pen lines and dark areas of wash seem to have been done at the same instant as were the flowing washes. The action and function of these light washes themselves are exciting. They do not logically describe the planes of each figure, yet their distribution on the page creates a mutual attraction. This fluid, watered ink used so skillfully by Tiepolo is the only material that could create this particular effect.

Copying

As we have implied, one does not acquire a personal handwriting by emulating a master. The student's goal in copying is not duplication but understanding, in the hope that this insight will help to develop a personal handwriting and individual attitudes toward form. So it was that Constable did not simply make a reproduction of a landscape by Ruisdael that he admired [312]. In the process of develop-

312 Jakob van Ruisdael (c. 1628–1682; Dutch). *Landscape with a Cornfield.* Oil on canvas, 18 × 21½" (46 × 55 cm). Courtesy Thomas Agnew & Sons, Ltd., London.

ing his own ideas about landscape form, he transcribed in his sketchbook a few painterly notes on the spatial divisions, weights, and patterns employed by the Dutch master [313].

Similarly, in a pen-and-ink study after an etching by Goya, Delacroix translates the original medium into swift, wet washes [314]. This variation changes the tempo of the work and creates a sense of immediacy that forces the viewer to see all the actors at once.

In Figure 315, Jean-Antoine Watteau transforms a head by Rubens by adding his own vibrant punctuation. Instead of a gradual transition from light to dark, Watteau heightens the value range by accenting the features with swift, dark strokes that combine to form a diagonal axis across the composition.

The intelligent student copyist does not experience a drawing more fully than does the sensitive layman but may experience it in a different way. The copyist can perceive the positioning of a particular form in a particular space or divorce a form from its environment for individual study. One may discover, for example, that a seemingly straightforward head in an Ingres drawing is actually a very complicated structure. Copying this head with its special attitude will reveal the uniqueness of its foreshortening and the reasons for the exaggerated tilt in space.

313 John Constable (1776–1837; English). *Landscape with Cornfield* (after Jakob van Ruisdael). 1819. Pencil, 3½ × 4⅜″ (9 × 11 cm). Courtesy the Executors of the Estate of Lt. Col. J. H. Constable.

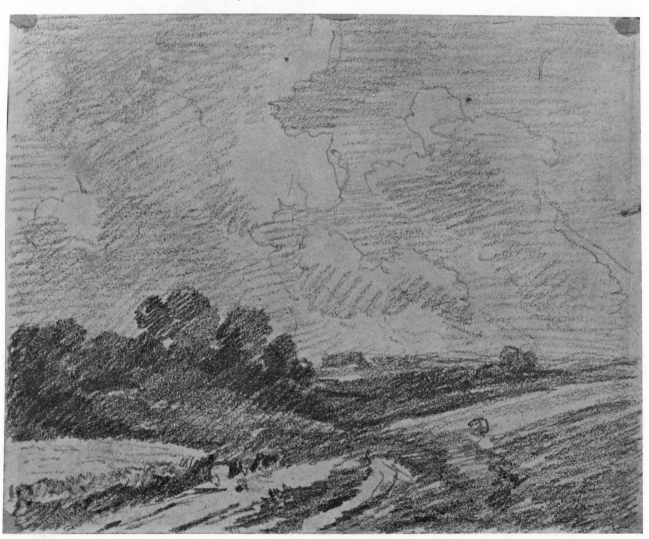

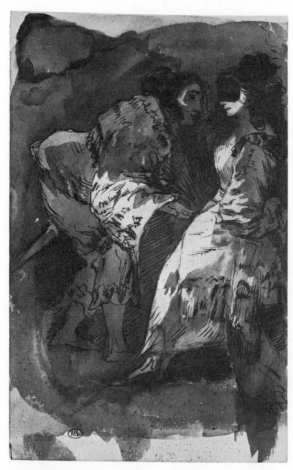

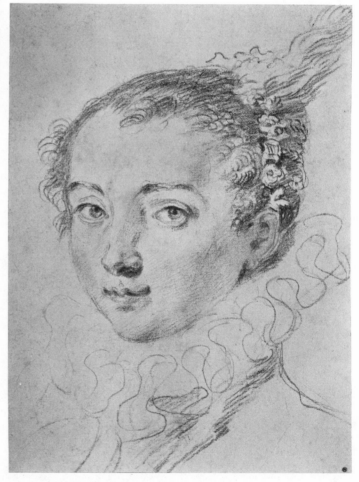

above: **314** Eugène Delacroix (1798–1863; French). *Masquerade* (after Francisco Goya, *Nadie se Conoce*, No. 6, *Los Caprichos*). c. 1830–1840. Pen and ink with wash, 7 × 4¼″ (18 × 11 cm). Louvre, Paris.

right: **315** Jean-Antoine Watteau (1684–1721; French). *Head of a Woman* (after Peter Paul Rubens). Black and red chalk, 12¼ × 8⅞″ (31 × 23 cm). Museum Boymans-van Beuningen, Rotterdam.

In copying a Tiepolo wash drawing the perceptive student can realize the miracle of suggestion in the master's floating washes, which do not strictly define form in space but seem to dance from one form to another. Or the copyist can discover the inner pressures of energy in Rembrandt's instrumentation, as these marks simultaneously create light and space for the compositional intent.

Studying the structure of a masterwork is at least as important as understanding its instrumentation. However, the practice of imposing triangles, circles, and S-curves over great works usually leads to oversimplification, if not to complete boredom. Another dangerous method is to cover a work with enforced surface marks. This has led to such bizarre experiments as applying Mondrian's field of plus and minus signs to a drawing by Titian. The idea, then, is not really to copy but to be aware of how the instrument and its instrumentation act as carriers of ideas and attitudes.

Student Response

In the study of masterworks the students were encouraged to use the copying experience directly by first making a free copy and then attempting their own drawings with the same attitude in mind. No specific instructions were given.

One student began by making a copy of an Ingres portrait. As a copy it was well done, but the student felt there was little experience extracted. He explained that he had chosen Ingres as a personal challenge, because his own tendencies were quite different. He then experimented with some freely invented studies after Poussin's figure compositions in wash [316]; these were much more in keeping with his own interests. During the next few weeks he produced a series of reactions to Poussin, of which Figure 317 is an example. This was copying for a purpose. Months later the student's own work, done independently of class study, revealed an interplay of figure and ground—that is, a harmony of interspaces and dark shapes [318]. In these studies the student's personal expression forms the composition.

316 Nicolas Poussin (1594–1665; French). *The Rape of the Sabines.* Pen and bistre ink with black chalk. Royal Library, Windsor Castle, England (reproduced by gracious permission of Her Majesty Queen Elizabeth II).

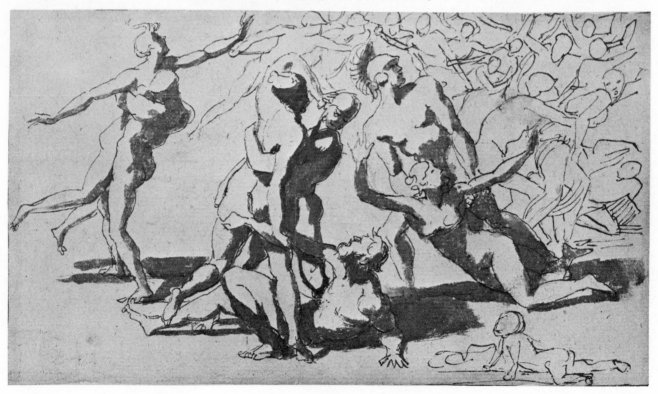

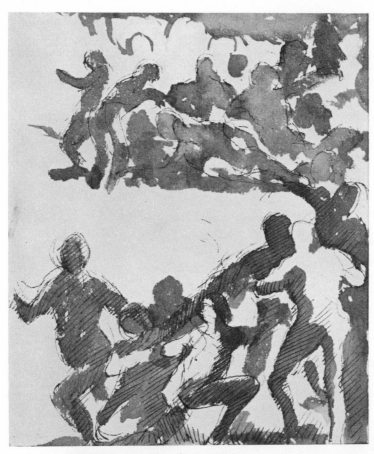

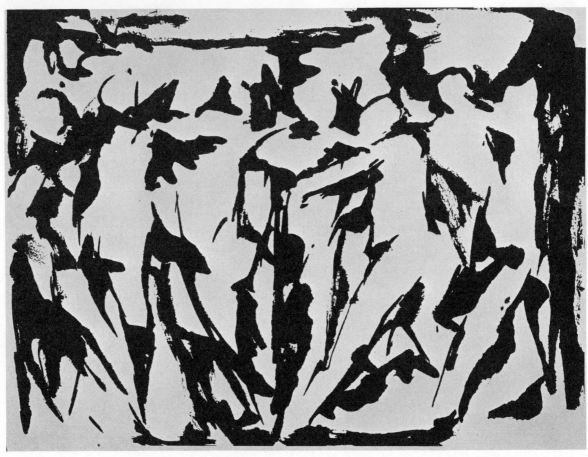

left: **317** Barry Schactman. *Study after Poussin.*
1959. Brush and ink with wash. Collection Yale
University Art Gallery.

below: **318** Barry Schactman. *Figure-Ground
Interplay.* 1959. Brush and ink. Collection Berit
and Richard Lytle, Woodbridge, Conn.

Two studies after Ingres [319, 320] illustrate different kinds of investigation. In Figure 319 the position of the figure in space is presented without the main interest—the head form. In studying these secondary shapes, this almost bland underpinning, we see Ingres' seemingly sketchy but firmly stated figure. In the original, with its insistence on the face, one is hardly aware of the firm structure that supports it.

In Figure 320 the copyist exaggerates the way in which Ingres stretched the eyes and mouth around the sphere of the head. This stretching, which we normally associate with a more sumptuous, "expressive" instrumentation and attitude, is beautifully understated with a hard yet delicate pencil line. The student copyist, of course, is studying rather than imitating.

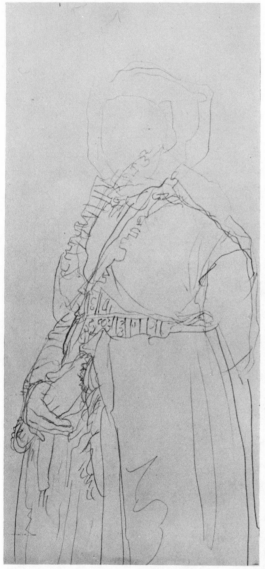

left: **319** William Cudahy. *Study after Ingres.* 1961. Graphite pencil. Collection Yale University Art Gallery.

below: **320** William Cudahy. *Study after Ingres.* 1961. Graphite pencil. Collection Yale University Art Gallery.

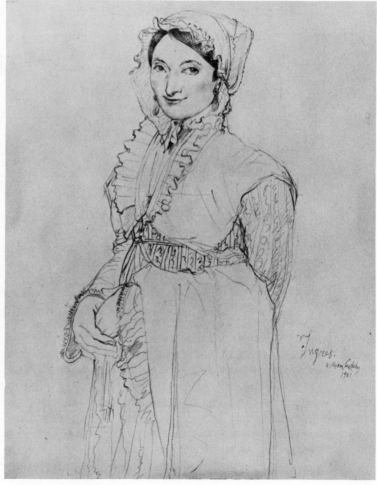

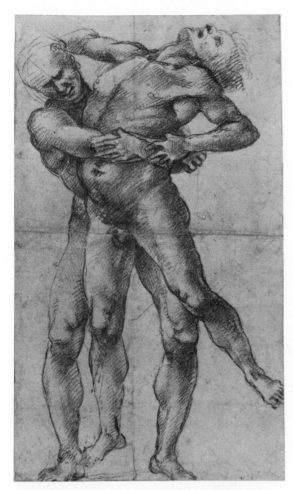

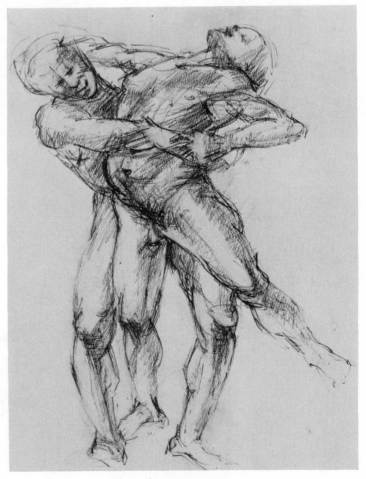

above: **321** Luca Signorelli (1441?–1523; Italian). *Hercules and Antaeus*. Royal Library, Windsor Castle, England (reproduced by gracious permission of Her Majesty Queen Elizabeth II).

right: **322** Barbara Duval. *Study after Signorelli*. 1981. Graphite pencil. Collection Yale University School of Art.

To change form attitudes when copying a masterwork is difficult, for the master turns us into a servant of the copied work. To assert another form language one must pay attention to the model (the copied work) and one's own intention. Let us illustrate a successful transformation: The serpentine rippling effect of muscles in this violent pose [321] is changed to an attitude of blocked-out simplified stretching planes in Figure 322. This superimposition of attitudes is a difficult challenge; it is important because it teaches us to see independently.

left: **323** Frank Moore. *Study after Hopper* I. 1973. Wash. Collection Yale University Art Gallery.

below: **324** Frank Moore. *Study after Hopper* II. 1973. Wash. Collection Yale University Art Gallery.

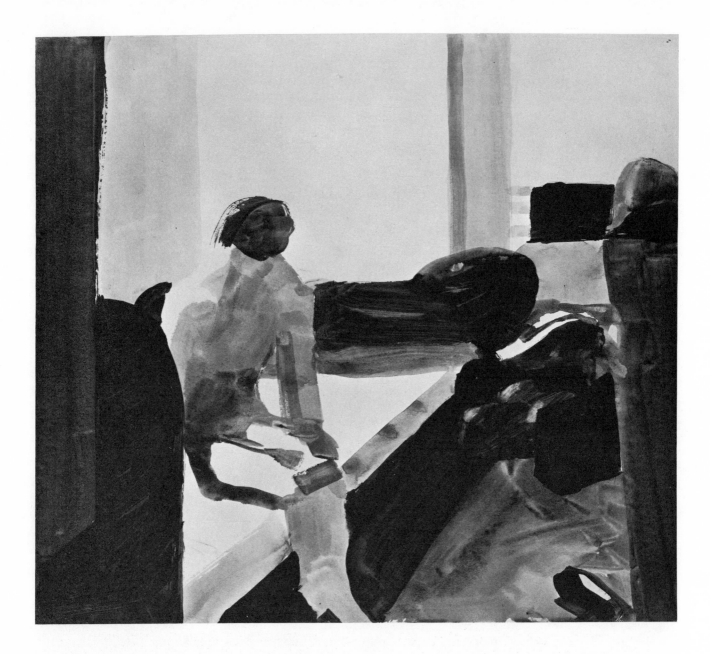

The following excerpts are from a student's diary, recording the stages of his analysis through "copying" of Edward Hopper's *Hotel Room*:

> "The first study was a direct try at paraphrase, a try at measuring the tempo" [323].
> "I sought to decompose the composition to determine the weights of the shapes in their places" [324].
> "Less heavy handed—more in the spirit of the work without imitating. The flow is less clogged, the space a little more measured." [325].

325 Frank Moore. *Study after Hopper* III. 1973. Wash. Collection Yale University Art Gallery.

From Drawing to Painting

The wash drawings in Figures 323–325 with their solid tonal or brushed planes are similar to paintings when seen in reproduction. How appropriate, therefore, to bypass the border of convenient categories and discuss painting as an outgrowth of drawing.

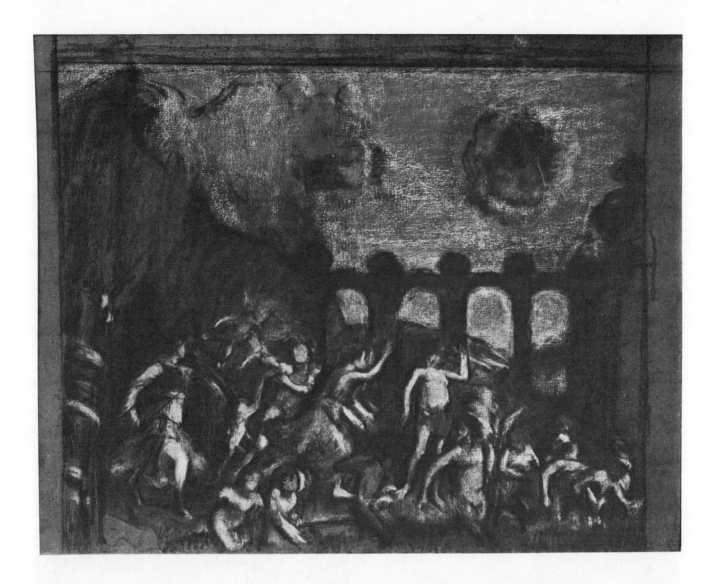

The transition from drawing to painting is a simple one if we keep within the broad boundaries defined in Chapter 4: Drawing is form without color. Artists in the past have often wished to explore form by means of a black-and-white or monochromatic palette without sacrificing the fluidity and sweep that can be attained with the brush and a liquid medium. Working from a photograph, Edgar Degas copied a fresco by Mantegna in charcoal and white chalk on brown canvas [326].

Student Response

Following the same restriction to black, white, and shades of gray makes for an ideal exercise in the boundary area between drawing and painting. By working in a water-based medium, acrylic, which produces both watercolor transparencies and varying opaque thicknesses—together with a simple support, chipboard—we are perhaps painting and drawing at the same time. At least this medium is calming to the student, who does not panic at the thought of the act of painting, with all its associated aesthetic and technical hurdles.

Acrylic paint does not need much exploration to achieve a workable control. The brushing—thick and thin applications—comes naturally to anybody with some basic drawing skill.

The necessary supplies were pint-size jars of black and white acrylic pigment, chipboard, and a 4-foot-square backboard or wallboard, to which the chipboard was stapled. Also required were paper peel-off palettes, acrylic gesso (for a ground, when desired), and four or five brushes ranging from thin watercolor brushes to 3-inch house-paint brushes. The brushes, support, paint, and palette are simple, and technical proficiency is no problem. We started with objects that could be multiplied—fruits and vegetables. The only stipulation was that no other kinds of objects be used, especially the traditional art-school props that frequently add a false note of variety for its own sake. Such variety tends to weaken or destroy the content and the formal problems of the exercise. Introducing too many objects that cannot be related naturally most often leads the beginner to reproduce the surface texture of each object and ignore the spatial effect of the whole page.

Students set up their own arrangements so that personal preferences in grouping or arranging became immediately evident. Symmetry and assymmetry, crowding, openness, weighted pressure—all these sensations and more appeared at the outset through the placement of forms in a preferred order.

The first and most persistent problem is composition—how to sustain an orchestrated surface. These exercises are thus about composing, and their ultimate goal (presented directly in the last problem) is the discovery that manipulating a physical sensation, through pressure, overlapping planes, or a desired set of proportions, is clearly allied—or, rather, permanently fused—with the content.

In Figure 327 the technical approach is almost identical to the brush-and-wash drawings in the Hopper reconstructions; there are few opaque touches. A liquid fluency is maintained throughout. This technical fluidity matches the physical effect: a nicely measured, constant rhythmic pulse is held in place by the

327 Pam Ozaroff. *Still Life*. 1975. Acrylic on cardboard. Collection Yale University School of Art.

above: **328** John M. Hull. *Still Life*. 1975. Acrylic on cardboard. Collection Yale University School of Art.

below: **329** John M. Hull. *Still Life*. 1975. Acrylic on cardboard. Collection Yale University School of Art.

weighted verticals. Although the work does seem to borrow heavily from Cézanne, its motif is honestly pursued and not merely imitative.

In Figure 328 we encounter vigorously brushed, heavily contoured forms, enlarged in relation to the page and to the viewer. This is not the measured beat of Figure 327. These forms crowd us. The sizes are irregular, as are the brush strokes and the rhythm. The more enlarged forms in Figure 329, by the same artist, crowd us even more. The enlargement of these forms sets up an aggressive scale that makes us feel small. The forms in both examples loom large and heavy.

Crowding is the theme of Figure 330, in which a narrow vertical format, with forms cropped on all sides, carries the message of pressure from left and right—a definite physical effect.

330 Alain Capretz. *Still Life*. 1975. Acrylic on cardboard. Collection Yale University School of Art.

331 Craig Davis. *Study of Shoes.* 1975. Acrylic. Collection Yale University School of Art.

As an extension of this problem students were instructed to set up a still life of their own choosing. In Figure 331 we again see our old friends the shoes, but this time in a very complicated space. First, the floor plane that houses the shoes is cocked at an angle to the left and tightly held from the back by a vertical mass at the table corner and a diagonal from the far right. In this rigidly held stage, a shoe in the half light pushes up from the left corner, extending the diagonal. The main shoes seem to be walking, one in front of the other. The brushing, especially of the floor plane, also plays its part in both holding the gravity and surrounding and echoing all the movements. It is a tautly held construction.

In the next problem we are back at copying. The students chose from a group of clear black-and-white reproductions of Poussin paintings. Why Poussin? In Poussin we have certainly one of the great stage managers in visual drama. Scale and movement are held perfectly in adjustment, to say the very least. The students were removed enough from the story content in Poussin to build relationships in a purely visual manner. The goal, then, was not reproduction but the study of these relationships.

Even within a seemingly rigid didactic exercise, individual expression was not lost. Personal preferences for angular planar relationships or overall baroque movement appeared naturally as a by-product of reconstruction. The personal handwriting of forming strokes varied from one individual to the next.

In Figure 332 the student built up coat upon coat of paint until he could satisfy his own goal of simplifying the masses and establishing interconnections of shape and pattern. It took constant shifting and realigning of planes to satisfy his desire of squeezing out the essence he found in the Poussin composition [333]. The result appeared to some of the class as a giant still life.

above: **332** Scott Stenhouse. *Study after Poussin*. 1975. Acrylic on cardboard. Collection Yale University School of Art.

below: **333** Nicolas Poussin (1594–1665; French). *Bacchanalian Revel before a Term of Pan*. 1636–1637. Oil on canvas, 2′9″ × 4′7⅞″ (.84 × 1.4 m). National Gallery, London (reproduced by courtesy of the Trustees).

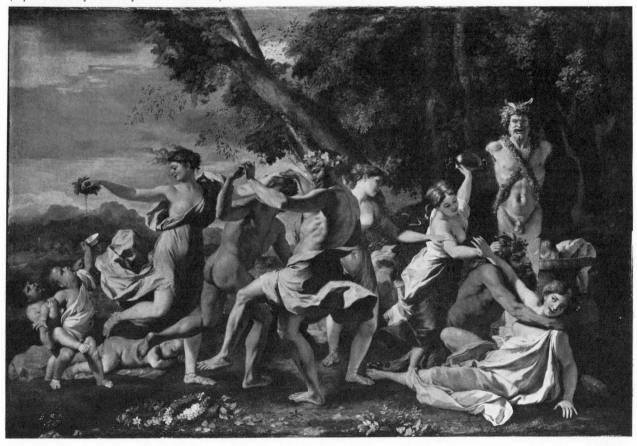

right: **334** Edouard Manet
(1832–1883; French). *At the
Café*. 1878. Oil on canvas,
30¾ × 33″ (78 × 84 cm).
Sammlung Oskar Reinhart,
Winterthur, Switzerland.

below: **335** Jack Huston.
Study after Manet. 1975.
Acrylic and charcoal on
cardboard. Collection Yale
University School of Art.

The main spatial divisions of a Manet [334] were directly indicated in charcoal on bare gray cardboard in Figure 335. The artist captures the strong interplay of triangles and squares, the geometric orchestration, that gives the original its visual life.

The positive and negative shapes of a great Tintoretto painting [336] are reinforced in Figure 337. The process entailed constant change and readjustment to produce the right flow, the right scale of relationships. The resulting texture was again a by-product of the trial-and-error search.

left: **336** Tintoretto (1518–1594; Italian). *The Wedding at Cana.* 1561. Oil on canvas. Santa Maria della Salute, Venice.

below: **337** John Swanger. *Study after Tintoretto.* 1975. Acrylic on cardboard. Collection Yale University School of Art.

above: **338** John Singer Sargent (1856–1925; American). *Daughters of Edward Darley Boit.* 1882. Oil on canvas, 7'3" (2.2 m) square. Museum of Fine Arts, Boston (gift of Mary Louisa Boit, Julia Overing Boit, Jane Hubbard Boit, and Florence D. Boit, in memory of their father, Edward Darley Boit).

right: **339** Alain Capretz. *Study after Sargent.* 1975. Acrylic on cardboard. Collection Yale University School of Art.

In a painting by John Singer Sargent [338] the figures are life-size. Concentrating on the values but above all on the proportion, the student finally achieved, after four good tries, the correct scale of relationships [339]. This final version, although only 9 inches high in actual size, seems visually very large.

Another problem drew upon the masters again to show that proportion, scale, light, composition, and so forth are themselves expressive elements even without a built-in "interesting" subject. The students were asked to set up a still life that would translate the masses of a masterwork into objects, then to work from this approximation.

A pencil, some cloth, and a collection of small boxes makes a fairly close family resemblance to an original Braque [340]. The student does not merely imitate the Braque, for he has to follow the flow of his own paraphrased invention, which produces its own problems and intricacies [341, page 254].

340 Georges Braque (1882–1963; French). *Road Near L'Estaque.* 1908. Oil on canvas, 23¾ × 19¾" (60 × 50 cm). Museum of Modern Art, New York (given anonymously).

From Drawing to Painting 253

341 Scott Stenhouse. *Still Life Based on Braque's "Road Near L'Estaque."* 1975. Acrylic on cardboard. Collection Yale University School of Art.

In our final example Manet's *Olympia* [342] is brilliantly reproduced by a woman's shoe, an artificial rose, an ink bottle, and some drapery [343]. Humor aside, this excellent effort presents a freely constructed approximation of the masterwork's original proportions and tonal values.

In this chapter we have emphasized tool marks and their relationship to form. We have seen that with the same instrument many kinds of instrumentation are possible, depending on the concept and the form attitude. There is beauty in the way marks move to encompass and release forms. The life of lines themselves—their speed, weight, and movement orchestrated in a personal way—is a natural by-product of the search for form.

We have also seen that copying is a challenge if we do not simply imitate but use the masterwork as a basis for paraphrase. We have explored, too, in the series of black-and-white acrylic paintings a transition from drawing to painting, keeping in mind what seemed hardest to learn: the limitless possibilities of personal expression within purely pictorial modes.

above: **342** Edouard Manet (1832–1883; French). *Olympia*. 1863. Oil on canvas, 4'3¼" × 6'2¾" (1.2 × 1.9 m). Louvre, Paris.

below: **343** Anne E. Heideman. *Still Life Based on Manet's "Olympia."* 1975. Acrylic on cardboard. Collection Yale University School of Art.

CHAPTER 13

Choices

In this final chapter we shall reinforce some of the ideas developed throughout the book, using master drawings as illustrations, and we shall explore still further the possibilities that exist in the art of drawing.

The first four drawings are concerned with the same subject, a seated or half-length female figure, but each is conceived within a distinct vision that directs the style, the touch, and the spatial arrangement. The purpose gives birth to the idea.

Picasso's straightforward portrait of Dr. Claribel Cone [344] is a complete graphic work in itself. It is not, so far as we know, a study that was to be executed in another medium. In this period (1922) Picasso, following Ingres' lead, focused with penetrating clarity on the head, and, in particular, on the facial features. The artist also suggested, in an understated way, the character of the hands, the folds of the dress, and so forth. Yet the whole figure is rather like a piece of sculpture on a pedestal, seen from one fixed, foreshortened position. The projection of the skull into three-dimensional space is clear, as are the transitions from the shoulder to the bust and from the knee to the pad on the floor. The unified projection of related forms could be translated into sculpture from this seemingly offhand line drawing.

By contrast, Georges Seurat's conté crayon study for *Les Poseuses* [345, page 258] confronts us with one dark, dramatic profile, the first impression of which is of pure silhouette, beautifully settled on the page. The edges of the drawing, which crop the top of the head, suggest a window in which the figure is set against the radiant light of the background. But after we adjust our eyes to sharp contrast in the light, we begin to perceive the character of the head, the slightly open mouth, and the distinctly formed features. Our initial awareness of one large shape thus broadens into an understanding of the particular form.

344 Pablo Picasso (1881–1973; Spanish). *Portrait of* Dr. *Claribel Cone.* 1922. Graphite pencil, 9½ × 8³⁄₁₆″ (24 × 21 cm). Baltimore Museum of Art (Cone Collection, formed by Dr. Claribel Cone & Miss Etta Cone of Baltimore, Maryland).

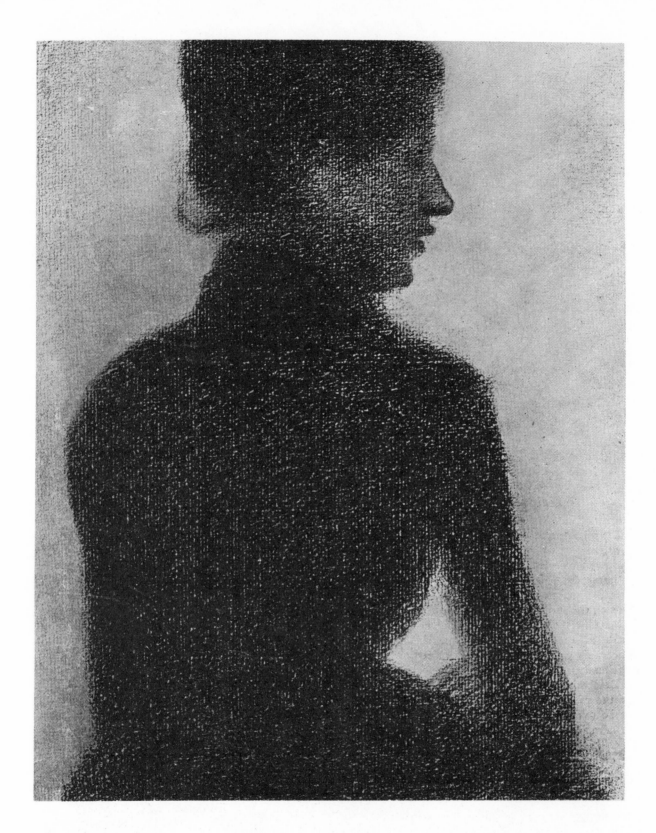

345 Georges Seurat
(1859–1891; French). *Une
Poseuse Habillée.* c. 1887.
Conté crayon, 12½ × 9½"
(32 × 24 cm). Destroyed in
the fire at the Gare des
Batignolles, Paris.

Holbein's *Portrait of Anna Meyer* [346] presents a silhouette. The figure is set
in a softly focused but intense light, and differences in the texture of skin, hair,
and dress are fully realized. The figure forms a triangle that easily fills the whole
space. The viewer is very close to the transfixed model, who seems unaware of the
intrusion. From this close range, we are directed to study what the artist wants us
to see.

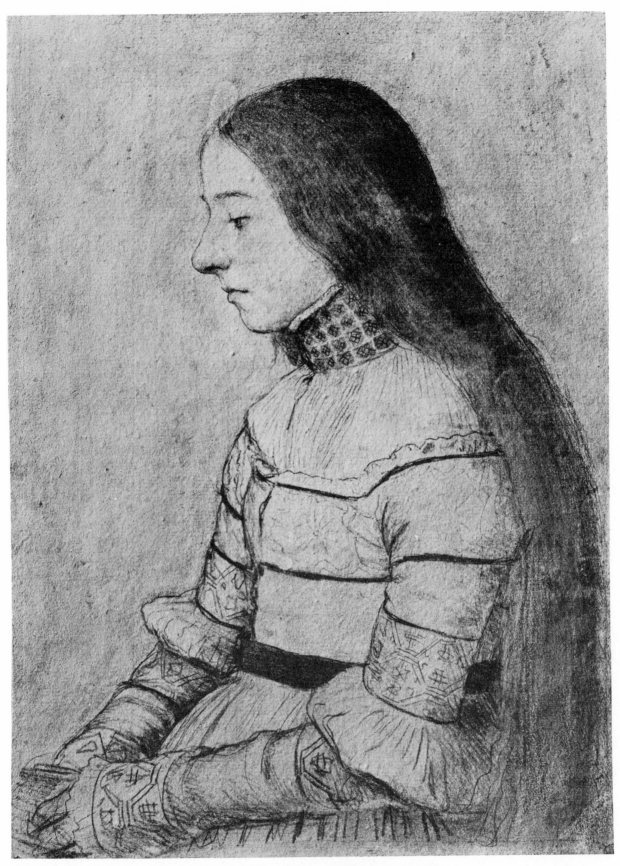

346 Hans Holbein the Younger (1497/98–1543; German). *Portrait of Anna Meyer.*
1525–1526. Colored chalks, 13⅞ × 10⅝″ (35 × 27 cm). Kupferstichkabinett,
Kunstmuseum, Basel.

Lamenting Woman by Matthias Grünewald [347] also forms a triangle, and it fills its space with the same components—hair, skin, and dress. But whereas the Holbein model is immobile, Grünewald's all-encompassing movements of form keep the viewer's eye moving through them. The tightly clasped hands act within these rhythms and connect the bodice to the hair at right. The head, twisting sharply in space, is distorted to make us see what seems impossible—the far side of the face. It is as if these spiraling rhythms, based in the two lower corners, gather momentum as they pulsate to the apex of the triangle, the head. In their speed they seem to gain pressure and push the forms of the far side of the head toward us.

These four drawings, which are all single-feature subjects, have some similarities, but they reveal how each concept dictates its own space, rhythms, focus, and instrumentation, all to reinforce the individual concept. Picasso and Holbein work from a fixed point with particular models; Seurat constructs one dark shape that houses a distinctly characterized head; and Grünewald's figure writhes under pressure from an all-embracing movement.

347 Matthias Grünewald (1470/75–1528; German). *Lamenting Woman with Folded Hands.* 1512–1516. Black chalk with white highlights, 16¼ × 11¾″ (41 × 30 cm). Sammlung Oskar Reinhart, Winterthur, Switzerland.

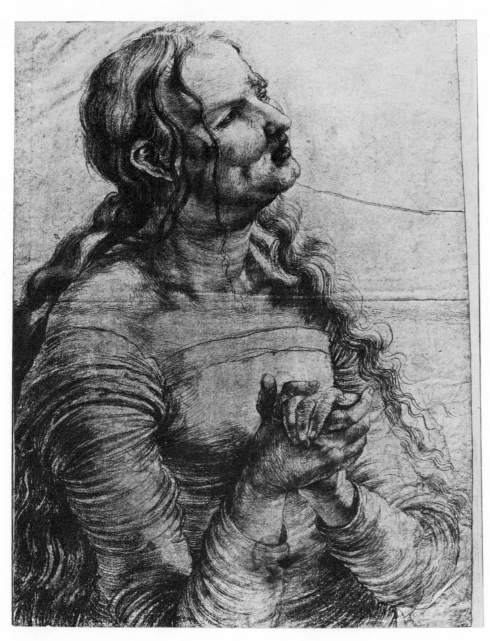

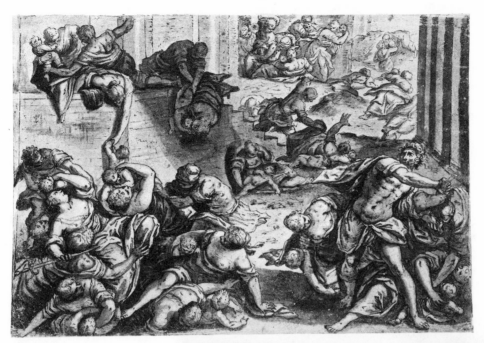

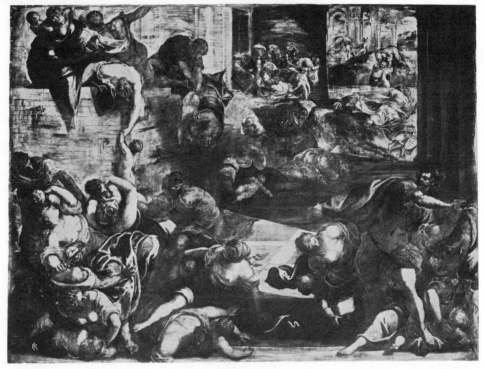

above: **348** Tintoretto (1518–1594; Italian). *Massacre of the Innocents.* Pen, wash, and ink. Albertina, Vienna.

right: **349** Tintoretto (1518–1594; Italian). *Massacre of the Innocents.* 1583–1587. Oil on canvas. Scuolo di San Rocco, Venice.

Tintoretto's *Massacre of the Innocents* in pen, ink, and wash [348] is a study for the painting [349]. Seeing them both together, we witness the artist editing his own composition. First, he reduces the scale of the lower right figure, which in the drawing dominates the space. He adds to this reduction by extending the row of vertical columns behind him so he becomes locked into the space. This action, in turn, makes the artist pull the figures above closer to the picture plane. In the original drawing these figures move diagonally into a deeper space. With the leftover space on top he carves an architectural niche to hold one group of figures, thereby setting up an additional compositional vignette. In addition, he makes the lower planes sharper by reinforcing hard-edge shadows. As a result, the entire space is compressed, with all the figures locked into strong planar forces.

above: **350** Rembrandt (1606–1669; Dutch). A *Winter Landscape*. Pen, brush, and brown ink on cream paper, 2¾ × 6¼" (7 × 16 cm). Fogg Art Museum, Harvard University (bequest of Charles Alexander Loeser).

below: **351** Paolo Veronese (1528–1588; Italian). *Studies for The Finding of Moses*. Pen and brown ink with brown wash, 6¾ × 7⁵⁄₁₆" (17 × 19 cm). Pierpont Morgan Library, New York.

352 Paul Cézanne (1839–1906; French). *Page from a Sketchbook with Self-Portrait.*
1884–1886. Pencil on white paper, 19¾ × 12½" (50 × 32 cm). Collection Lord Clark,
Hythe, Kent.

The drawing, the initial concept, is a work of art in its own right. Besides this,
it helps us document the steps toward the realization of the final masterpiece,
because we can read the artist's moves.

A more generalized style is that of Rembrandt in Figure 350, a small work in
pen and wash. The brief, quickly sketched marks explain the whole space in a
miraculous manner. We are pulled into the composition by the dark frontal post of
the fence, which then recedes, drawing us even farther into depth. We are returned
to the frontal plane by the clash of horizontal and vertical strokes on the right.
Here again is a complete artistic statement.

In Paolo Veronese's *Studies for the Finding of Moses* [351] we can follow his
search for the appropriate bodily gesture for individual figures and groups of
related figures as they surround the infant. In addition, we can find a configuration
of folds in drapery (in the center) plus sketches of a possible architectural back-
drop. All this in a sheet which measures less then 7 inches (17 cm) high.

Figure 352 is a sheet from Paul Cézanne's notebook. There is no single
subject, but rather a kaleidoscopic collection of several of his well-known themes:
a self-portrait, an apple, a moving female bather, a study after Goya. We are wit-
ness to the master's thoughts—he is thinking, searching, planning.

Michelangelo's *Anatomical Study* [353, page 264] reveals, as the title sug-
gests, a study of facts. But there is more than mere structural information in this
study. The page, whether by design or by instinct, is carefully composed. The leg

above: **353** Michelangelo (1475–1564; Italian). *Anatomical Study.* Pen and ink,
8⅜ × 10⅜″ (21 × 26 cm). Uffizi, Florence.

below: **354** Pieter Bruegel the Elder (1525/30–1569; Flemish). *Temptation of Saint Anthony.* 1556. Pen and ink on brownish discolored paper, 8⅝ × 13″ (22 × 33 cm). Ashmolean Museum, Oxford.

355 Francisco Goya (1746–1828; Spanish). *Bobalicón* (preparatory drawing for No. 4 in the *Disparates* series). Wash. Prado, Madrid.

forms are held in mutual tension, interlocked and interdependent. The grouping of these forms thus takes on a separate life, distinct from the problems of anatomical study.

Throughout this book we have emphasized the need to commit natural, human, and environmental forms to memory as a basis for individual interpretation. In this context it is appropriate to reproduce Bruegel's *Temptation of Saint Anthony* [354], a fantasy creation made up of invented and remembered forms from nature. Discreetly hidden in the lower right, Saint Anthony becomes part of a vast panorama of whimsical and grotesque characters.

Goya, too, creates a stage for his invented characters [355]. The bottom line acts as one step of the stage to support the minor character, while the second line, parallel to the first, provides a base for the main figure. Unlike Bruegel, who makes us see the whole stage from afar, Goya places us in front row center.

Summary

Compared to other visual media, drawing is a magical art. In no other medium can we go so directly from thought process to image, unencumbered by materials or extensive preparation. We are able, with experience, to refine our thoughts in a direct way, without complicated techniques. With this immediacy, drawing can

accommodate all attitudes, whether we are reacting directly to the forms around us, refining forms from memory, inventing new forms, or even planning complicated relationships.

Whether their purpose is the transformation of forms from the environment or inventions for the sake of plastic action alone, great drawings have a built-in economy of conception and performance. This economy is often deceiving to beginners, who may not be aware of the selecting process and the boiling down to essence that gave birth to a particular experience, and who may misread it as simplicity of conception.

The practice of slavishly imitating a master's work leads to frustration and, ultimately, to sterility, for the touch of the master's hand that we admire is the product of natural tendencies—personality, development, and genius. This accumulation of experience and personality builds a unique vision that transmits the message naturally. The young draftsman should, from the beginning, try to experiment with all modes of drawing, constantly trying on different suits to find out what fits before considering the polished technical performance. What we like initially in the masters changes with experience. Even mature artists admire what is not natural to themselves: A "baroque" artist may like Mondrian, or a "minimal" artist may like Rubens. It is important to study rather than duplicate, for understanding fosters natural development, while emulation may lead to a parody of mannerisms.

It is dangerous to use a bit of "master technique" to dress up a work or to conceal a lack of formal invention. What we must extract from the masters is the kind of thinking that was employed and the growth of an ability to select, for we cannot start directly where someone else left off. A lifetime's experience that has developed an attitude cannot be obtained by mere imitation. Still, it is the work of the masters that puts us on the right track, that makes us see the world of forms and our own environment in a new way and inspires us to develop our own ways of seeing, and, just possibly, of inventing our own world of form life.

Forms from our imagination or from the physical environment, which we can call *life forms*—such as a tree in nature or demons in the mind of a Bruegel—are transmitted by the artist's vision and skill to create something new—a *form life*. This cycle from life form to form life begins in drawing when the artist, haunted by an image or an idea, puts pencil to paper.

Index

A page number in **boldface** type indicates the page on which the cited work of art is reproduced.

Photographic Sources

References are to figure numbers unless indicated Pl. (plate).

Figs. 68 and 88 were drawn by Felix Cooper, New York.

All student works in the Yale University Museum of Art were photographed by Joseph Szaszfai, Branford, Conn.

Alinari/Editorial Photocolor Archives, Inc., New York (41, 336); Lichtbildwerkstätte "Alpenland," Vienna (45); Jörg P. Anders/Bildarchiv Preussischer Kulturbesitz, W. Berlin (307); Anderson/Editorial Photocolor Archives, Inc., New York (238, 349); Bulloz, Paris (225, 355, Pl. 7); Barney Burstein, Boston (75); Carlton Studios, London (97); Leo Cave, Ottawa (70); Geoffrey Clements, Inc., Staten Island, N.Y. (12); A. C. Cooper Ltd., London (17, 93, 95, 244, 316, 321); A. Frequin, The Hague (14, 315); Laboratoire et Studio Gérondal, Lille (249); Giraudon, Paris (342); Mel Goldman Studio, Boston (28); Solomon R. Guggenheim Museum, New York (21); Hans Hinz, Allschwil, Switz. (346); Hirmer Verlag, Munich (187); Jacqueline Hyde, Paris (4); International Exhibitions Foundation, Washington, D.C. (91); Bruce C. Jones, Centerport, N.Y. (16); B. P. Keiser, Braunschweig, W. Ger. (62); Ralph Kleinhempel, Hamburg (38, 98); Lauros-Giraudon, Paris (190, Pls. 6, 8); MAS, Barcelona (50, 63, 80, 355); Robert E. Mates, New York (52, 102); Pierre Matisse Gallery, New York (5, 191); Studio Jacques Mer, Antibes, Fr. (46); New York Academy of Medicine (186); Sydney W. Newbury, London (312); Eric Pollitzer, Hempstead, N.Y. (5, 120); Réunion des Musées Nationaux, Paris (49, 60, 76, 78–79, 118, 133, 147, 230, 239, 303, 314, 326); Earl Rippling, New York (72); Soprintendenza alle Gallerie, Florence (59, 353); Stedelijk Museum, Amsterdam (121, 140, 152); Walter Steinkopf/Bildarchiv Preussischer Kulturbesitz, W. Berlin (22, 69); Soichi Sunami, New York (39); Joseph Szaszfai, Branford, Conn. (92, 212); Taylor & Dull, Inc., New York (232).

Figs. 1, 67 from Agnes Humbert, *Henri Matisse*, Bibliothèque Aldine des Arts, Volume 37. Paris: Fernand Hazan, 1956.

Figs. 1, 67 from *Henri Matisse, Dessins*, by A. Humbert, vol. 37 of Bibliothèque Aldine des Arts, Fernand Hazan, Paris, 1956.

Fig. 235 from Fritz Schiders, *Plastisch-Anatomischer Handatlas*. Leipzig: Verlag E. A. Seeman, 1922.

Figs. 236, 237 from Victor Perard, *Anatomy and Drawing*. New York: Victor Perard, 1928.

Works by Arp, Bonnard, Calder, Giacometti, Kandinsky, Leger, Modigliani, Villon: © A.D.A.G.P., Paris, 1983. Works by Klee: © A.D.A.G.P., Paris/COSMOPRESS, Geneva, 1983. Works by Mondrian: © BEELDRECHT, Amsterdam/V.A.G.A., New York, 1983. Fig. 42: © S.I.A.E., Italy/V.A.G.A., New York, 1983. Works by Bonnard, Degas, Dufy, Matisse, Picasso, Redon, Renoir, Rouault: © S.P.A.D.E.M., Paris/V.A.G.A., New York, 1983. Figs. 132, 135, 209: © ARCH.PHOT., Paris/S.P.A.D.E.M./V.A.G.A., New York, 1983.